ALBRECHT DÜRER

The Human Figure

ALBRECHT DÜRER

The Human Figure

The Complete
'Dresden Sketchbook'

Edited, with an introduction, translations and commentary by

WALTER L. STRAUSS

Dover Publications, Inc., New York

Published in Canada by General Publishing Company, Ltd., 30 Lesmill
Road, Don Mills, Toronto, Ontario.
Published in the United Kingdom by Constable and Company, Ltd., 10
Orange Street, London WC 2.

This Dover edition, first published in 1972, is an original new edition of
Dürer's *Dresden Sketchbook* by Walter L. Strauss, who has supplied the
complete text, including the first English translations of the handwritten
inscriptions on the drawings.
The illustrations have been reproduced from those in the portfolio *Das
Skizzenbuch von Albrecht Dürer in der königlichen öffentlichen Bibliothek
zu Dresden*, edited by Robert Bruck, originally published by J. H. Ed.
Heitz (Heitz & Mündel), Strassburg, 1905, in the series *Studien zur
deutschen Kunstgeschichte*.

International Standard Book Number: 0-486-21042-1
Library of Congress Catalog Card Number: 70-184686

Manufactured in the United States of America
Dover Publications, Inc.
180 Varick Street, New York, N.Y. 10014

INTRODUCTION

ALBRECHT DÜRER was born in the bustling Imperial City of Nuremberg, in southern Germany, in the year 1471. Although he is known as Germany's greatest painter, he is even more significant as an innovator in the field of woodcuts and engravings, and in the theory of proportions of the human figure.

He has left us a legacy of some six dozen paintings, more than one hundred engravings, about 250 woodcuts, and more than a thousand drawings, apart from three published books on theoretical subjects and voluminous manuscripts.

Until the end of his life Dürer experimented with techniques, media, color, and subject matter. Each of his works is a pictorial statement distinguished by a surprising modernity. This is due in great part to what has become known as the rationalization of sight, the rendering of objects according to a system of perspective that has remained standard since the time of the Renaissance.

Dürer was greatly concerned with exploring the theoretical aspects of perspective and of human proportions. Among the more than 1500 pages of his manuscripts at Dresden, London, Nuremberg, and Berlin, the predominant part is devoted to studies of the proportions of the human body. These manuscripts reveal how meticulously Dürer pursued the subject in order to arrive at a workable system of constructing the human figure, suitable for artists. Finally he described several methods in his *Vier Bücher von menschlicher Proportion (Four Books on Human Proportion)* published a few months after his death in 1528.

There is preserved at Dresden a fair manuscript copy of Book I of the *Four Books on Human Proportion*, its pages numbered 1 to 89. On the first page is written: "1523 at Nuremberg, this is Albrecht Dürer's first book, written by himself. This book I improved and handed to the printer in 1528. Albrecht Dürer."*

 * It was during 1523 that Dürer came into the possession of a manuscript of the writings of Leon Battista Alberti concerned with this same subject. This may have been the cause of the postponement of the publication of Dürer's book.

A great number of preparatory drawings for the *Four Books on Human Proportion* (together with several studies for other works) are bound in an album, measuring 11½ × 8¼ inches (294 × 206 mm), known as the *Dresdner Skizzenbuch (Dresden Sketchbook)*. This album, all the illustrations of which are reproduced in the present volume, takes its name from the fact that it has been at Dresden since the eighteenth century. Originally in the collection of Count Heinrich von Brühl (1700–1763), Prime Minister of the King of Saxony, it has been at the Sächsische Landesbibliothek (Saxon State Library, formerly the Royal Saxon Library) since 1769. It is catalogued as Manuscript R-147.

The assertion by Robert Bruck (editor of the 1905 edition) that the *Sketchbook* derives from the library of the Nuremberg theologian Joachim Nägelein is erroneous. The Nägelein manuscript was still in the possession of his family in 1775 and is now at the Germanisches Nationalmuseum (German National Museum) in Nuremberg.

There is one indication, far from conclusive, that the *Sketchbook* once belonged to an Italian owner. Its first sheet (not illustrated here) is inscribed: "Varii Schizzi di Mano propria di Alberto Durero, Pittore Alemanno" (various sketches from the hand of Albrecht Dürer, German painter).

It is conceivable that the drawings of the *Dresden Sketchbook* belonged at one time to Dürer's closest friend, Willibald Pirckheimer, who may have given them to one of his many Italian acquaintances.* It was Pirckheimer who edited and supervised the printing of the *Four Books on Human Proportion* after Dürer's death. Dürer had completed the manuscript except for the very last pages of Book IV, dealing with stereometric construction. Some of the very drawings pertaining to this final chapter are among those in the manuscript at Dresden.

Strictly speaking, the *Dresden Sketchbook* is not a sketchbook but a collection of various drawings made for Dürer's own reference or in preparation for some of his works. They are bound together in no particular order. Some of the sheets are blank, others have drawings on both sides. In a number of instances, sketches on small slips of paper have been pasted onto larger sheets. Seventy-eight of the sheets have an old numbering in red ink (1–78); no further

* But the drawing No. 152 seems to militate against this view because it was used for a woodcut illustration that appeared first in the second, posthumous edition of Dürer's *Unterweisung der Messung* (Nuremberg, 1538).

attention has been given to these numbers in the present commentary. At some subsequent time all the sheets were rearranged and renumbered from 90 to 195, a continuation of the numbering of the above-mentioned manuscript (also at Dresden) of Book I of the *Four Books on Human Proportion*. These folio numbers 90–195 are indicated in the present commentary, and a concordance between them and the plate numbers of this edition will be found on page 349.

Forty of these drawings were published by A. von Eye after the *Sketchbook* was briefly exhibited at Nuremberg on the occasion of the four hundredth anniversary of Dürer's birth in 1871. When Robert Bruck issued his edition in 1905, he arranged the sheets according to subject, although without regard to chronology, and reproduced them on 160 plates. Bruck's plate numbers are given in the present commentary, and there is also a concordance between his plate numbers and the present ones, to be found on page 351.

In the present edition an attempt has been made to place the drawings approximately in chronological order within the divisions by subject; the largest section, that on human proportion, has been further subdivided into nineteen appropriate groups. This new chronological sequence should make it easier to follow the development of Dürer's studies. Dürer indicated a date on only very few of these drawings. The others can be dated only by relating them to those of known date on the basis of style, technique, and method of construction. In some cases the watermark of the paper serves as a guide to establish the authenticity of a given drawing (about half a dozen items in the *Dresden Sketchbook* are probably not by Dürer) or to associate it with a group of others. Such determinations are necessarily conjectural to some degree. All the watermarks used in the *Dresden Sketchbook* are reproduced on page 353.

The section "Notes on the Use of the Commentary" which follows the List of Plates indicates what type of information will be found in the commentary to this edition. An extensive bibliography will be found on page 345.

It must be borne in mind that the drawings of the *Dresden Sketchbook* are not finished works of art. They are mere sketches which serve to give a glimpse of the working methods of the artist and a sampling of the diversified interests of Albrecht Dürer.

W. L. S.

CONTENTS

NOTES ON THE USE OF
THE COMMENTARY

The commentaries to the plates include the following information:

(a) The dimensions of the original sheets of the drawings in millimeters and inches, height before width. Where the drawing is on a small piece of paper that has been pasted onto a larger album sheet, the dimensions are those of the smaller piece.

(b) Identification of the watermarks of the papers used for the drawings.*

(c) The folio numbers of the drawings (numbers ranging from 90 to 195; see Introduction) inscribed on the original manuscript sheets (given as f.90r, f.90v, etc., r and v standing for recto and verso, respectively). A concordance between these numbers and the plate numbers of the present edition will be found on page 349.

(d) The numbers assigned to the drawings by Bruck (given as Br.1, Br.2, etc.) in his 1905 edition of the *Dresden Sketchbook*, the only previous publication to include all the *Sketchbook* drawings (see Introduction). A concordance between Bruck's numbers and the plate numbers of the present edition will be found on page 351.

(e) The catalogue or figure numbers assigned to those *Dresden Sketchbook* items included in the works by Panofsky, Tietze, Winkler, and Rupprich listed below. (Using the abbreviations P, T, W, and R, these numbers will be given as P.1, T.2, W.3, etc. Reference numbers to Rupprich will also include his volume number, thus: R.III.100.) These identification numbers assigned by earlier scholars will often be followed by a brief résumé of their comments on the drawings (particularly with regard to dating and authenticity), thus:

T.564: About 1514.
P.1316: Not by Dürer.

(f) New comments by the present editor, including full translations, for the first time in English, of all the handwritten inscriptions on the drawings.

* The author wishes to thank Professor Hans Rupprich of the University of Vienna and Mr. Helmut Deckert, Acting Director of the Sächsische Landesbibliothek in Dresden, for their kind communications and assistance, particularly on the subject of watermarks.

Following is a complete list of the abbreviations used in the commentary and the identification of the works to which they refer:

Br. R. Bruck, *Das Skizzenbuch von Albrecht Dürer in der königlichen öffentlichen Bibliothek zu Dresden*, Strassburg, 1905 (earlier edition of the *Dresden Sketchbook*).

f. Numbers of the folios of Manuscript R-147 at the Sächsische Landesbibliothek in Dresden.

P. E. Panofsky, *Albrecht Dürer*, Princeton, 1943.

R. H. Rupprich, *Dürers schriftlicher Nachlass*, 3 vols., Berlin, 1956–1969.

T. H. Tietze and E. Tietze-Conrat, *Kritisches Verzeichnis der Werke Albrecht Dürers*, Augsburg, 1928; Basel-Leipzig, 1931.

W. F. Winkler, *Die Zeichnungen Albrecht Dürers*, 4 vols., Berlin, 1936–1939.

All other authors mentioned in the commentary are cited by their last name only. Their works are fully identified in the Bibliography on page 345. The "Sloane" mentioned often in the commentary refers to Dürer manuscripts from the collection of Sir Hans Sloane (1660–1753) in the British Museum, London; there are four bound volumes numbered from 5228 to 5231, and one volume, numbered 5218, from which most of the drawings have been removed to be individually mounted.

I. STUDIES IN HUMAN PROPORTION

1 Nude woman, front and rear views superimposed.

222 × 117 mm; 8¾ × 4⅝ in.
No watermark.

f.160r; Br.90.
T.357: About 1508.
P.1182: About 1500, rather than 1508, because of stylistic parallels
between the tracing of this drawing (No. 2) and the preparatory
drawing for Dürer's engraving "Nemesis" of 1502.

Experimental drawing. Dürer attempts to picture the front and rear
view of the figure simultaneously within the same contours. The
drawing obviously predates Dürer's studies of the theory of human
proportion.

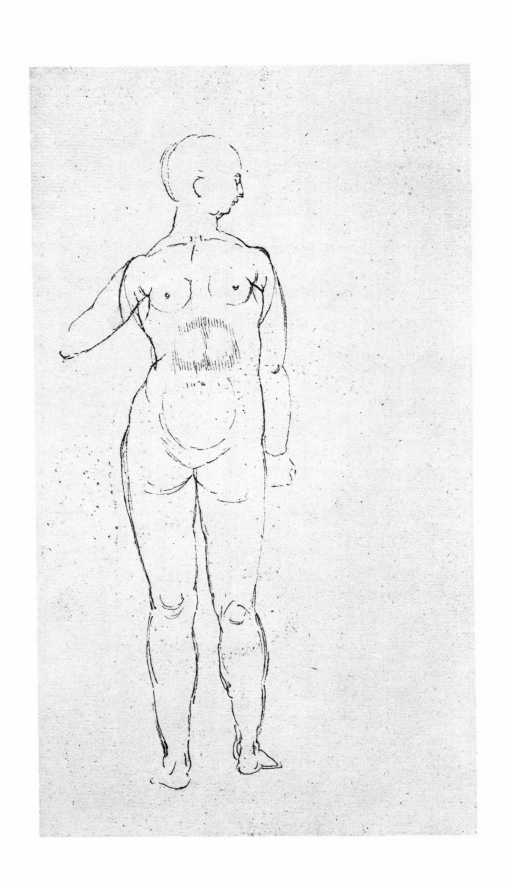

2 Nude woman seen from behind.

217 × 123 mm; 8⅝ × 4⅞ in.
Watermark: high crown.

f.164r (along with No. 46); Br.92.
T.358: About 1508.
W.I.XVI:* Closely related to the drawing W.159, "Nude Woman
 Praying."
P.1183: About 1500, rather than 1508, because of stylistic parallels
 to the preparatory drawing (W.266) for the engraving "Nemesis."

The drawing appears to be partly traced from No. 1 but finished more
elaborately. In this instance the positions of the arms are experi-
mentally reversed.

* This refers to Plate XVI of the supplement *(Anhang)* of Vol. I of the
Winkler work.

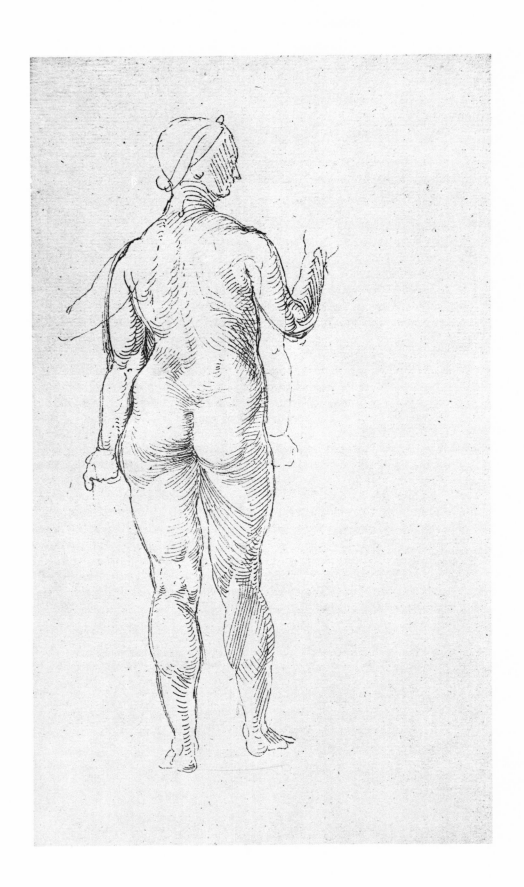

3 Nude woman, constructed.

290 × 194 mm; 11⅜ × 7⅝ in.
No watermark.

f.161r; Br.72.
R.II.41: Closely akin to Sloane 5228/142.*

Recto of No. 4. Probably 1500. One of the earliest constructed figures. The chest is based on a rectangle. The early date is established by the watermark of the drawing Sloane 5228/142 at the British Museum in London. This watermark, a Gothic P, appears only in works by Dürer before 1506.

By Dürer's own report, he first learned about constructing the human figure from Jacopo de Barbari: "I know of no one who has written about a system of human proportion, except a man, Jacobus, a native of Venice, and a charming painter. He showed me how to construct a man and a woman based on measurements. I was greatly fascinated by his skill and decided to master it. But Jacobus, I noticed, did not wish to give me a clear explanation. So I went ahead on my own and read Vitruvius. He describes in part the proportions of man's limbs." (Extract from Sloane 5230/44, London, British Museum.)

Jacopo de Barbari, a Venetian painter and engraver, came to Nuremberg, Dürer's native city, in April 1500 in the service of the Emperor. He stayed for a little more than one year. It was he who kindled Dürer's lifelong interest in the study of human proportion.

In these earliest drawings, based on what little de Barbari had disclosed, Dürer employed analogue measurements of various unrelated parts of the body. These, combined with geometrical shapes, then determined the outline of the human figure.

* This indicates folio 142 of the Sloane MS volume 5228. Sloane drawings will be indicated in this manner throughout the commentary.

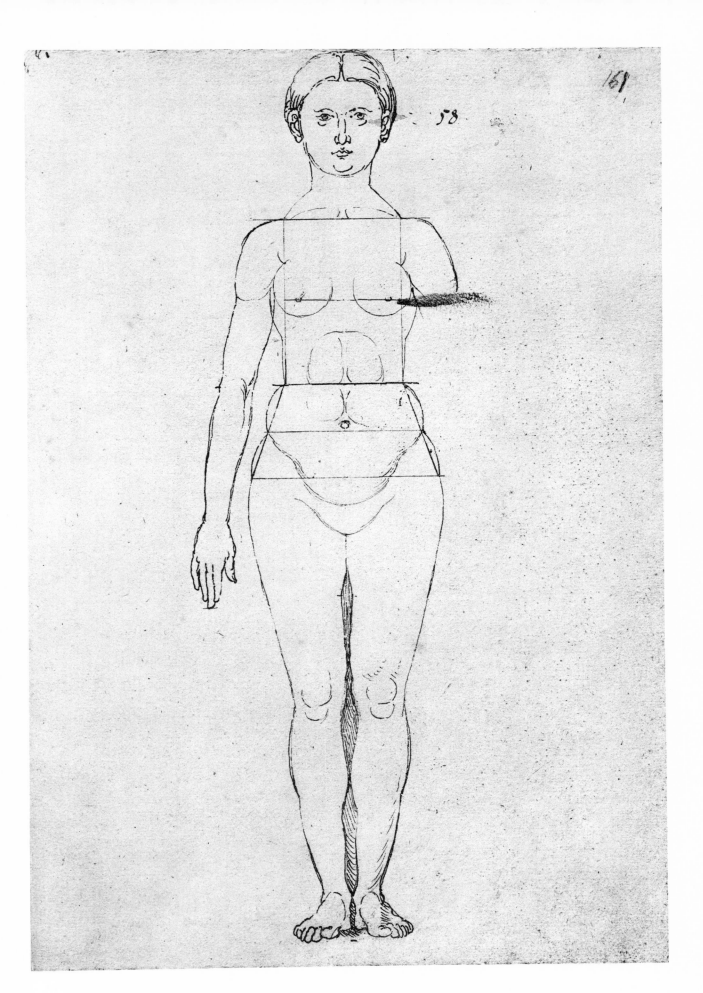

4 Nude woman, tracing.

290 × 194 mm; 11⅜ × 7⅝ in.
No watermark.

f.161v; Br.73.
R.II.41.

Verso of No. 3, from which it is traced in order to show the appearance without the construction lines.

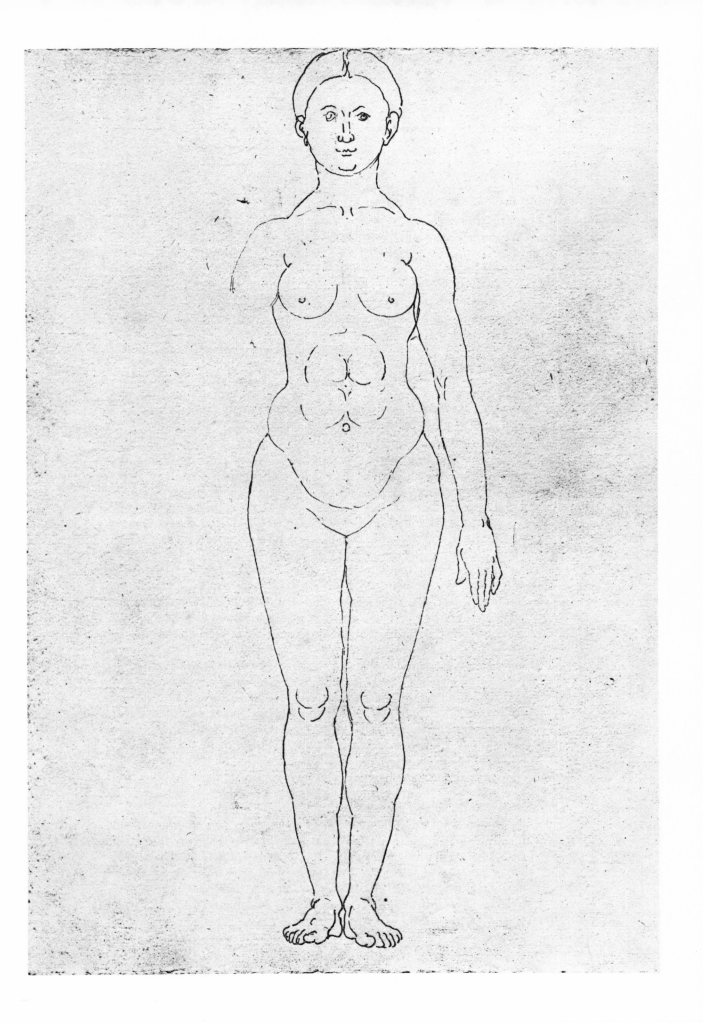

5 Nude woman with staff, constructed.

290 × 194 mm; 11⅜ × 7⅝ in.
Watermark: bull's head with cross and serpent.

f.162r; Br.70.
T.167: About 1500.
W.415: About 1506; akin to Sloane 5218/184.
P.1635: About 1500. Panofsky refutes Winkler's 1506 datings, which are in turn based on Flechsig (Vol. II, p. 193). Panofsky is critical of Flechsig's "superficial" knowledge of the subject (P.1627).

Recto of No. 6. Probably 1500. The construction of this drawing is based on the canon of Vitruvius, although the chest is still constructed on a square. The right leg is corrected.

Marcus Vitruvius Pollio (31 B.C.–14 A.D.) was a military architect under the Emperor Augustus. His works were rediscovered at the monastery of Monte Cassino in the fifteenth century. Editions of his *De architectura libri decem* were published at Rome (1486), Florence (1496), and Venice (1497).

His system is based on a combination of analogue measurements of parts of the body and a rudimentary system of fractional relationships of portions of the body to its height.

"A magnificent temple cannot be constructed properly, unless it is built in an orderly manner with regard to symmetry and proportion of its parts, as is the case with a well-built man. For the human body is designed by nature, put together and created so that the head from the chin to the hairline measures one tenth of the entire body. Likewise the flat or extended hand from the wrist to the tip of the middle finger is equal to the distance from the chin to the part of the hair, i.e. one eighth part. Likewise from the bottom of the neck and the high point of the chest to the hairline, one sixth; and to the top of the head, one quarter. But to the level of the mouth, one third; from the tip of the chin to the nose, from the tip of the nose to the midpoint of the eyebrows, and thence to the root of the hair, each one third. The length of the foot is one sixth of the body length, the forearm one quarter, the chest one quarter. In this manner all other limbs have their proportional measurements, which were observed by ancient painters and sculptors.

"In this same fashion the magnificent temples must be designed, so that their parts are proportional to the entirety. Further, the navel is the center of the entire body. If a man lies down with extended arms and legs, and a circle is drawn around him with the navel for its center, it will touch the tips of the fingers and toes." (From Vitruvius' *De architectura libri decem*, Book III, Chapter I.)

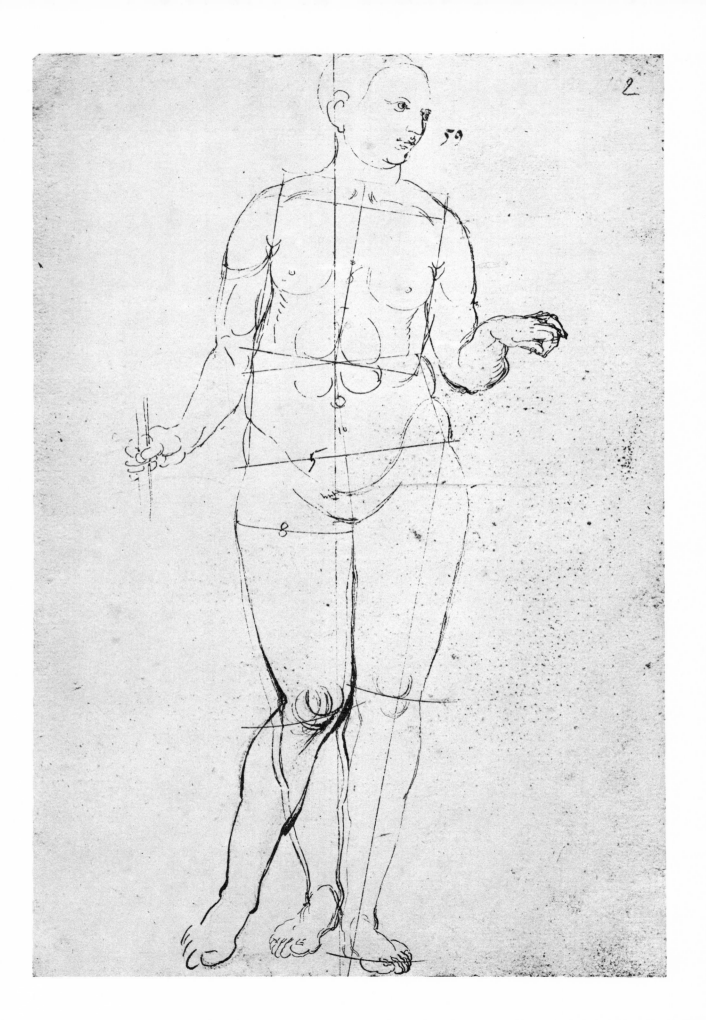

6 Nude woman with staff and cornucopia.

290 × 194 mm; 11⅜ × 7⅝ in.
Watermark: bull's head with cross and serpent.

f.162v; Br.71.
T.168.
W.416.
P.1636: 1500–01.

Tracing of the body of No. 5 on the verso. The cornucopia is patterned on the one in Mantegna's engraving Bartsch 19.

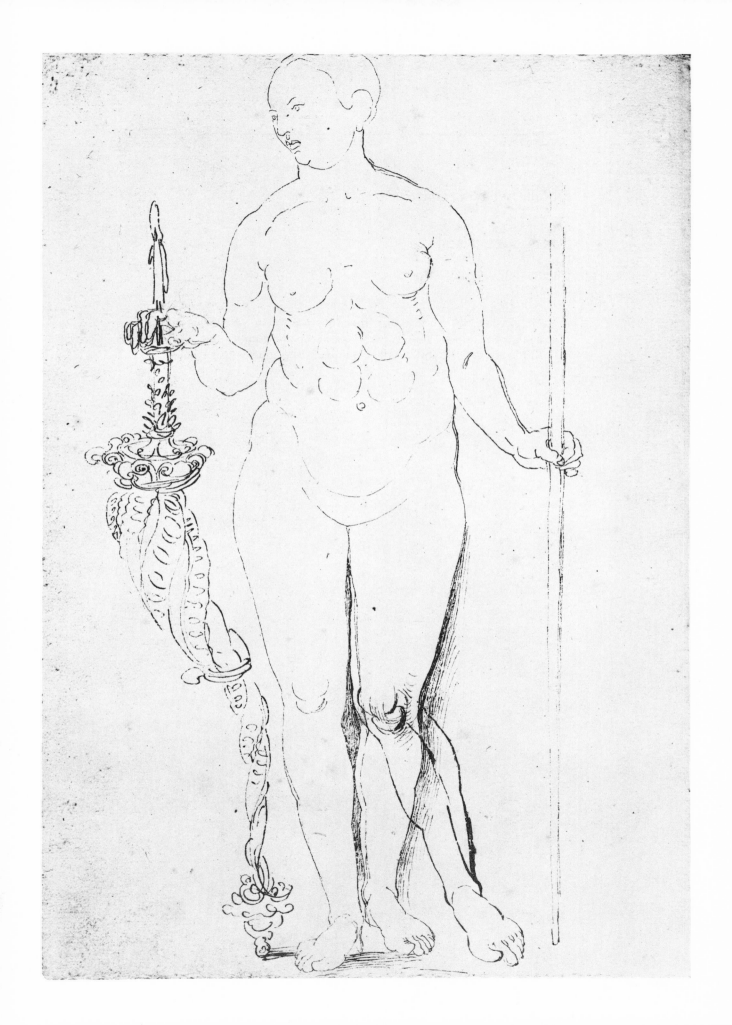

7 Nude woman, constructed.

214 × 92 mm; 8⅜ × 3⅝ in.
Watermark: trident.

f.155r; Br.91.
R.II.247.

Recto of No. 29. Early drawing constructed on the basis of an equilateral triangle. The distances between the nipples and between each nipple and the low point of the neck are equal.

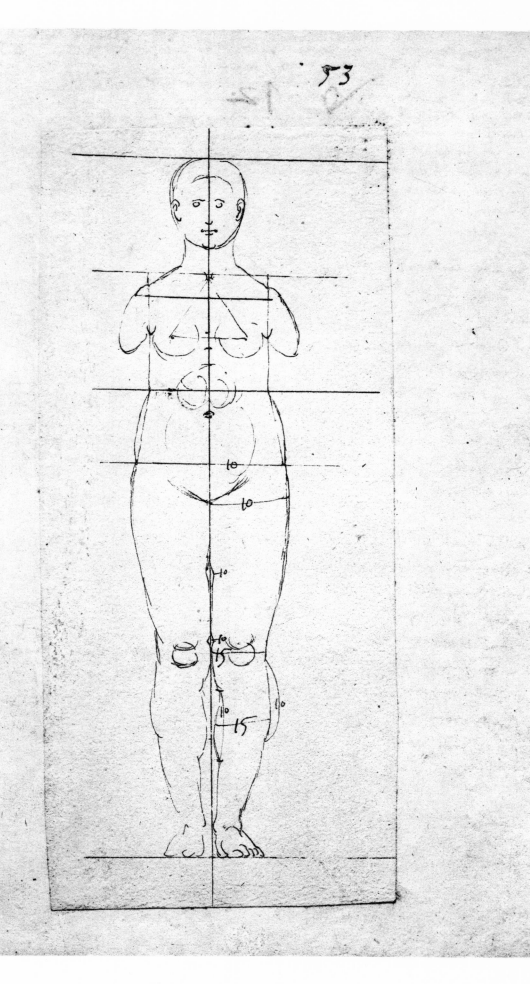

8 Nude man, constructed.

294 × 208 mm; 11½ × 8⅛ in.
No watermark.

f.105r; Br.20.
R.II.165: 1507–08.

Recto of No. 9. Constructed by means of the "triangle method" of No. 7 combined with the use of a compass. Probably 1500 or shortly thereafter. Dürer is still experimenting with various methods of constructing the human figure before arriving at a purely fractional system based on body length.

Notation in Dürer's handwriting: "Draw a line divided into eight parts. Call the top 'a.' The first section of one eighth denotes the head. The large circle denotes the arms. It is one quarter of the length. In its center is the depression of the heart. The small circle is to have a diameter one quarter less than the large one. Its center is to be the navel, located on the low point of the large circle. The low point of the smaller circle is the groin. Mark it with an 'a.'

"Now take the compass and place it on the last-mentioned point and open it to the center of the depression of the heart. Then move it to the navel and draw a large arc. Where it crosses the large circle mark 'b' and 'c.' This is the point of attachment of the arms."

9 Nude man, tracing.

294 × 208 mm; 11½ × 8⅛ in.
No watermark.

f.105v; Br.21.
R.II.165.

Tracing of No. 8 without construction lines.

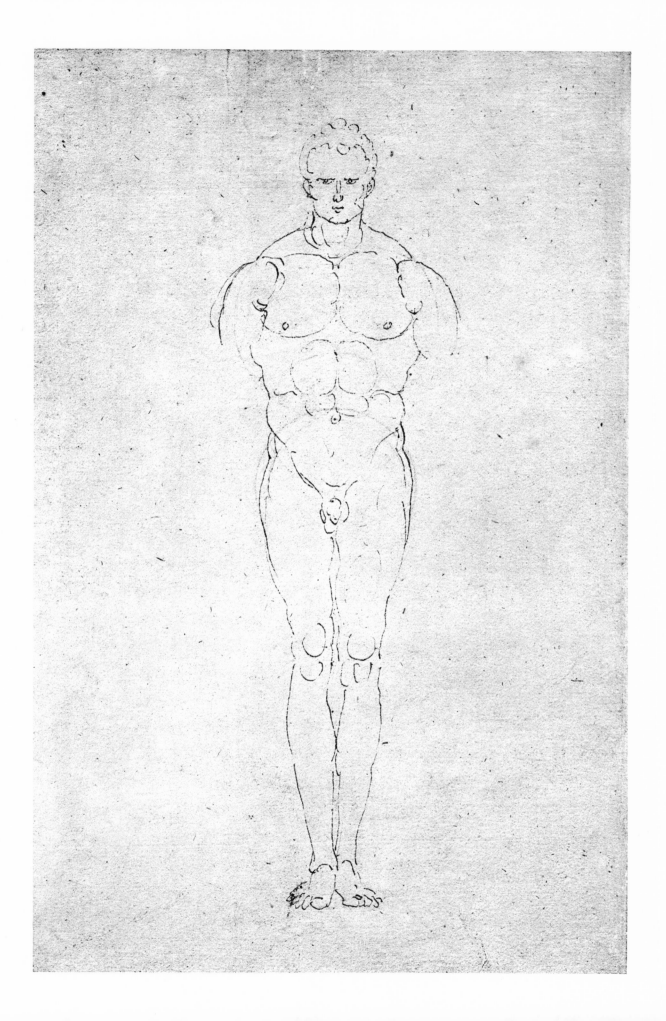

10 Nude man, constructed; fragment of a drapery study.

294 × 210 mm; 11½ × 8¼ in.
No watermark.

f.119v; Br.46.
R.II.165: 1507–08.

Verso of No. 11. Variation of the method employed for No. 8. The notation on the left side of the triangle reads "face length"; next to the groin, "center."

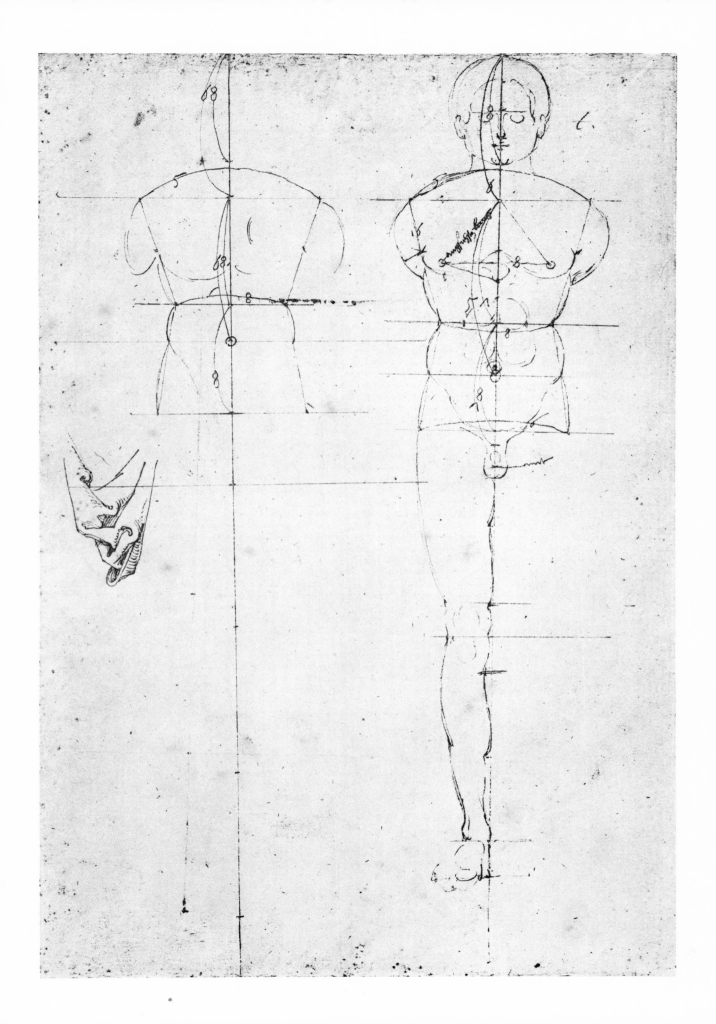

11 Nude man, tracing; construction grid.

294 × 210 mm; 11½ × 8¼ in.
No watermark.

f.119r; Br.47.
R.II.165: 1507–08.

Tracing of No. 10.

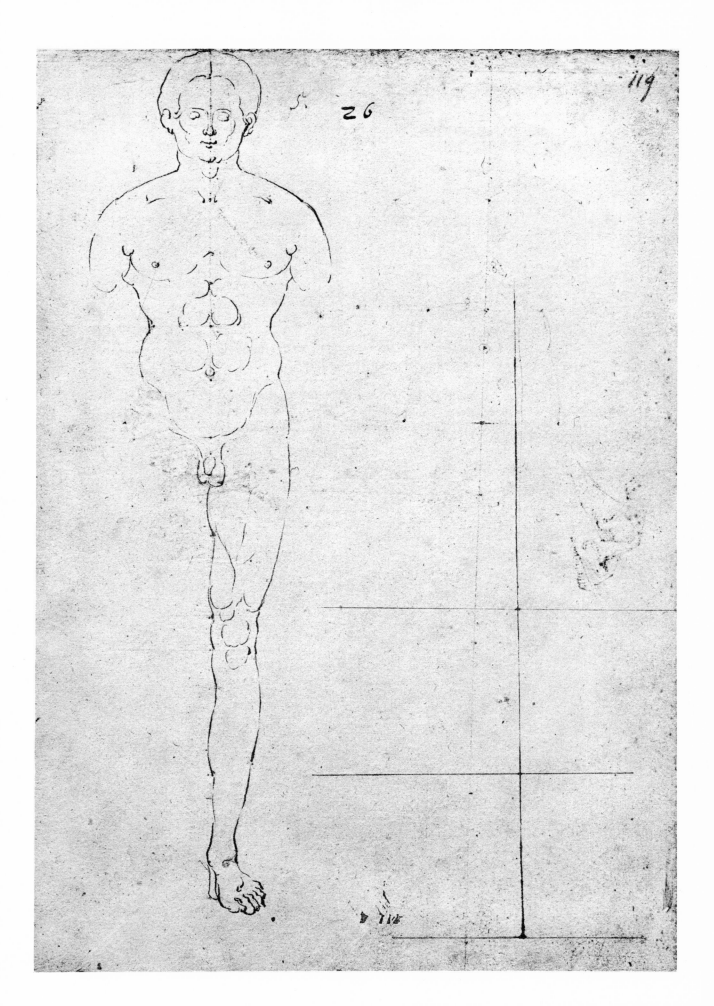

26

119

12 Nude man, constructed; ground plan of the human body.

294 × 208 mm; 11½ × 8⅛ in.
No watermark.

f.132r; Br.52.
R.II.165: 1507–08.

Recto of No. 13. Improvement of the method, combining a chest triangle and the use of a compass for the basic construction. The additional fractional proportions point to a slightly later date than drawings Nos. 8–11, yet may still precede Dürer's journey to Italy in 1506–07.

The ground plan of the human body is the earliest of its kind, marked by the pronounced nipples.

The notation on the center line reads: "middle."

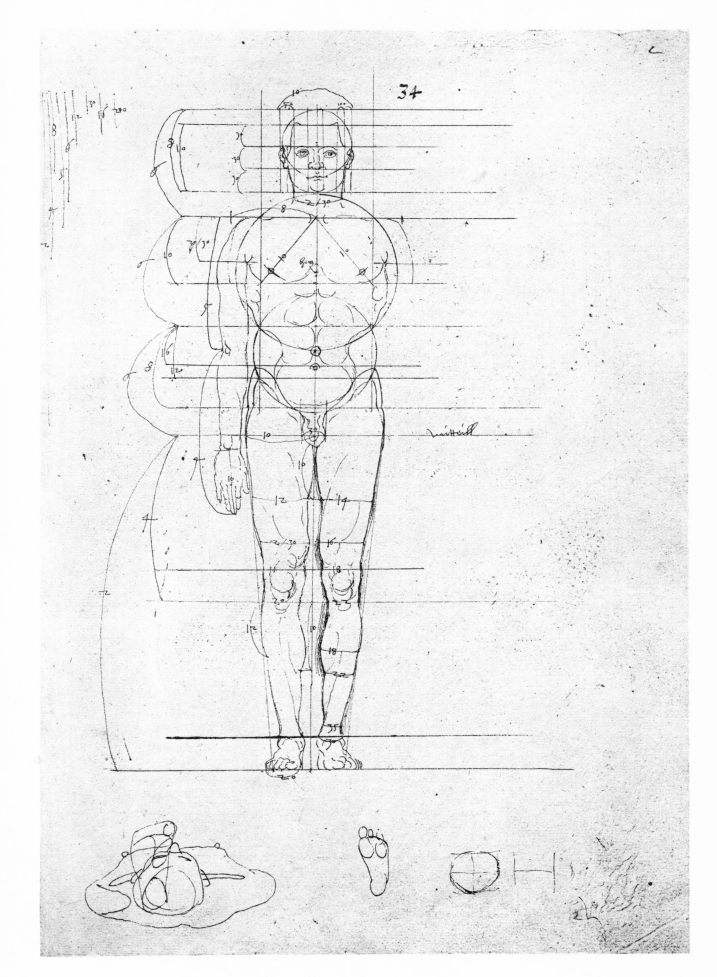

13 Nude man, tracing.

294 × 208 mm; 11½ × 8⅛ in.
No watermark.

f.132v; Br.53.
R.II.165: 1507–08.

Tracing of No. 12.

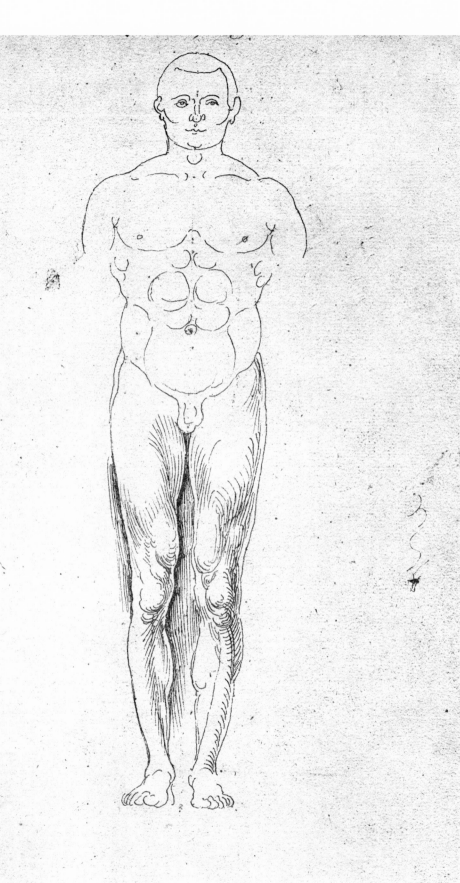

14 Nude woman, constructed.

290 × 188 mm; 11⅜ × 7⅜ in.
Watermark: bull's head with cross and serpent.

f.163r; Br.74.
T. 175: About 1500. Stance akin to the style of de Barbari.
W.417: Akin to Nos. 3 and 4 and to W.411 and W.413. About 1506.
P.1631: About 1500.

Recto of No. 15. About 1500. Experimental construction of an inclined figure by means of the compass. Closely akin to the drawing "Nude Woman Holding Shield and Lamp" (W.413) and the "Allegory of Lechery" (W.158).

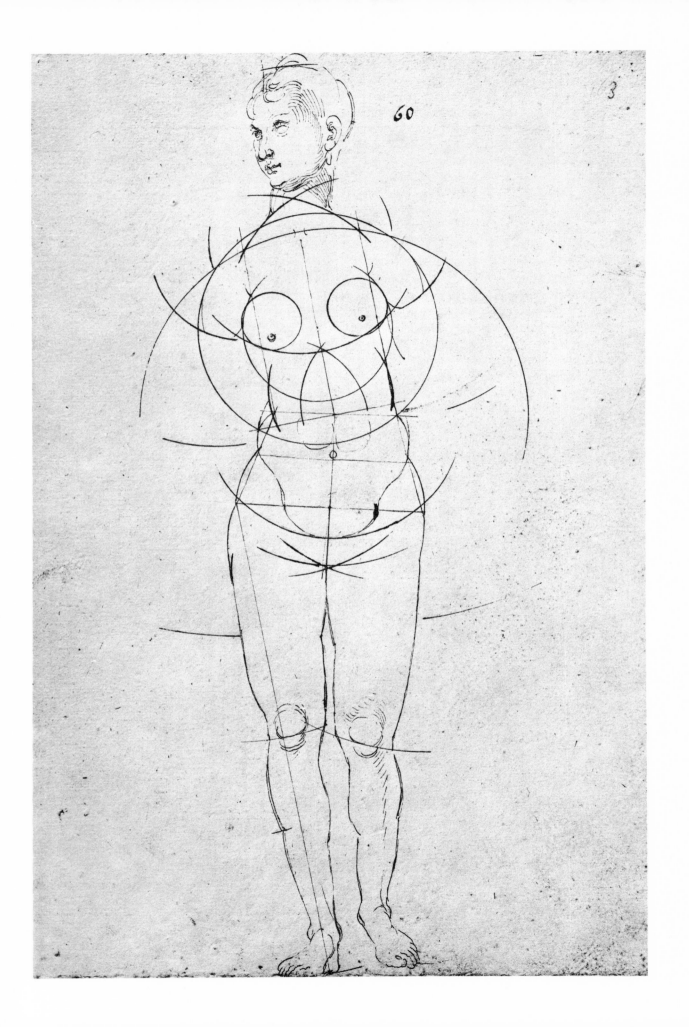

60

15 Nude woman, tracing.

 290 × 188 mm; 11⅜ × 7⅜ in.
 Watermark: bull's head with cross and serpent.

 f.163v; Br.75.
 T.176: About 1500.
 W.418: About 1506.
 P.1632: About 1500.

 Tracing of No. 14.

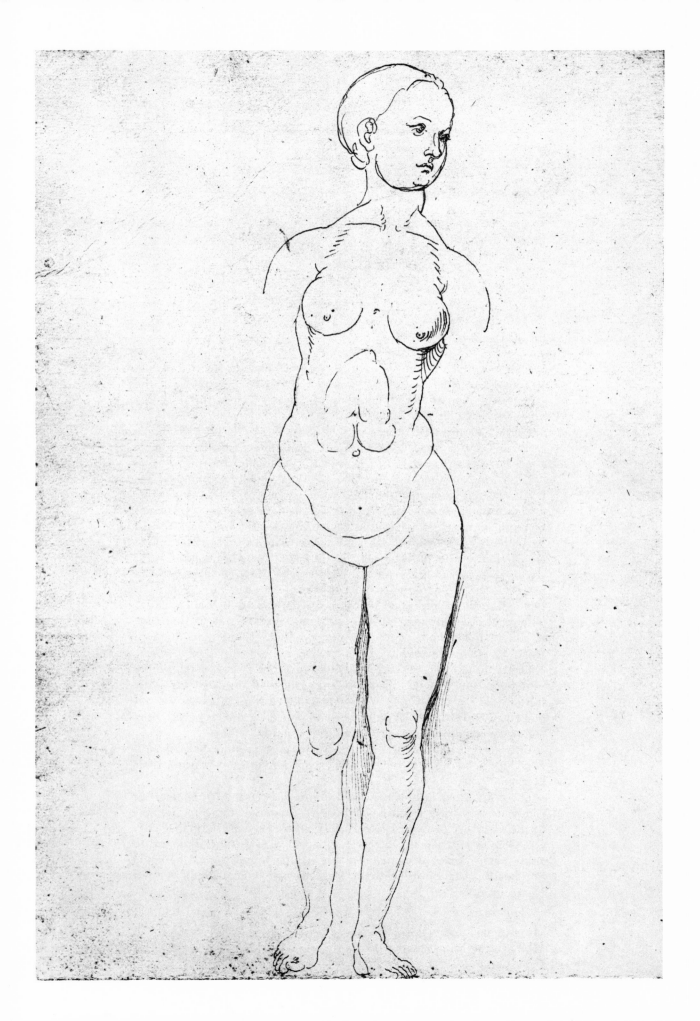

16 Woman in profile, standing and sitting.

295 × 208 mm; 11½ × 8⅛ in.
Watermark: trident.
Dated 1507.

f.151r; Br.86.
T.347.
P.1640.
R.II.231.

One of the first drawings in which a purely anthropometric system of construction, based on the length of the body, has replaced the geometrical method. The notation in Dürer's handwriting reads: "This was also already drawn in 1507."

Dürer had spent the entire year 1506 in Italy. He returned home early in February 1507. Accordingly, the influence of Leonardo da Vinci has been discerned in this and the following drawings.

Leonardo was about twenty years Dürer's senior. Although it has been repeatedly asserted that the two artists met in Italy, no positive evidence of this has ever been discovered. If they did not meet directly, it is entirely possible that Leonardo's designs were transmitted to Dürer by students or in some other way. Dürer undertook a special journey to Bologna late in 1506 for the express purpose of studying perspective (letter of October 13, 1506). His teacher's name has not come down to us. It may have been Luca Pacioli or someone close to him. Just before his departure from Venice, Dürer purchased an edition of Euclid's *Elements*. Pacioli was at that time working on his own edition of Euclid. Perhaps this fact induced Dürer to pursue the subject.

Leonardo and Pacioli had left Milan together after the fall of the Sforzas in 1499. It was also Leonardo who had provided the illustrations for Pacioli's *De divina proportione*, which, however, was not published until 1509. A contact with Pacioli would explain how Dürer obtained access to drawings by Leonardo.

By a strange coincidence, neither Leonardo's *Trattato della pittura* nor Dürer's *Four Books on Human Proportion* appeared during their lifetime.

Dürer's teacher in Bologna could not have been Bramante, as prior commentators have suggested,* because Bramante came to Bologna in the company of Pope Julius II only after the capture of that city. On October 13, when Dürer reported his plan to visit Bologna to study perspective, "which someone is willing to teach me," he could not possibly have meant Bramante, because Bologna had not yet been captured.

* W. Stechow, "Dürers Bologneser Lehrer," *Kunstchronik*, Neue Folge, Vol. XXXIII, 1922, p. 251.

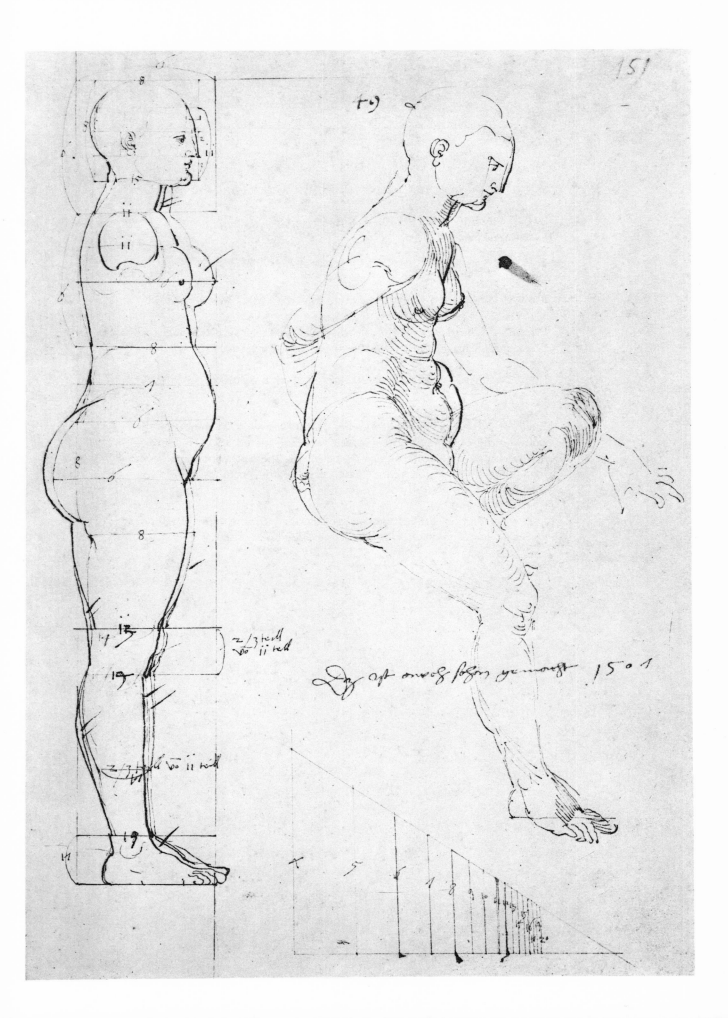

17 Stout woman, constructed, standing and sitting, in profile.

294 × 208 mm; 11½ × 8⅛ in.
Watermark: trident.
With Dürer's monogram.

f.145r; Br.76.
T.656: About 1516 because akin to the drawing "Women's Bath" (W.622), which bears this date.
P.1643: About 1508. Panofsky disputes Tietze's assertion because the similarity is limited to the motif and does not extend to the style.
R.II.233: Based on the schematic drawing at London, Sloane 5231/ 143.

Recto of No. 18. The stout woman of this drawing is obviously the same as the one pictured in No. 23, which is dated 1508 in Dürer's handwriting. The construction is based on the anthropometric system. Dürer's notations read: "The curve of the buttocks should extend as far horizontally as it is high" and "Place the head in its stead."

A very similar stout woman is described in the third book of Dürer's *Four Books on Human Proportion*, folio R III.

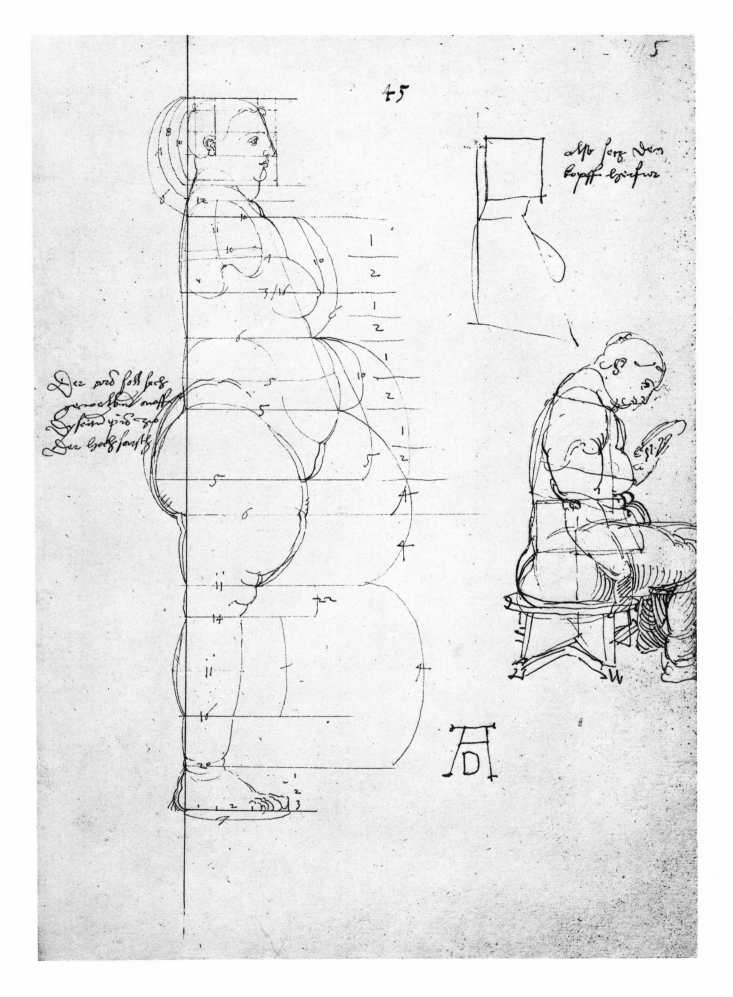

18 Stout woman, tracing.

294 × 208 mm; 11½ × 8⅛ in.
Watermark: trident.

f.145v; Br.77.
R.II.233.

Tracing of No. 17.

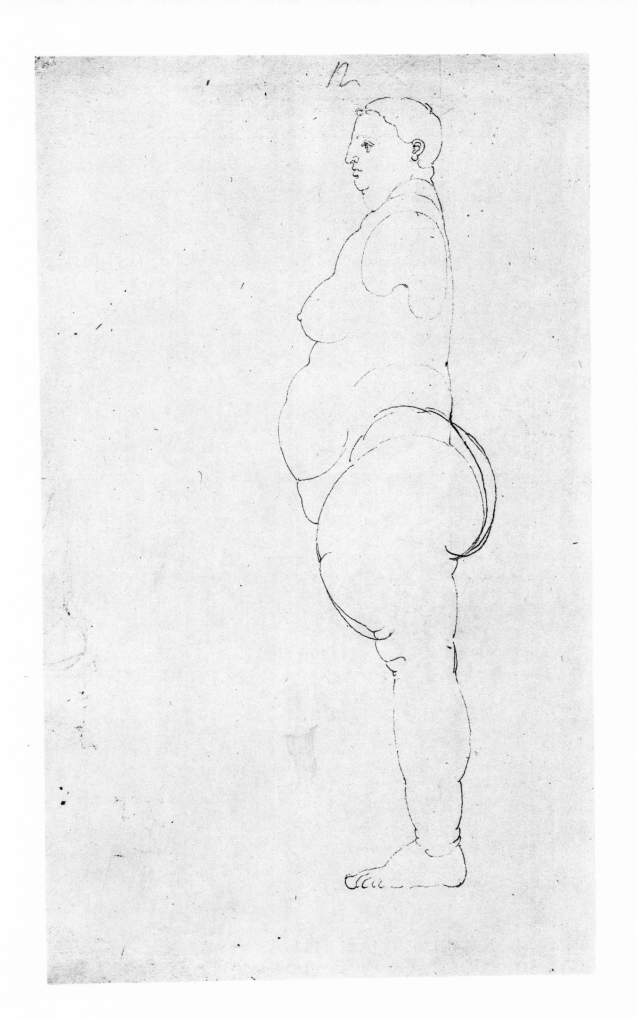

19 Stout woman, constructed.

293 × 206 mm; 11⅜ × 8 in.
Watermark: trident.
With Dürer's monogram.

f.150r; Br.78.
R.II.233.

Revision of No. 17.

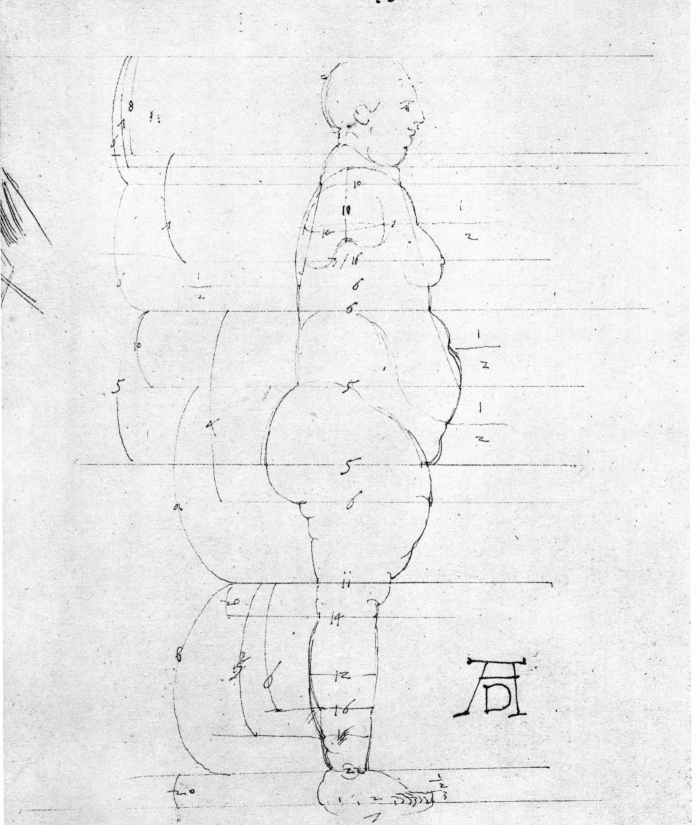

20 Stout woman; seated Madonna.

293 × 203 mm; 11½ × 8 in.
No watermark.
With Dürer's monogram.

f.170v; Br.80.
T.364: The Madonna and the monogram are drawn with a broader
 pen; about 1508.
W.442: 1507–08.
P.661: About 1508.
R.II.233.

Verso of No. 120. Panofsky calls the Madonna of this drawing
"magnificent." It is closely related to Dürer's painting "The Ma-
donna with the Iris" and the woodcut "The Holy Family with Five
Angels." Because it is on the same page as the stout woman, and
therefore dates from about 1508 (see No. 23), it cannot be prepara-
tory to the aforementioned works, but a revision of the earlier con-
cept, incorporating Dürer's Italian experience.

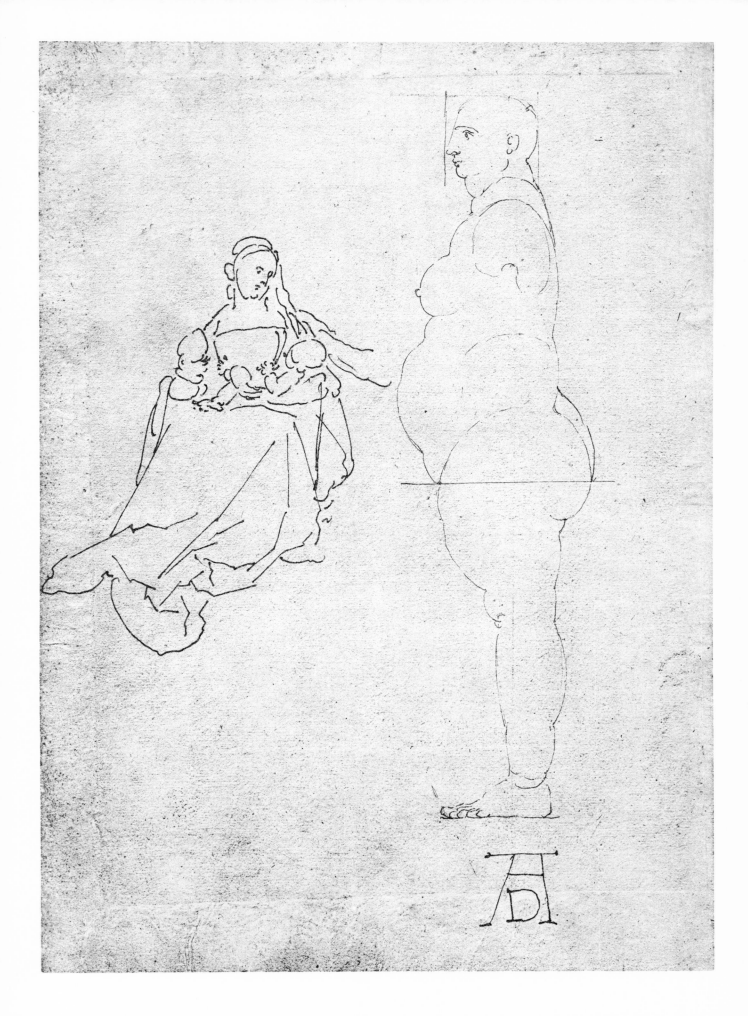

21 Stout woman; Madonna on crescent moon; Turk's head; drapery study.

294 × 208 mm; 11½ × 8⅛ in.
Watermark: trident.
With Dürer's monogram.

f.165r; Br.81.
T.465: 1511–15.
W.546: 1514–15; preparatory for Dürer's engravings of "The Madonna on the Crescent Moon" of 1514 and 1516.
P.701: 1511–12.
R.II.233.

Recto of No. 22. The stout woman must be dated 1508 (see No. 23). The Madonna is obviously a later addition, as it is superimposed on the drapery study. Dürer very often added new sketches on older, partly used sheets of paper.

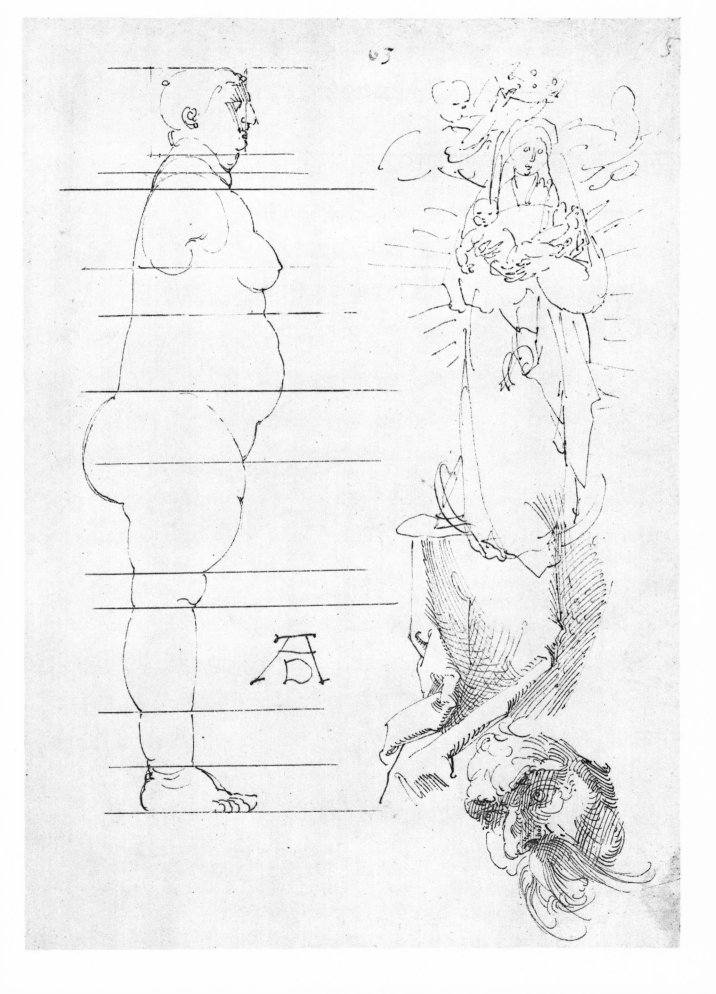

22 Stout woman, tracing; child, constructed.

294 × 208 mm; 11½ × 8¼ in.
Watermark: trident.

f.165v; Br.82.
R.II.233 and R.II.341.

Verso of No. 21. The stout woman must be dated 1508 (see No. 23). The construction of the body of a child is presumably a later addition, dating from 1513 (cf. No. 47).

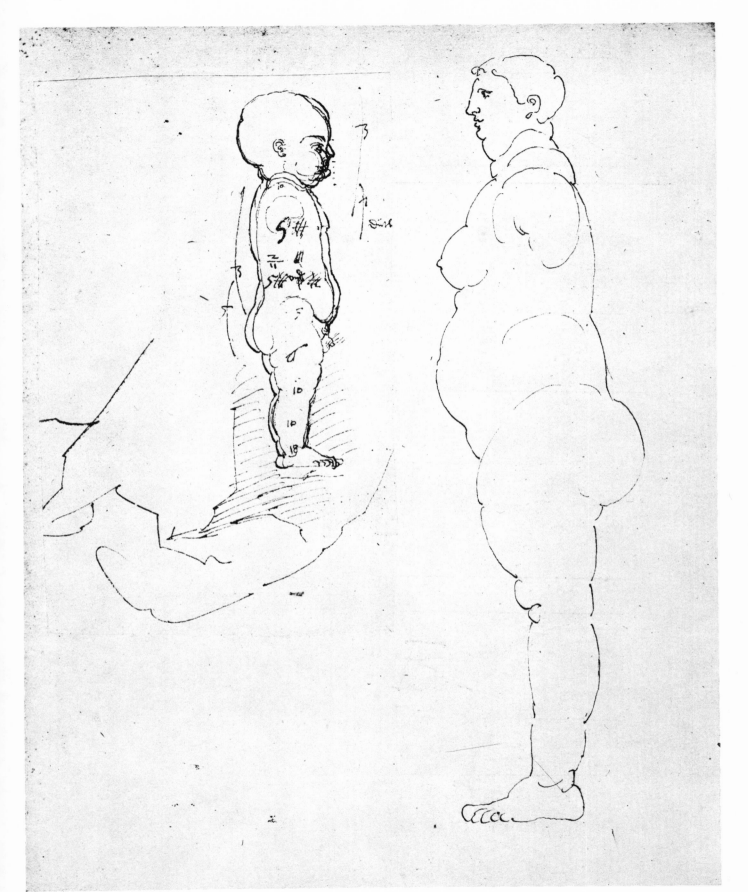

23 Stout woman, front view.

294 × 208 mm; 11½ × 8⅛ in.
Watermark: trident.
Dated 1508.
With Dürer's monogram.

f.146r; Br.79.
R.II.233.

Recto of No. 124. The authentic date and monogram on this draw-
ing of a stout woman serves to date the preceding profile studies.
A number of similar studies of this body type are preserved at Lon-
don (Sloane 5228/133; 5231/10–12).

24 Woman of eight headlengths, constructed.

294 × 202 mm; 11½ × 8 in.
Watermark: trident.

f.153r; Br.87.
R.II.245: To be dated 1508.

Recto of No. 26. This drawing and the following two are drawn in a slightly larger scale than all the others. Inscribed: "You may divide the distance from the top to the buttocks into three equal parts, or from the top to the bottom of the neck one sixth. Also from the buttocks to the waist, one sixth. The center line belongs to the figure. It indicates its length."

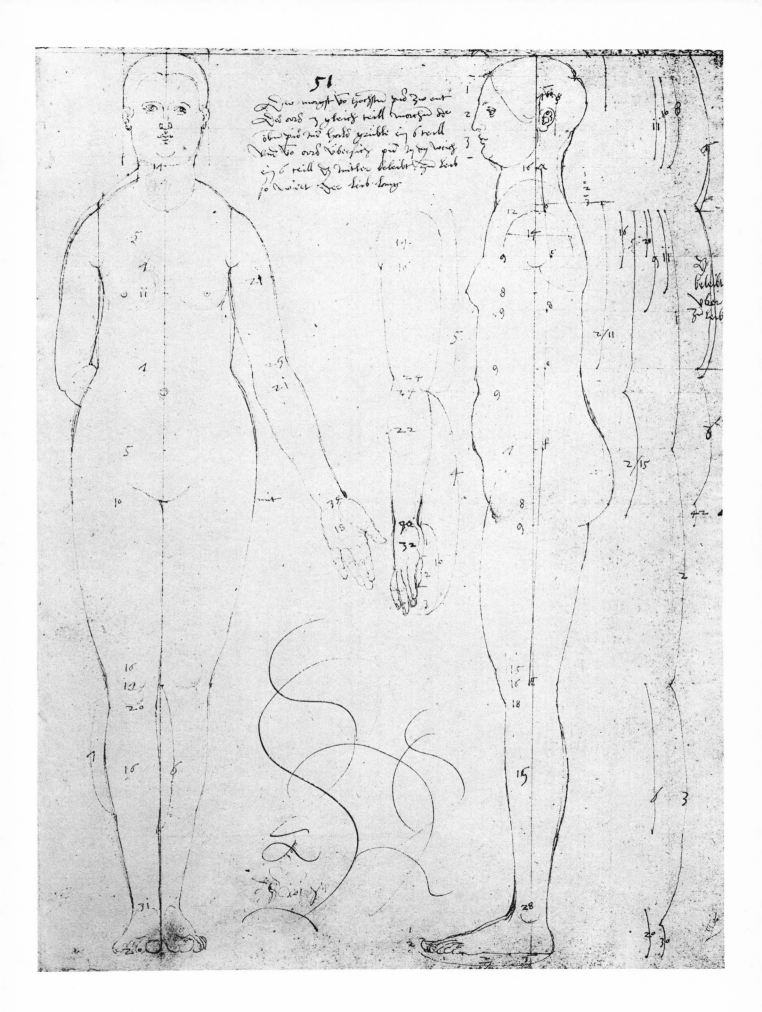

25 Woman of eight headlengths seen from behind, tracing.

294 × 202 mm; 11½ × 8 in.
No watermark.

f.158r; Br.89.

The woman of No. 24 seen from behind.

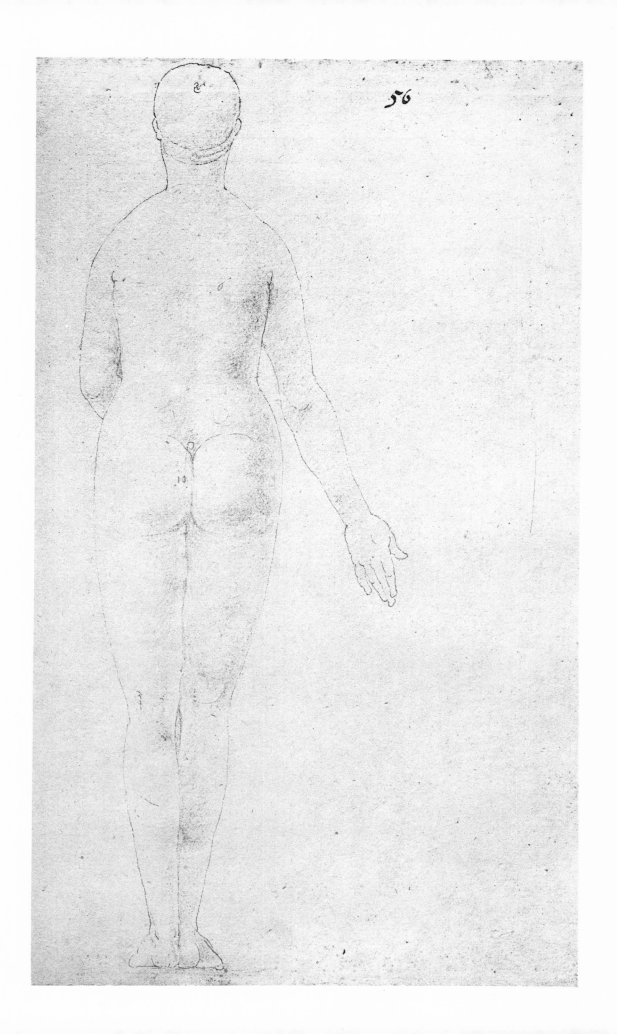

26 Woman of eight headlengths, tracing.

294 × 202 mm; 11½ × 8 in.
Watermark: trident.

f.153v; Br.88.
R.II.245.

Tracing of No. 24 on the verso.

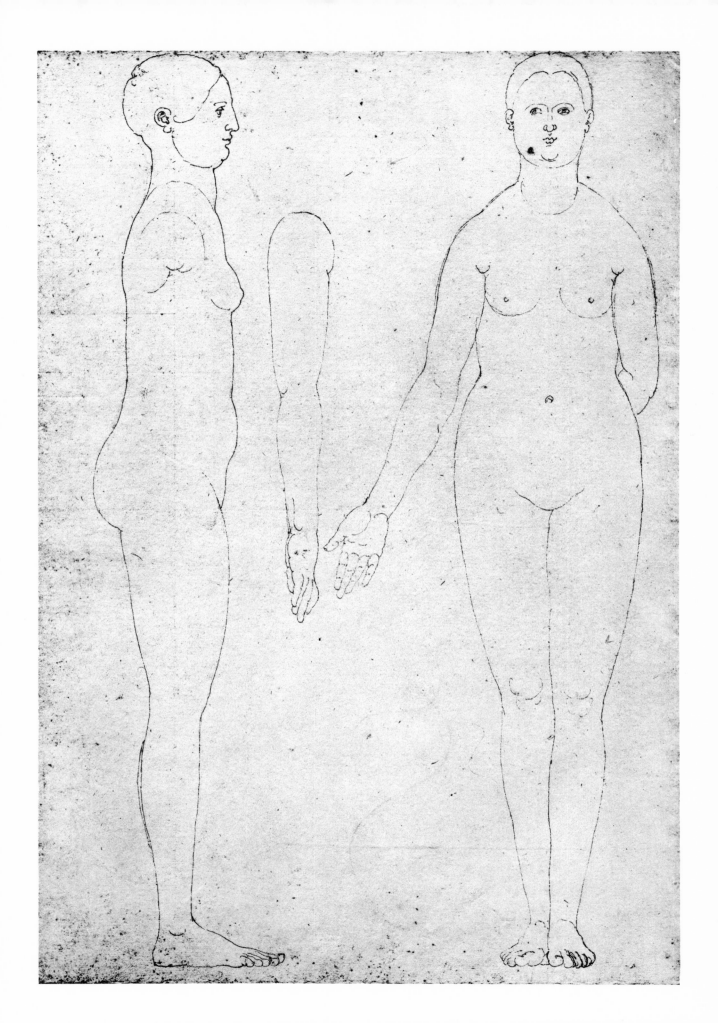

27 Man of eight headlengths, constructed.

178 × 171 mm; 7 × 6¾ in.
Watermark: trident.

f.104v; Br.19.
P.1603: Probably 1507.

Verso of No. 44. The drawing appears to be a tracing after an Italian model, perhaps of the school of Leonardo da Vinci. It is illustrated in E. Panofsky's *Codex Huygens and Leonardo da Vinci*, London, 1940.

The strict division into eight equal parts places it close, in point of time, to the following drawing. The division of the face is not strictly Vitruvian although Arpad Weixlgärtner (1906, p. 22) believed that Leonardo da Vinci's "Vitruvian Man" in Venice served as its model.

Until 1971 this drawing was pasted on the verso of No. 44. When it was removed from its backing, another drawing was discovered on its own verso: a tracing of the man on the left without indication of the measurements.

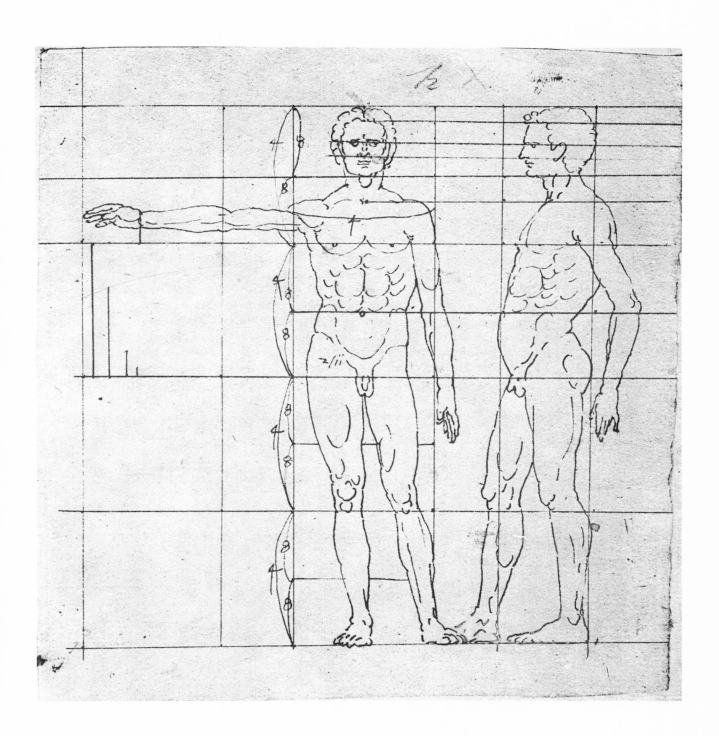

28 Woman of eight headlengths, constructed.

292 × 208 mm; 11½ × 8⅛ in.
Watermark: trident.
Dated 1509.
With Dürer's monogram.

f.156r; Br.83.
P.1641: Dated 1509, but executed 1507.
R.II.247.

Recto of No. 30. According to Panofsky, the drawing dates from 1507, but was corrected in 1509. The corrections, the date, and the monogram are in light brown ink. The accompanying text on folio 155 (No. 29) is reproduced by Bruck without explanation on his plate 160. It is written in the same ink as the original sketch. This text is reminiscent of Leonardo da Vinci's preoccupation with comparing measurements of unrelated parts of the body. The special attention given to the body sections measuring one eighth of the total length relate this drawing to No. 27. It is also closely related to No. 16 and to Sloane 5231/13.

Notations on the drawing: "The distance from the low point of the neck to the waist is equal to that from the low point of the neck to where the hair begins above the forehead."

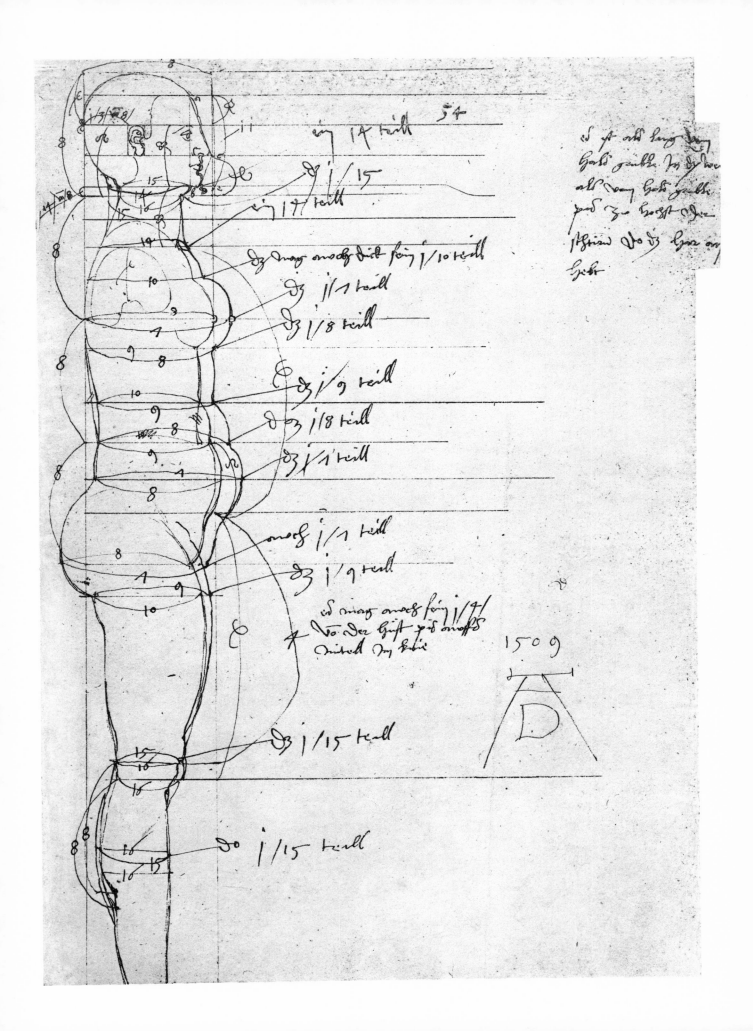

29 Text accompanying No. 28.

292 × 208 mm; 11½ × 8⅛ in.
Watermark: trident.

f.155v; Br.160.
Panofsky, *Dürer's Kunsttheorie*, Berlin, 1915, p. 106.

Verso of No. 7. The translation is as follows:

"The head, to the tip of the chin, is divided lengthwise into four sections. The uppermost is the hair, the second the forehead, the third the nose, the fourth to the tip of the chin. This leaves the part below the chin [submaxillary triangle].

"Or else, take one eleventh part of the entire length; it will give you the face above the chin. The remaining portion is the hair above the forehead. Likewise, you will divide this eleventh of the length into three parts. It comprises forehead, nose, and chin. Behind the ear you also measure one third of an eighth of the body length. The ear is as long as the nose and half the width of the neck measured from the back to the bottom of the chin in a line with the beginning of the eyebrows and the point of the hair.

"The face is one eleventh of a person's entire height. If one fourteenth part is added it will make the eighth part of the body length that equals the head. Add to this the part below the chin. The neck below the chin is equal in width to half of the head. The forehead begins on the line *ab* where the chin ends. The shape of the face is marked by *ac*. The lower part of the nose is marked *cd* ending in the middle of *bc*. The distance from the eyebrows to the chin equals that from the chin to the low point of the neck. Wherever you see lines marked with a cloverleaf they are of equal length.

"The shoulder is on a level with the low point of the neck. It inclines to a point as high as half the width of the neck. The width of the shoulder is equal to the distance from the neck to the eyebrows. The thickness of a shoulder equals that of the neck. The length of the forehead equals the distance from the nipples to the end of the chest. Below the breast the thickness of the body equals one ninth of its length. Likewise, at the waist its thickness is one tenth. Therefore there are four equal lengths: from head to neck, from neck to nipples, the third to the navel, the fourth to the groin. These are four quarters one above the other.

"The distance from the navel to the groin equals that from the neck to the eyebrows. Also from above the buttocks to the front is an eighth part. And above the belly it is also one eighth part. Then

30 Woman of eight headlengths, tracing.

292 × 208 mm; 11½ × 8⅛ in.
Watermark: trident.

f.156v; Br.84.

Tracing of No. 28 on the verso.

(continued from page 58)

below this line at the high point of the belly, the buttocks begins their curvature. They extend one fourth of this one eighth part so that the buttocks end below the point of the groin.

"The distance from the low point of the neck to where the hip begins equals the distance from there to the midpoint of the knee. But the knee measures one sixteenth. The leg below the buttocks, one tenth, and diminishes down toward the knee as shown in the figure.

"The foot is one seventh of the entire height. Its height equals one third of its length. The ankle is at the midpoint of the height of the foot. The toes measure a third part of the length of the foot. The root of the big toe measures one third of the height of the foot. Accordingly the toes are diminished in size as you can see. The calves end one eighth below the knee. The thickness above the calves is a tenth part. The leg at the ankle measures the same as the distance from the high point of the neck to the nose."

31 "Strong handsome man of eight headlengths," constructed.

293 × 208 mm; 11½ × 8⅛ in.
Watermark: trident.

f.126v; Br.13.
R.II.171.

Verso of No. 32.

Inscription: "Turn this sheet over and you will see the man's figure without numbers and letters."

The drawing is best described by Dürer himself in a notation at London (Sloane 5230/160); "I wish now to draw first the figure of a strong man like Samson or Hercules. Do it as follows: Draw the head in three sections, one next to the other, measuring one eighth part of the height. The top is touched by the forehead, the bottom by the chin." Akin to Sloane 5228/98.

In an introductory draft, dated 1512 (Sloane 5230/24), for his projected book on painting, Dürer expresses regret that the books of the old masters have been lost, and that he has not heard of any new author who describes the subject except some "who do not understand it."

No drawings have come down to us of studies in the proportion of man for the years 1510–1511. The first drawing bearing a date after 1509 is dated 1512.

Dürer's theoretical studies of this year are of three categories: a group that continues the system employed in the years 1507–1509, classifying the human figure according to stature, i.e. stout, strong, Samson, etc; a so-called "retrospective group," reminiscent of the Apollo-like drawings of 1501; and a third group, based on varying numbers of headlengths.

The earliest drawings of the last type probably date from the end of 1512. Many more are dated 1513. This system was known to Filarete, and is described by Pompeius Gauricus in his *De Sculptura*, published at Florence in 1504. A copy of this book is listed in the inventory of the library of Dürer's closest friend and mentor, Willibald Pirckheimer. He describes figures of seven, eight, nine, and ten headlengths, and suggests that the same can be done for a child's body.

Among Dürer's papers there are two sketches, or more probably tracings, which are clearly based on Gauricus. The system differs from Dürer's customary one, in that two half-sections are interposed at the neck and the ankle of a man of nine headlengths.

According to Giesen, Dürer's acquaintance with Gauricus dates from 1512.

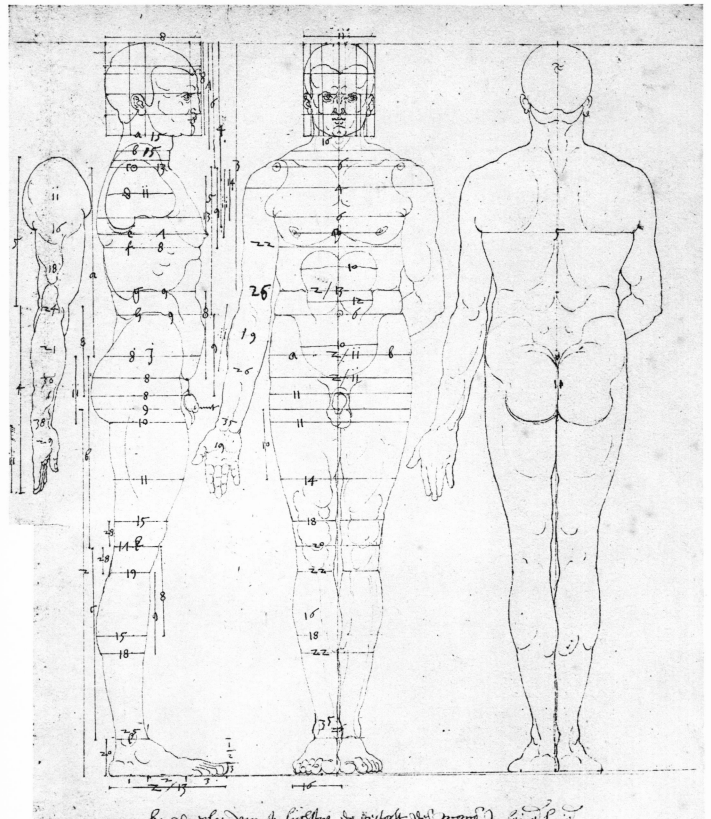

32 "Strong handsome man of eight headlengths," tracing.

293 × 208 mm; 11½ × 8⅛ in.
Watermark: trident.

f.126r; Br.14.
R.II.171.

Tracing of No. 31.

Inscription: "Do not be concerned that these measurements make the man appear too stout and uncouth. Once you bend the figure and position the face properly, the light and shadow will change the impression. It will no longer be rough if you proceed correctly in the other respects."

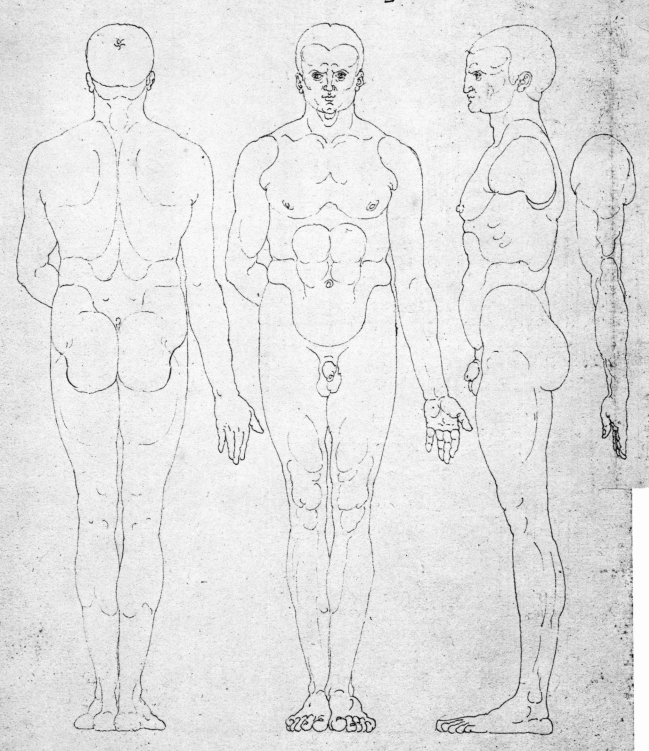

die bod dich bedunckieg vz dise wad zo dick und krolett sij vsey drosij prow wauest
vud In de achtely dis gesicht weht richtst so wacht lichr und schatten dj es gar vill vudich
sehw nawst die grob bedienckeig vsey dro In vudrst zicht a scht

33 Strong handsome man, constructed.

293 × 204 mm; 11½ × 8 in.
Watermark: trident.

f.125v; Br.48.
R.II.67.

Verso of No. 34. This drawing perhaps predates No. 31. Akin to
Sloane 5230/98, 102, 167.

 Inscription: "From the top to the low point of the neck one sixth
 part.
 From the top to the bottom of the sternum one quarter.
 From the low point of the neck to the thigh one quarter.
 From the thigh to the center of the knee one quarter.
 From the knee to the ankle one quarter.
 The width of the man at the shoulders on a line with the low
 point of the neck one quarter."
 On the chest: "heart."
 On the groin: "center."

von Scheitel biß zum Halsgrüble
ist ein 6 teill

von Scheitel biß zum Herzgrüblin
ist 4 teill

von Halsgrüble biß zu erst der Hüft ist
ist 4 teill

von der Hüft biß unter das knie ist 4 teil
vom kny biß noch den ziger ist 4 teill

über so ... mit lang des Halsgrüblend
ist der 4 teild

34 Strong handsome man, tracing; Christ before Pilate.

293 × 204 mm; 11½ × 8 in.
Watermark: trident.

f.125r; Br.49.
T.383: 1508–09.
W.III.X.*
P.571: About 1510.

The strong handsome man is traced on the recto of No. 33. The small sketch of Christ before Pilate is generally presumed to be the preparatory drawing for the same subject (Bartsch 7) in Dürer's *Engraved Passion*. Accordingly it is in mirror image. If so, it may more properly be dated 1512, the date that appears on the engraving (reproduced below).

Recently, Lisa Oehler asserted that this drawing may have been preparatory for the *Green Passion* that has heretofore been dated 1504 (see Oehler in the Bibliography). However, the unusual borderlines suggest that this drawing may be an attempt to reduce another larger drawing experimentally to the size of the *Engraved Passion* series.

* This refers to Plate X of the Supplement *(Anhang)* of Vol. III of the Winkler work.

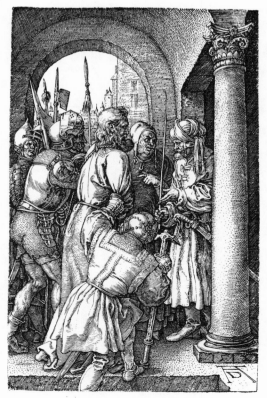

Christ before Pilate. Engraved version.

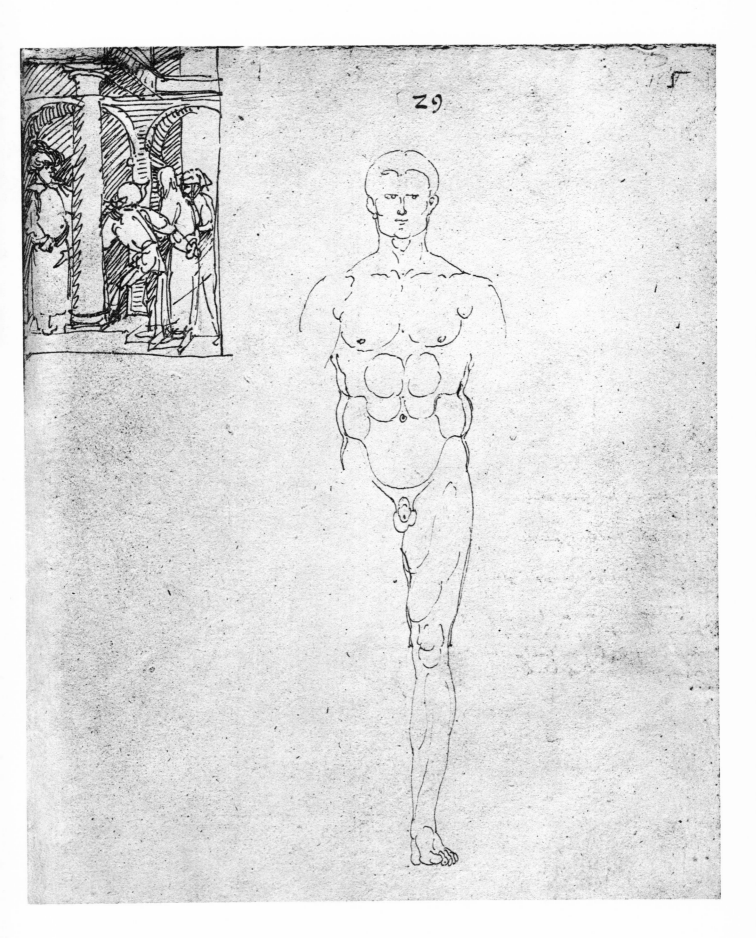

35 Strong woman of eight headlengths, constructed.

293 × 204 mm; 11½ × 8 in.
No watermark.

f.152v; Br.93.
R.II.270: 1513 or slightly earlier.

Verso of No. 36.
 Inscription: "Turn the sheet over and you will see this woman without the construction lines."

 Markings on figure: "Top.
 End of the forehead.
 Eyebrow.
 Tip of the nose.
 Tip of the chin.
 Beginning of the neck.
 Limit of the shoulder.
 Level of the shoulder.
 Low point of the neck.
 On the chest.
 Joint.
 Behind the joint.
 Nipple.
 Beneath the breast.
 Waist.
 Navel.
 Limit of the waist.
 Limit of the belly.
 Center.
 Limit of the groin.
 Limit of the buttocks.
 Special notch.
 Above the knee.
 Center of the knee.
 Below the knee.
 Calves, outer.
 Calves, inner.
 Below the calves.
 Ankle.
 Sole."

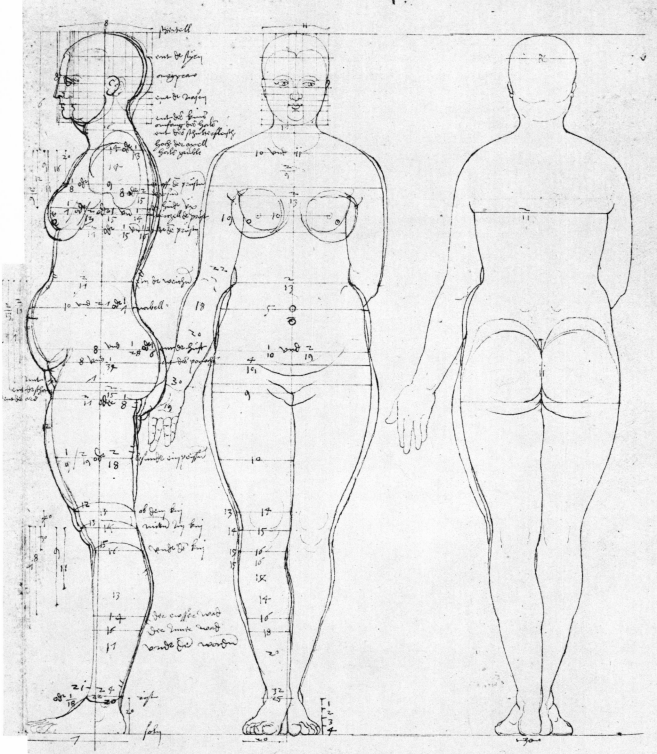

36 Strong woman of eight headlengths, tracing.

293 × 204 mm; 11½ × 8 in.
No watermark.

f.152r; Br.94.
R.II.270.

Tracing of No. 35 on the recto. The influence of Leonardo da Vinci has been seen in the parallel hatching of the contours. The small circles and clover leaves denote joints.

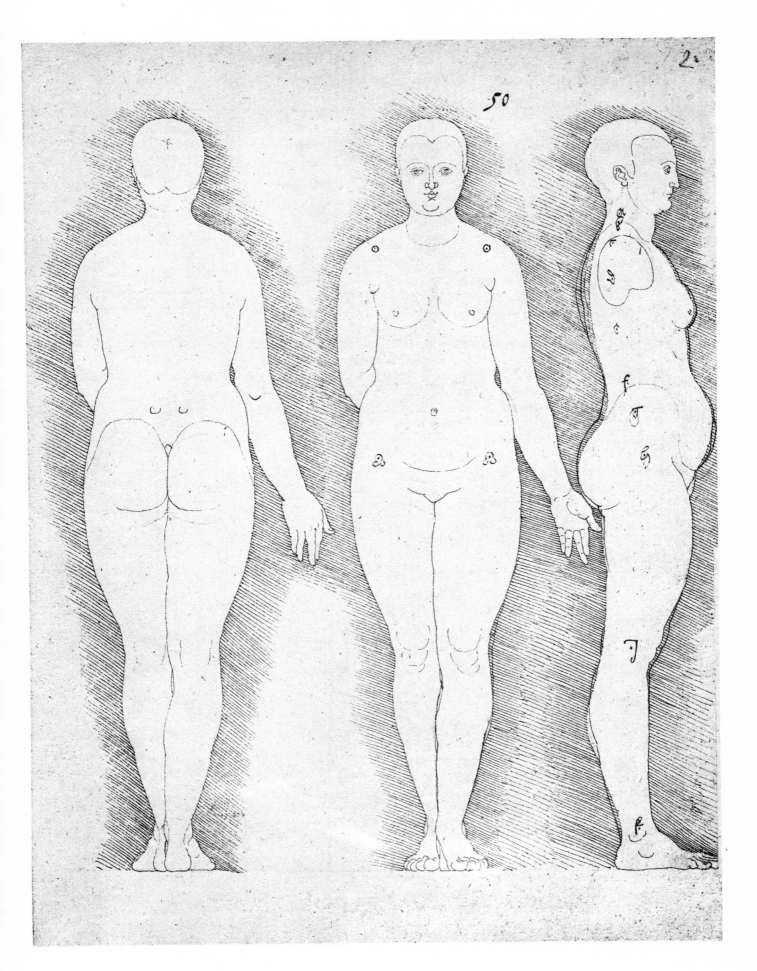

37 Nude man with mirror.

288 × 136 mm; 11¼ × 5⅜ in.
No watermark.
Dated 1512.
With Dürer's monogram.

f.118r (along with No. 68); Br.2.
P.1620.
R.II.181.

Nos. 37 and 68 are on the recto of No. 67. This drawing is part of the so-called "retrospective group," reminiscent of the representations of Apollo and Adam of 1501–1504. The pose is based on the "Apollo Belvedere"; the parallel shading is akin to drawings by Leonardo da Vinci.

 The "retrospective group" is discussed in the A. Wolf work listed in the Bibliography.

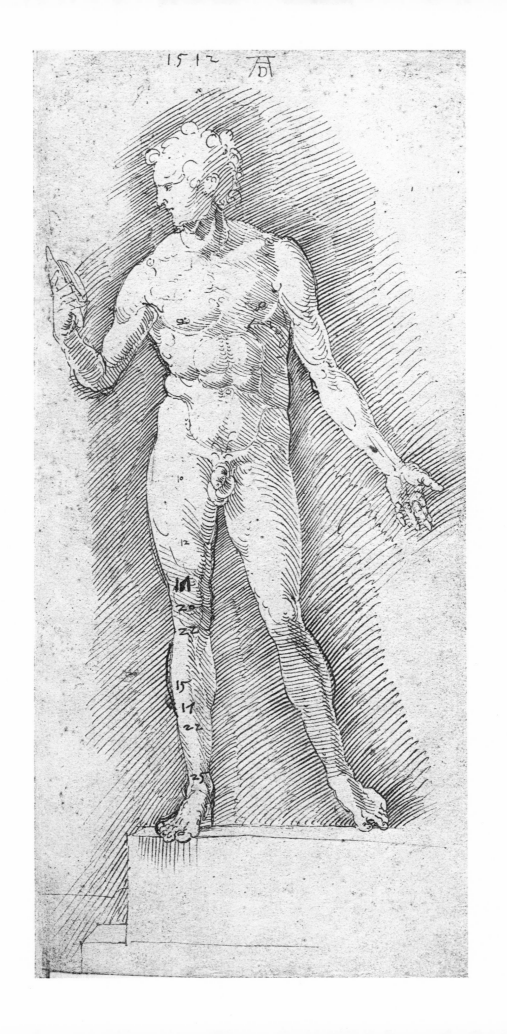

38 Two nude men; coat-of-arms of Willibald Pirckheimer.

288 × 201 mm; 11¼ × 7⅞ in.
No watermark.

f.169v; Br.45.
T.557: About 1513.
W.721: Probably 1504.
P.1510: Probably about 1513.

Verso of Nos. 39 and 128 (right).

The man pictured in the drawings is akin to No. 37. The coat-of-arms is probably preparatory to the one in the title-page border used in books by Willibald Pirckheimer beginning in 1513 (P.408).

The notation by Dürer is unrelated to the sketches. It reads: "Hans should be asked . . . I can slice off a circle whatever I wish . . . and can divide a circle in as many parts as desired."

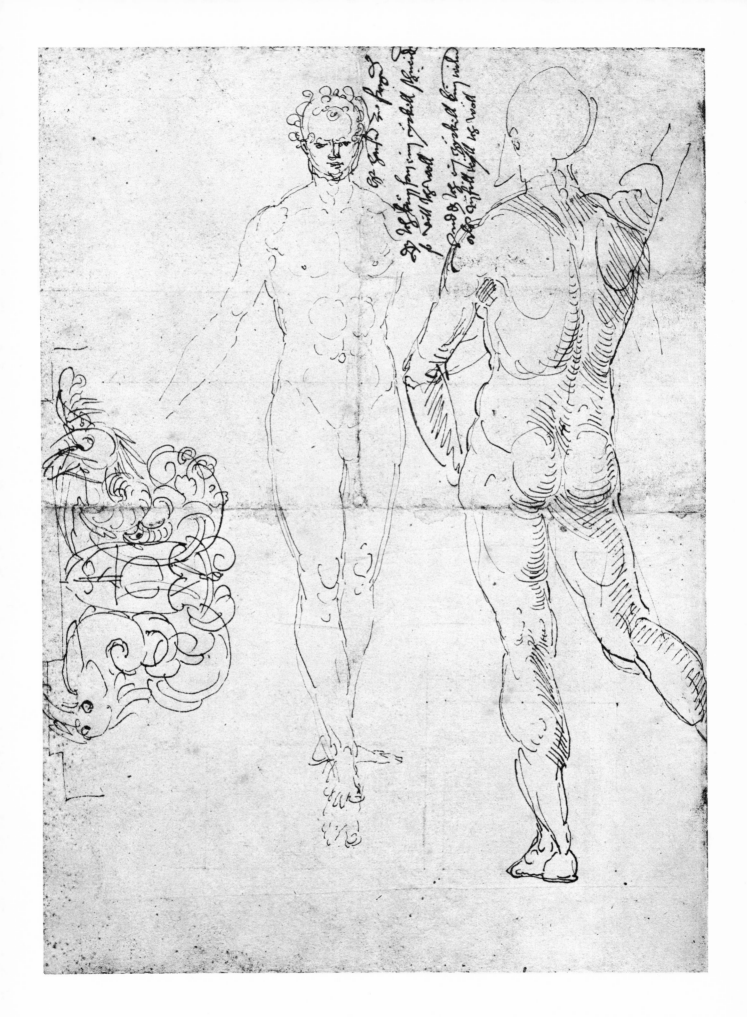

39 Nude man, half length.

120 × 73 mm; 4¾ × 2⅞ in.
No watermark.

f.169r (along with No. 128, right); Br.114 (along with Nos. 128, 138, and 146).

Recto of No. 38.

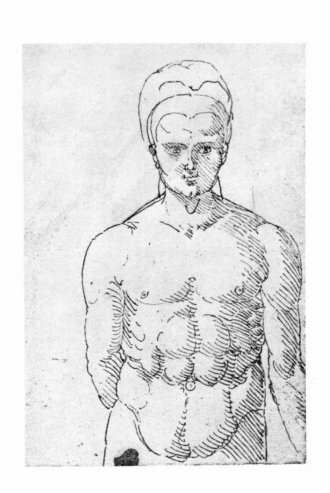

40 Man of eight headlengths with staff, constructed.

276 × 200 mm; 10⅞ × 7⅞ in.
No watermark.
Dürer's monogram partly trimmed off.

f.110r; Br.11.
P.1616: About 1512.
R.II.181: About 1512.

Recto of No. 41. This drawing belongs to the "retrospective group" like No. 37.

Notations by Dürer: "The head is one eighth part. From the chin to the forehead is one eleventh. From the top of the head to the point where the curvature of the neck begins, one seventh. If you wish to have a longer neck, take two thirteenths. Try the waist with two thirteenths."

According to Justi (see Bibliography) this is one of the earliest proportional drawings in which an alternate ratio is provided.

41 Man of eight headlengths with staff, tracing.

276 × 200 mm; 10⅞ × 7⅞ in.
No watermark.

f.110v; Br.12.
P.1617: About 1512.
R.II.181: About 1512.

The contours of No. 40 traced on the verso.

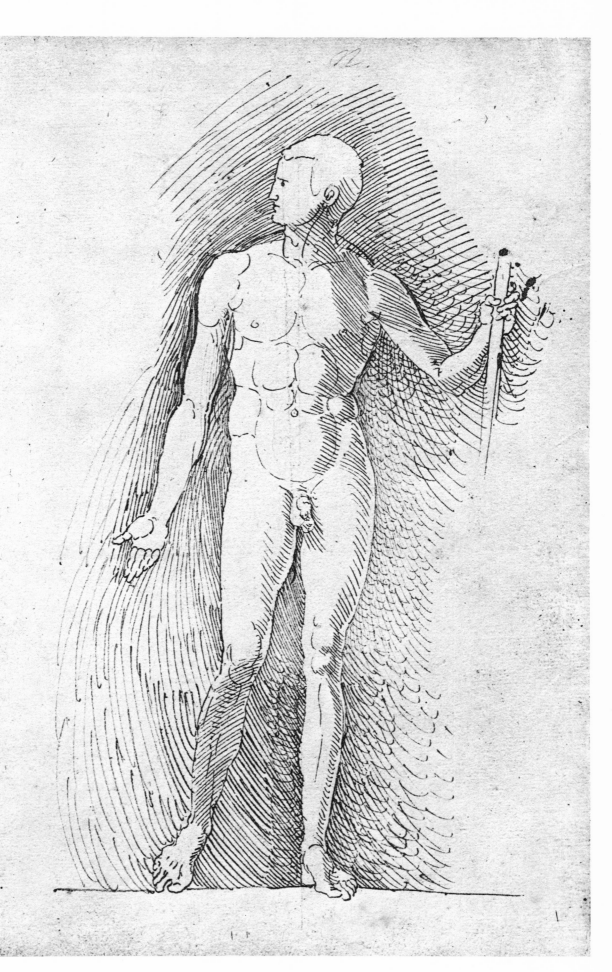

42 Man of eight headlengths; woman in motion.

267 × 192 mm; 10½ × 7½ in.
Watermark: trident.

f.134r; Br.67.

Recto of No. 92.

36

134

43 Man of eight headlengths; man in motion.

264 × 188 mm; 10⅜ × 7⅜ in.
Watermark: trident.

f.133r; Br.54.

Recto of No. 131.

35

44 Man of nine headlengths in profile.

256 × 176 mm; 10 × 6⅞ in.
Watermark: trident.

f.104r; Br.18.
P.1602.

Recto of No. 27. Tracing by Dürer of an Italian original based on the method described by Gauricus (see No. 31). Two half-sections are interposed at the level of the neck and the ankle. The watermark is the same as that of other drawings by Dürer of 1512–13. It was obviously made for reference as he did not employ this system in subsequent sketches.

23

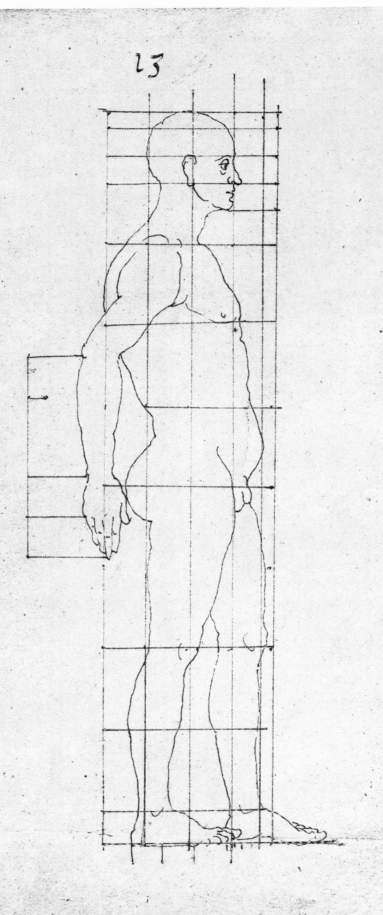

109

45 Man of nine headlengths, front view.

234 × 202 mm; 9¼ × 8 in.
No watermark.

f.123v; Br.1.
P.1602: Tracing by Dürer after the school of Leonardo da Vinci.

Companion piece to No. 44 and also based on Gauricus. It is here dated about 1512/13 because of the style of rendering the musculature and the closeness in time to the constructed body of a child (No. 46) that is specifically recommended by Gauricus.

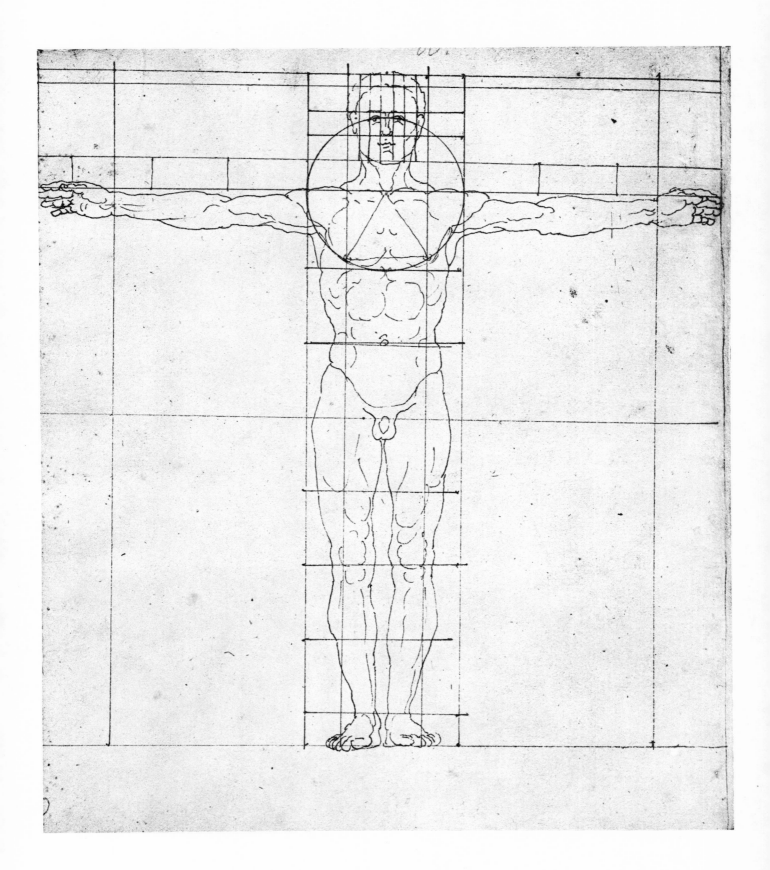

46 Body of a child, tracing.

294 × 208 mm; 11½ × 8⅛ in.
Watermark: high crown.

f.164r (along with No. 2); Br.100.
R.II.347.

Tracing of No. 47.

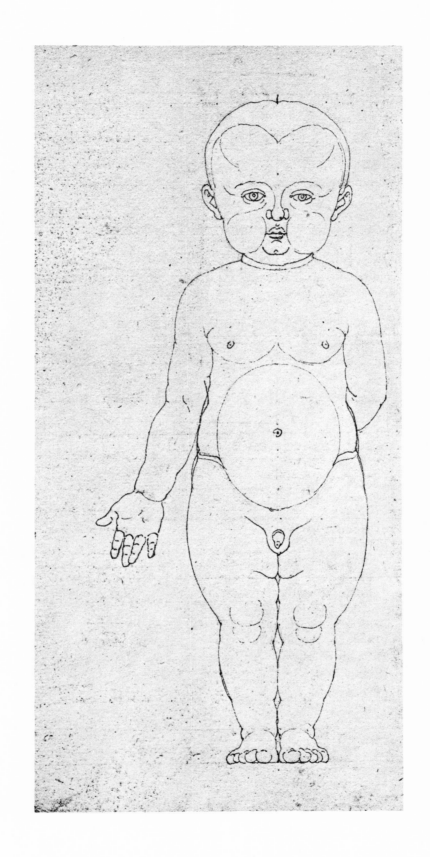

47 Body of a child, constructed.

294 × 208 mm; 11½ × 8⅛ in.
Watermark: high crown.
Dated 1513.
With Dürer's monogram.

f.164v; Br.99.
R.II.347: Related to Sloane 5228/186–87 and 5230/196.

Verso of Nos. 2 and 46. The construction of the body of a child is recommended in Gauricus' *De Sculptura*; this probably prompted Dürer to make this drawing (see Nos. 22 and 31).

Notations by Dürer on this drawing:
"Top of head.
Low point of hair.
Eyebrow.
Nose.
Mouth.
Chin.
Low point of neck.
Level of the shoulders.
Armpit.
Nipples.
Lower chest.
Waist.
Center of navel.
Hip.
Limit of belly.
On the organ.
Limit of the buttocks.
Crotch.
Above the knee.
Center of the knee.
End of the calves.
Ankle.
Sole."

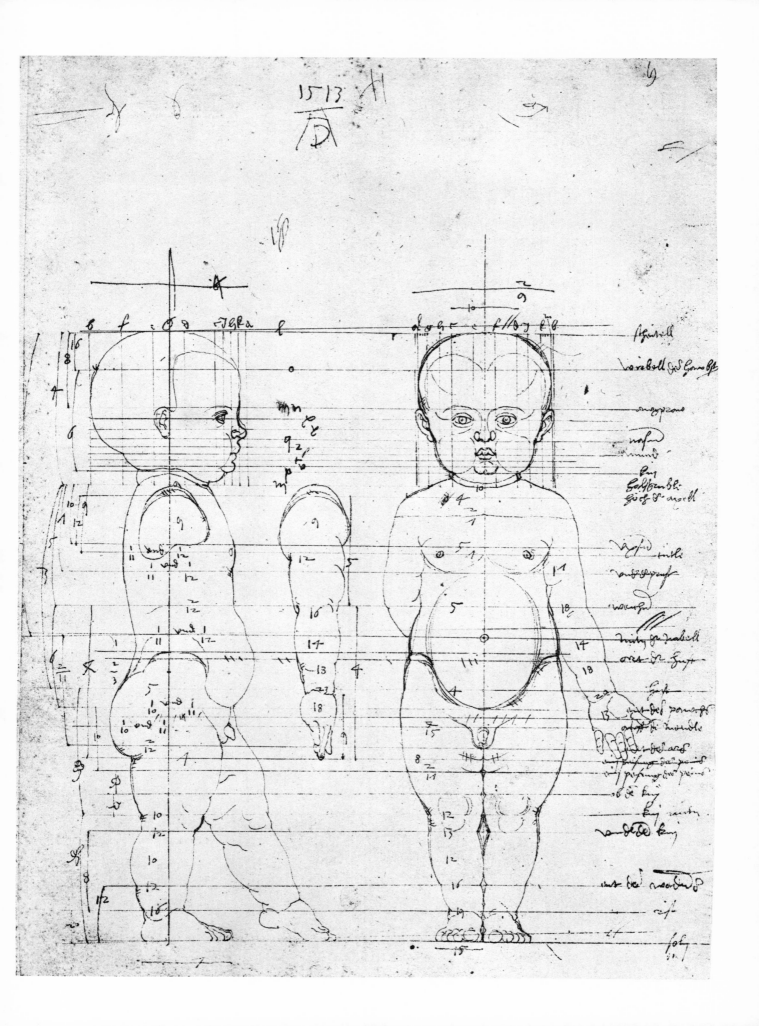

48 Man of eight headlengths.

287 × 207 mm; 11¼ × 8⅛ in.
Watermark: trident.

f.120r; Br.5.
R.II.181.

Recto of No. 49. Part of the "retrospective group" begun in 1512
and continued in 1513 (see No. 37).

Two alternate ratios are indicated on the figure for a lean or stout
figure, as mentioned by Dürer on the verso.

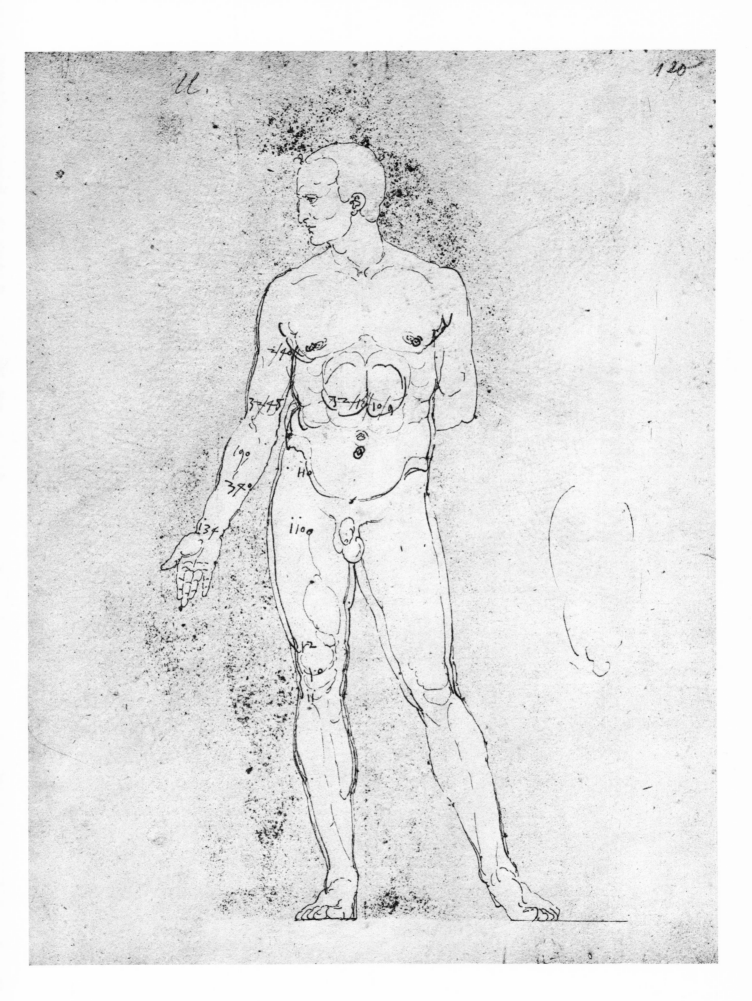

49 Man of eight headlengths, tracing.

287 × 207 mm; 11¼ × 8⅛ in.
Watermark: trident.
Dated 1513.
With Dürer's monogram.

f.120v; Br.6.
R.II.181.
P.1621.
W.650.

Contours of No. 48 traced on the verso. The background is washed with green, the figure touched with pink watercolor, the nipples of the breast with dark red, the hair with yellow.

Inscribed: "These are two kinds of proportions, stout and lean, as desired."

This sheet was formerly united in one sheet with No. 51.

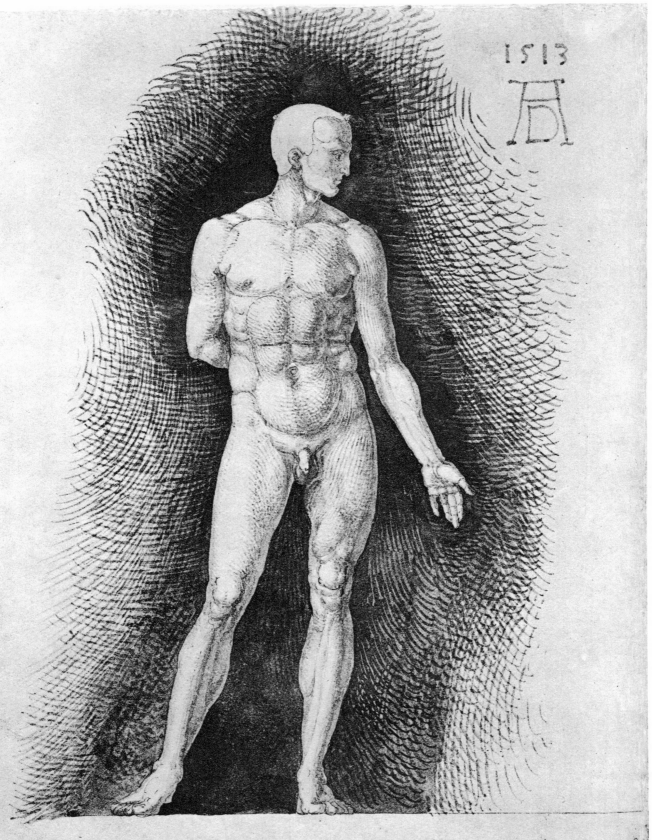

50 Man of nine headlengths; torso.

252 × 188 mm; 9⅞ × 7⅜ in.
Watermark: trident.

f.121v; Br.7.
R.II.181.

Verso of No. 51. Part of the "retrospective group" begun with No. 37. Related to the drawings of men of nine headlengths at London (Sloane 5228/5–6, 163; 5230/72, 73, 94, 96, 116, 117).

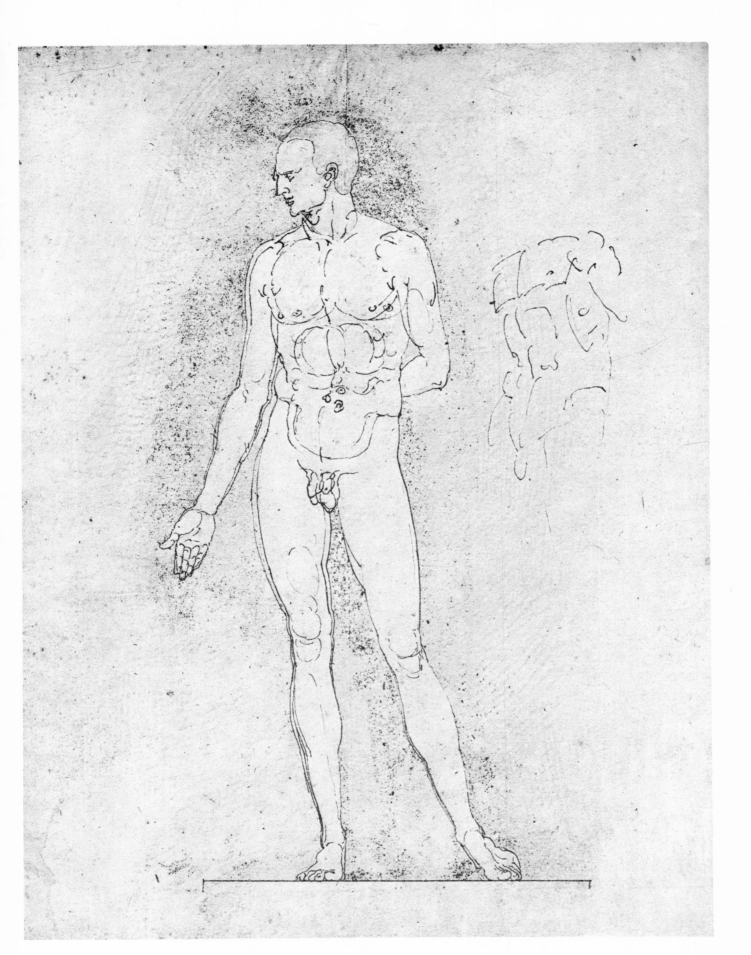

51 Man of nine headlengths, tracing.

252 × 188 mm; 9⅞ × 7⅜ in.
Watermark: trident.

f.121r; Br.8.
R.II.181.

Contours of No. 50 traced on the recto. Part of the "retrospective group." Same coloring as No. 49.
 Inscribed: "To be proportioned stout or lean as desired."
 This sheet was formerly united in one sheet with No. 49.

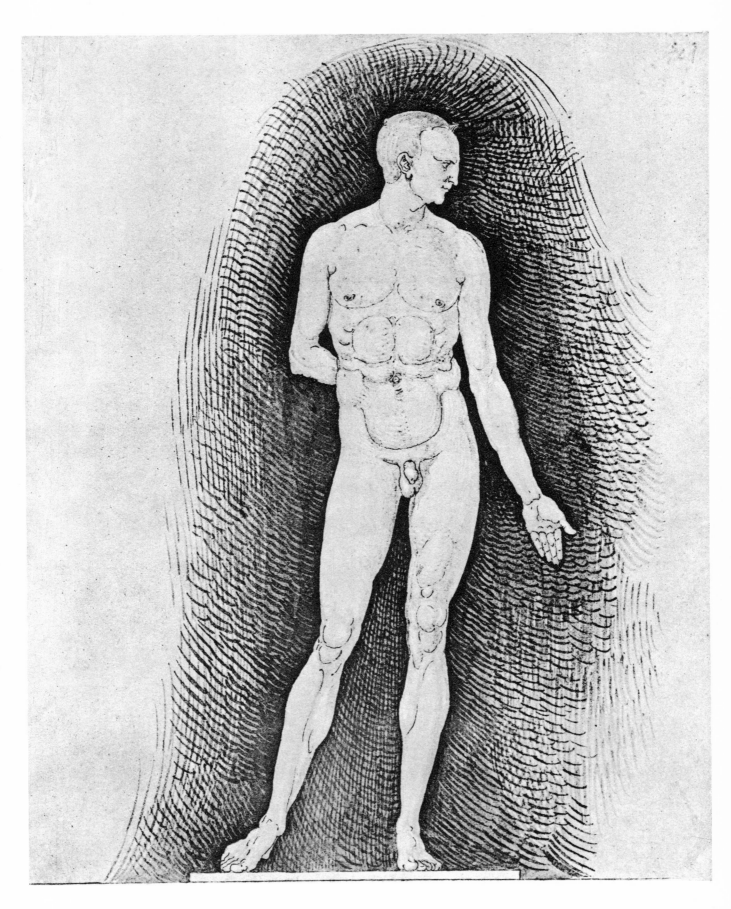

gporzed dick vnd dag dy may may

52 Man of eight headlengths, constructed.

293 × 208 mm; 11¼ × 8⅛ in.
No watermark.
Dated 1513.
With Dürer's monogram.

f.127r; Br.3.
R.II.178.

Recto of No. 53. Crossed out, nevertheless inscribed: "Describe this one, it is the better one." A similarly crossed out sketch is Sloane 5228/3–4.

53 Man of eight headlengths, tracing.

293 × 208 mm; 11½ × 8⅛ in.
No watermark.

f.127v; Br.4.
R.II.178.

Contours of No. 52 traced on the verso.

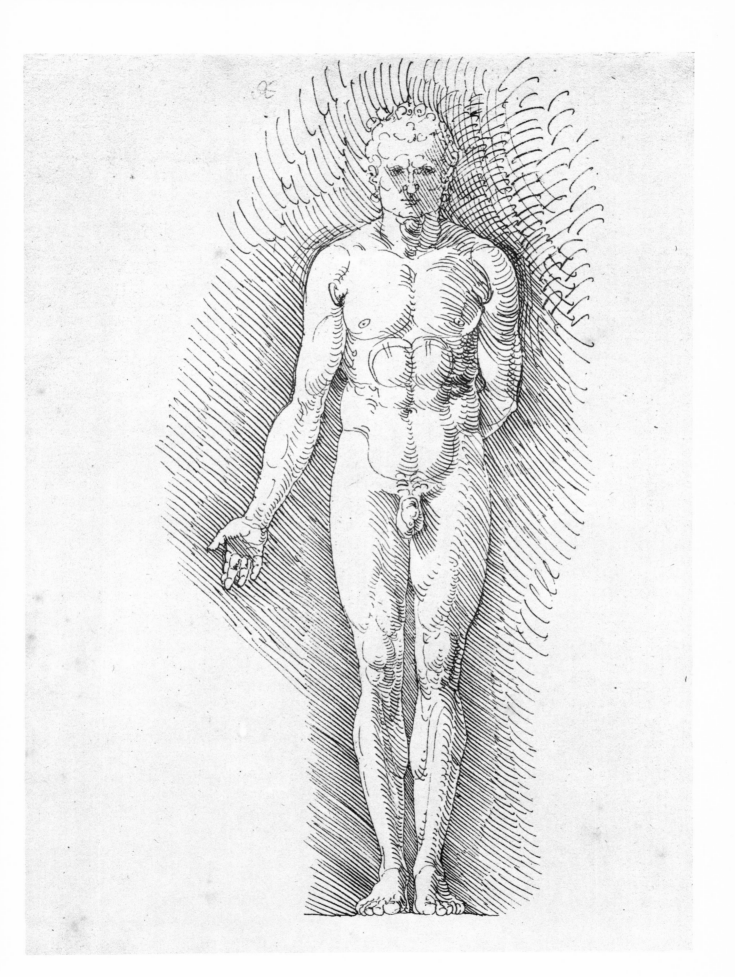

54 Nude man holding an orb, constructed.

280 × 202 mm; 11 × 8 in.
Watermark: trident.
Dated 1513.
With Dürer's monogram (authentic?).

f.135r; Br.9.
P.1619.
R.II.181.

Recto of No. 55. Part of the "retrospective group."
 Inscribed:
 "This measures 6 to the bottom of the neck.
 Above the shoulders the width is 4.
 The body is 3 in length and 2 in width at the waist.
 As long as the body, as wide at the hip.
 Half as wide as the waist.
 One quarter as wide as the body's length.
 The foot from the sole to the ankle, 18."

55 Nude man holding an orb, tracing.

280 × 202 mm; 11 × 8 in.
Watermark: trident.

f.135v; Br.10.
P.1619.

Contours of No. 54 traced on the verso. Part of the "retrospective group." The background filled in in black.

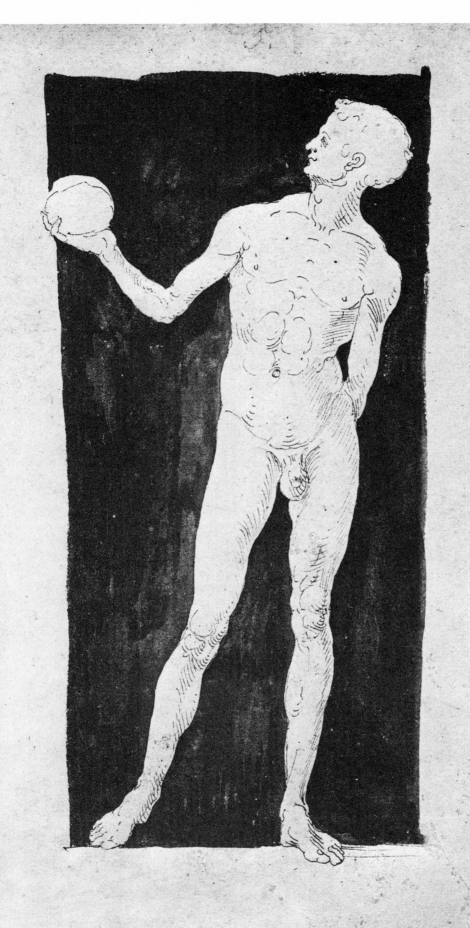

56 Man of eight headlengths, constructed.

294 × 200 mm; 11½ × 7⅞ in.
Watermark: trident.
Dated 1513.
With Dürer's monogram.

f.117r; Br.27.
R.II.215.

Recto of No. 57. This drawing serves to illustrate Dürer's system of "progressive proportion" that he began to experiment with at about this time. It is best described in Dürer's own words:

"Now that I have divided the torso, being the largest member of the human body, it is necessary to place the knee at the proper height. We know that the stronger will always overpower the weak. Likewise in the human body, its hind parts are always longer and thicker than those in front for the sake of strength. We shall notice that the arms, hands, fingers, legs, feet, toes are always shorter in front than further back. In the same manner I shall compare the three longest parts of the human body. Also here the strongest must be the longest.

"For the first part and the longest is the body from the neck to the waist. It combines in one section the control to activate the other parts of the body. The second longest part is the thighs from the hip to the knee. These should be shorter than the aforementioned part. The third is the shins between knee and ankle. These are the shortest of the three largest parts. You should compare the two shorter ones to the longer ones as follows: The first to the second is proportional as the second to the third . . . Euclid states" (Extract from the manuscript at London, Sloane 5230/61; watermark: trident.)

Inscribed: "The man in profile belongs to that marked 000."

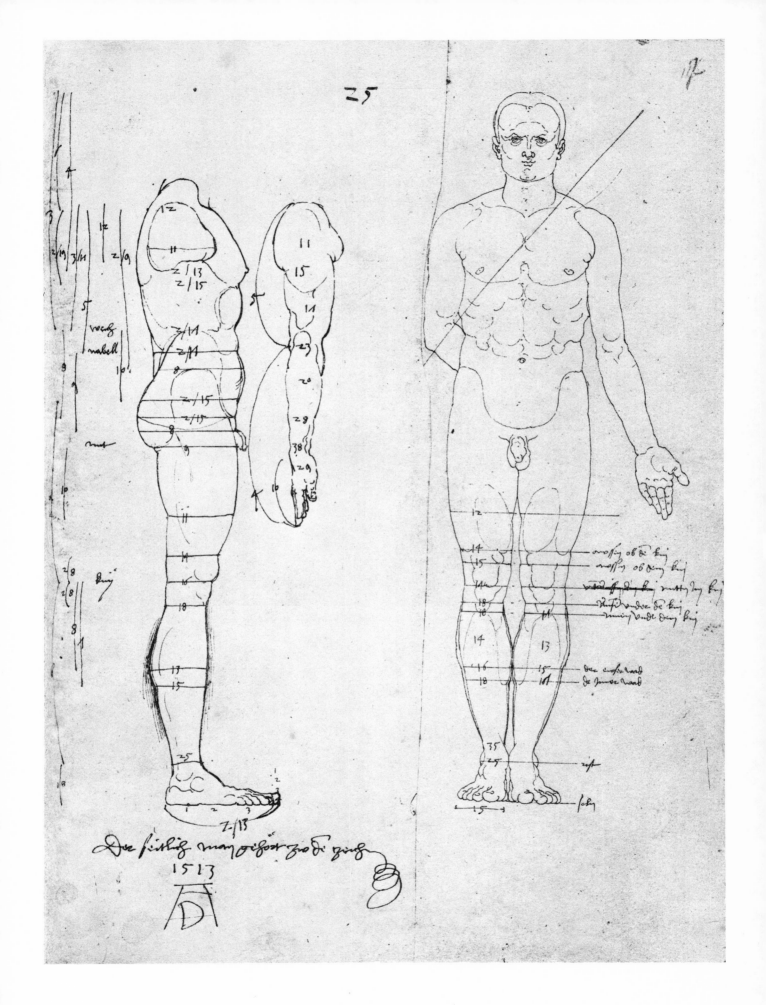

57 Man of eight headlengths, tracing.

294 × 200 mm; 11½ × 7⅞ in.
Watermark: trident.

f.117v; Br.28.
R.II.215.

Contours of No. 56 traced on the verso.
Inscribed: "Let it stay as it is."

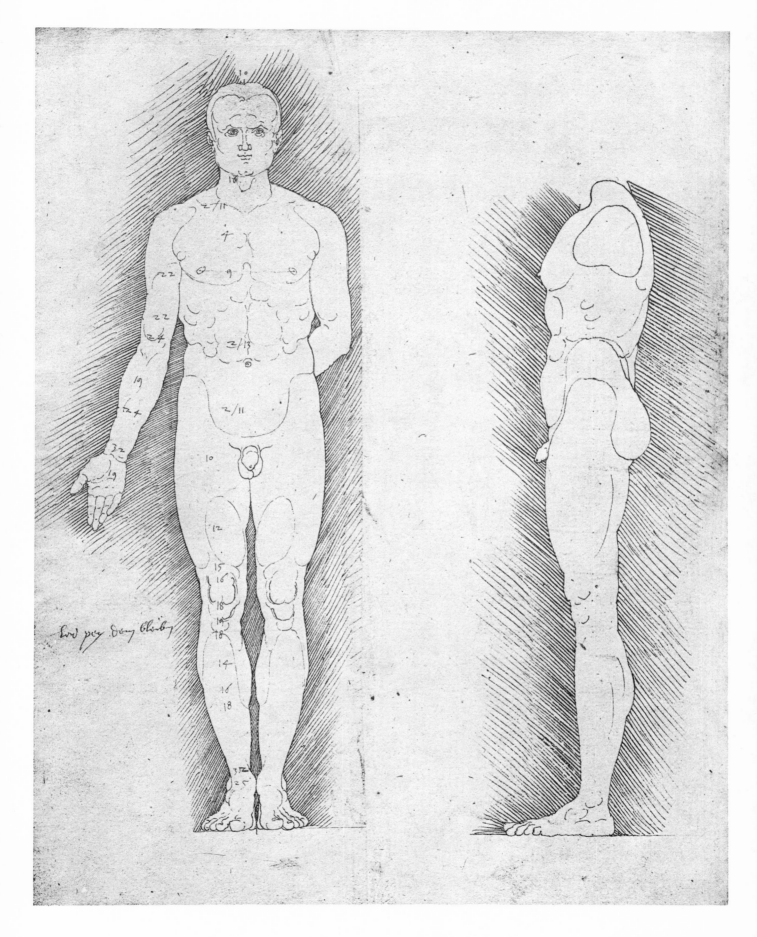

58 Man of eight headlengths.

293 × 206 mm; 11½ × 8⅛ in.
No watermark.

f.122r; Br.41.
R.II.215.

Recto of No. 59. Exceptionally the parallel shading is here added to the constructed figure on the recto.

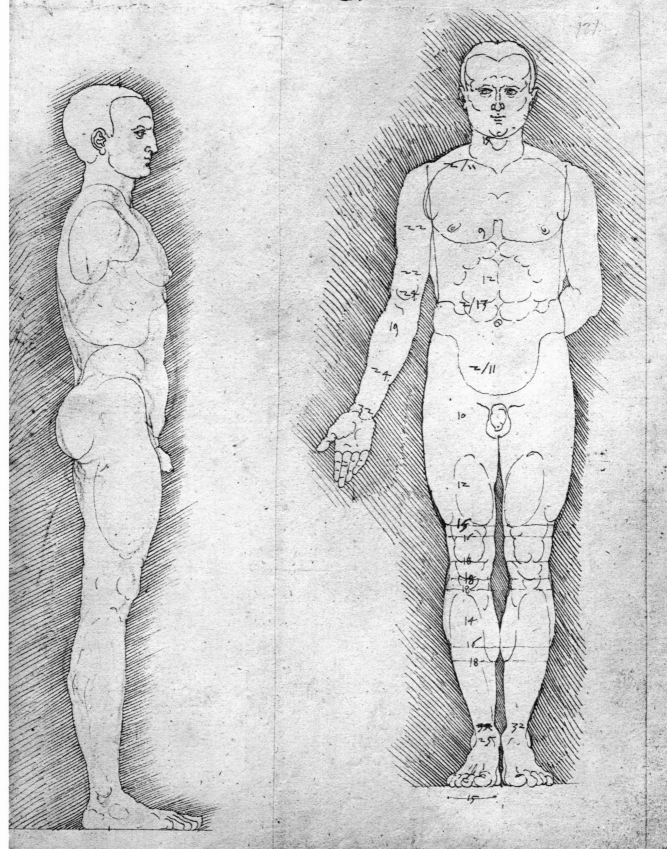

59 Man of eight headlengths, tracing.

293 × 206 mm; 11½ × 8⅛ in.
No watermark.

f.122v; Br. 42.
R.II.215.

Tracing of No. 58 on the verso.
 Inscribed: "This body is good."

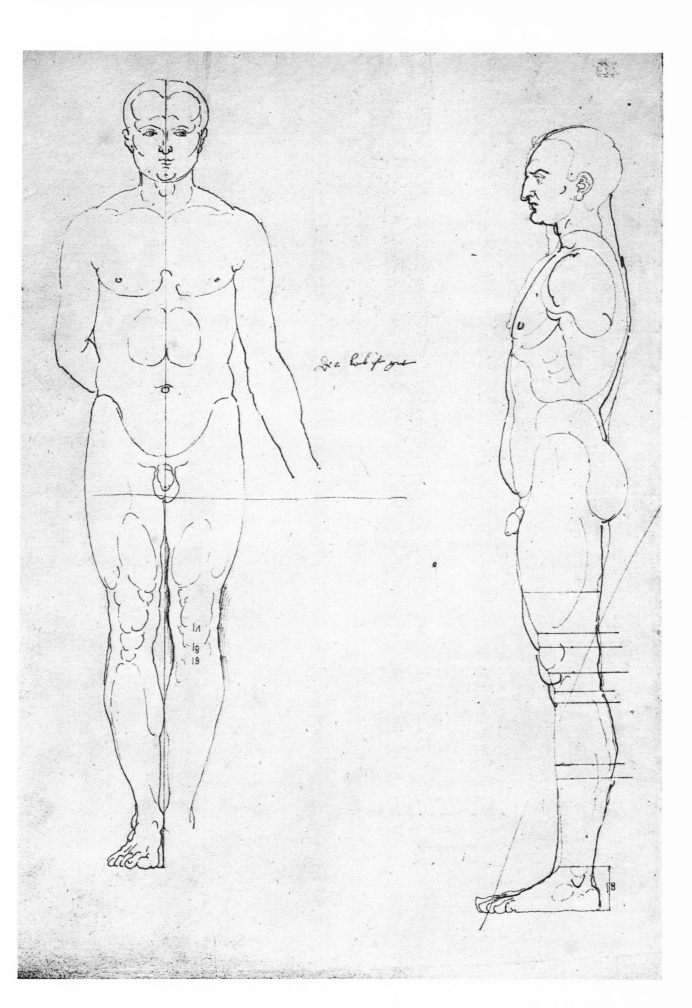

60 Man of eight headlengths, constructed.

292 × 207 mm; 11⅜ × 8⅛ in.
No watermark.

f.124r; Br.43.
R.II.224: About 1515.

Recto of No. 61. This drawing already comes close to the final version as pictured in the printed edition of Dürer's *Four Books on Human Proportion*, Nuremberg, 1528.

Notations:
"Top of head.
Forehead.
Chin.
Level of shoulder 15.
Level of collar 13.
Low point of neck 11.
In front at armpits 2/13.
Nipples 2/13.
Below the breast 4/27.
Bottom of the sternum 7.
Waist 8.
Navel 9.
Hip 2/17.
Below the hip 7.
Limit of the belly 1/14 and 1/15.
Penis 2/15.
Center 8.
Limit of the buttocks 2/19.
Knee center 2/31.
Below the knee 16.
Below the knee, inside 2/33.
Ankle 20.
Low point of the shin 17.
Sole."
"Above the knee 15.
Knee center 17.
Outside below the knee.
Inside below the knee 18.
Calves, outside 16.
Calves, inside 18."

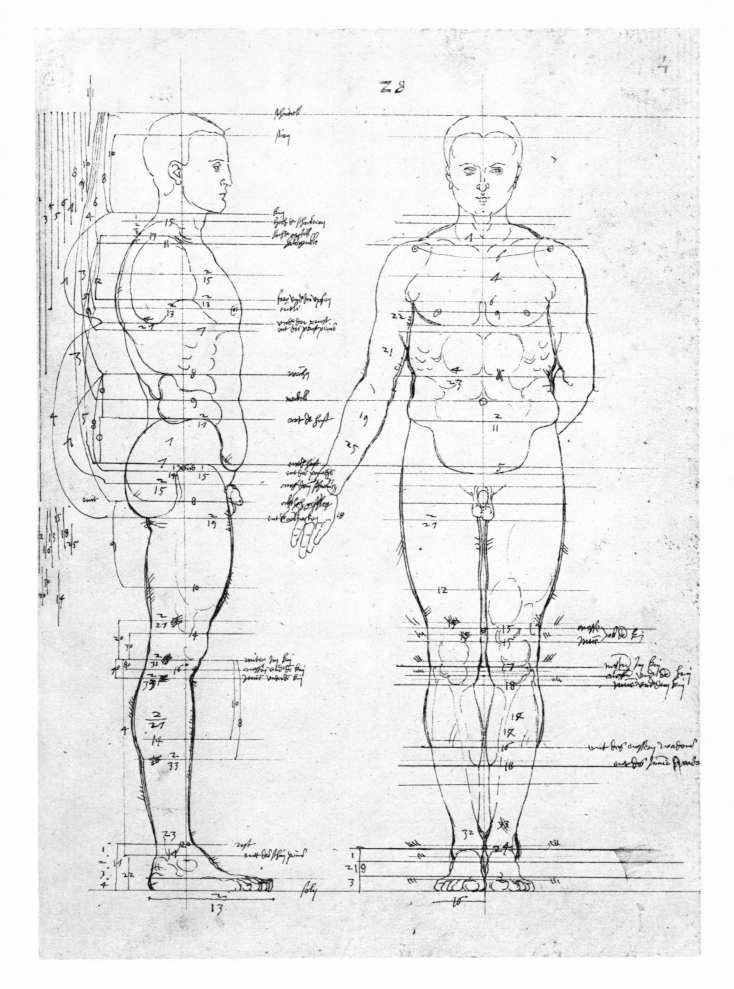

61 Man of eight headlengths, tracing.

292 × 207 mm; 11⅜ × 8⅛ in.
No watermark.

f.124v; Br.44.
R.II.224.

Tracing of No. 60 on the verso.

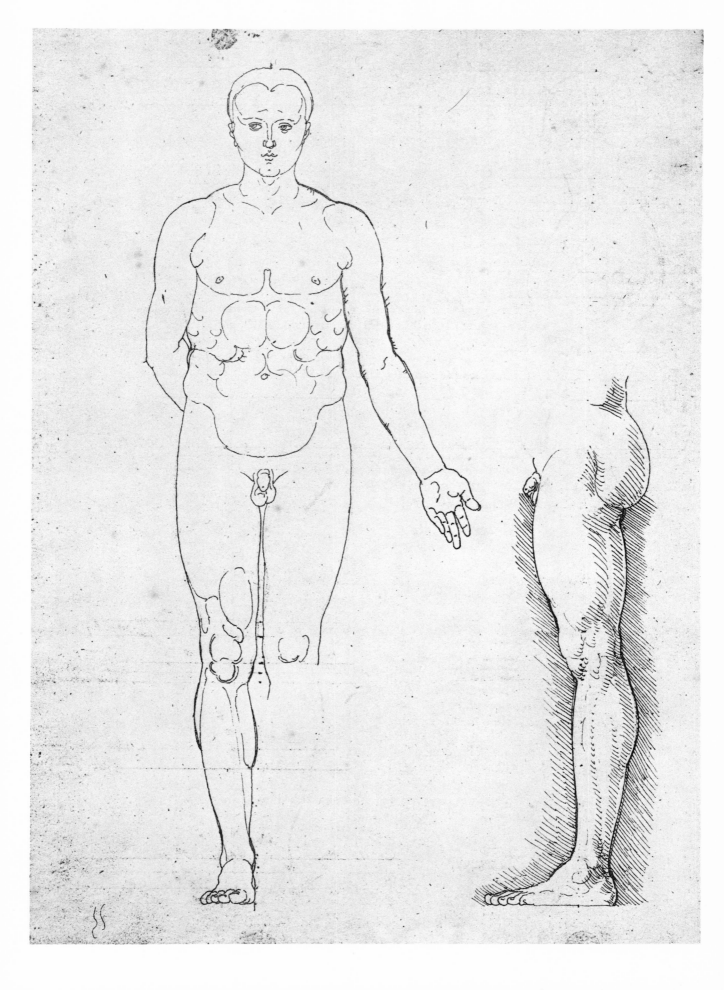

62 "Extra-strong man of eight headlengths," constructed.

293× 209 mm; 11½ × 8⅛ in.
No watermark.

f.107r; Br.25.
R.II.215: 1513 or later.

Recto of No. 63.
 The drawing is in brown ink except for the corrections of the con-
tours of the left figure and the diagonal line, which are in black ink.
 Inscribed:
 "These are the measurements of an extra-strong stout man.
 These are the numbers: (for the front view)
 Top of head.
 Forehead.
 Eyebrow.
 Nose.
 Chin 15.
 Level of the shoulders.
 Low point of the neck 2/11.
 Armpit 5.
 Nipples 9.
 Below the chest.
 Tip of the sternum.
 Waist 6.
 Navel.
 Waist.
 Hip 5.
 Limit of the belly.
 Penis 3/28.
 Center of the man 3/28.
 Groin 12.
 Above the knee, exterior 15.
 Knee center 14.
 Below the knee, inside 17.
 Calves, outside 15.
 Calves, inside 16.
 Ankle 25.
 Sole.
Note: The three long sections are made according to the rule."
 (i.e. progressive proportion, cf. No. 56.)

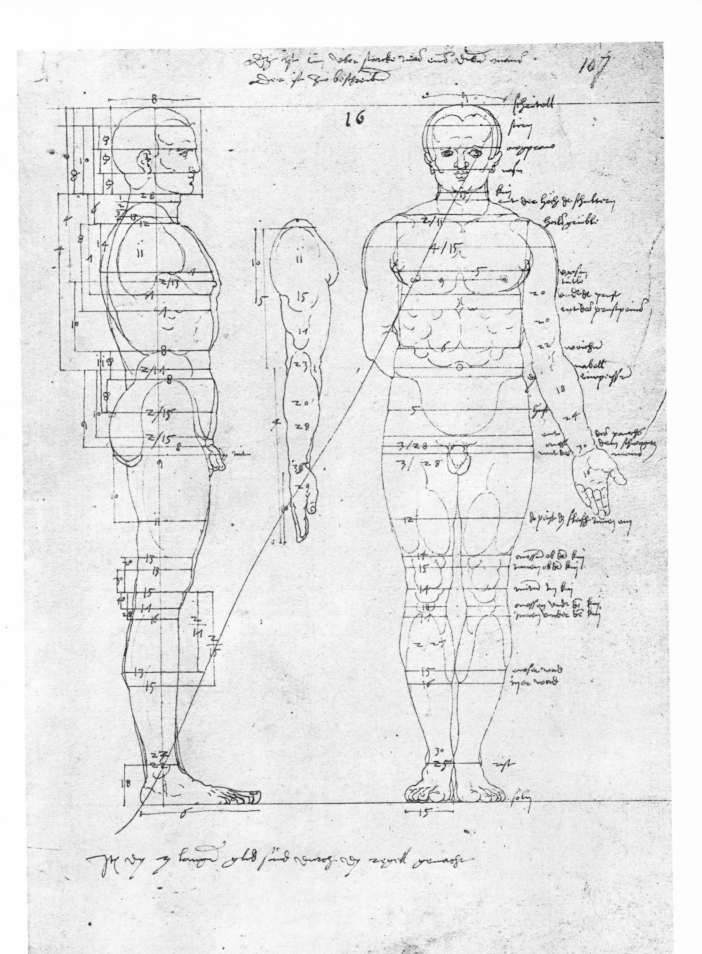

63 "Extra-strong man of eight headlengths," tracing.

293 × 209 mm; 11½ × 8⅛ in.
No watermark.

f.107v; Br.26.
R.II.215.

Contours of No. 62 traced on the verso.

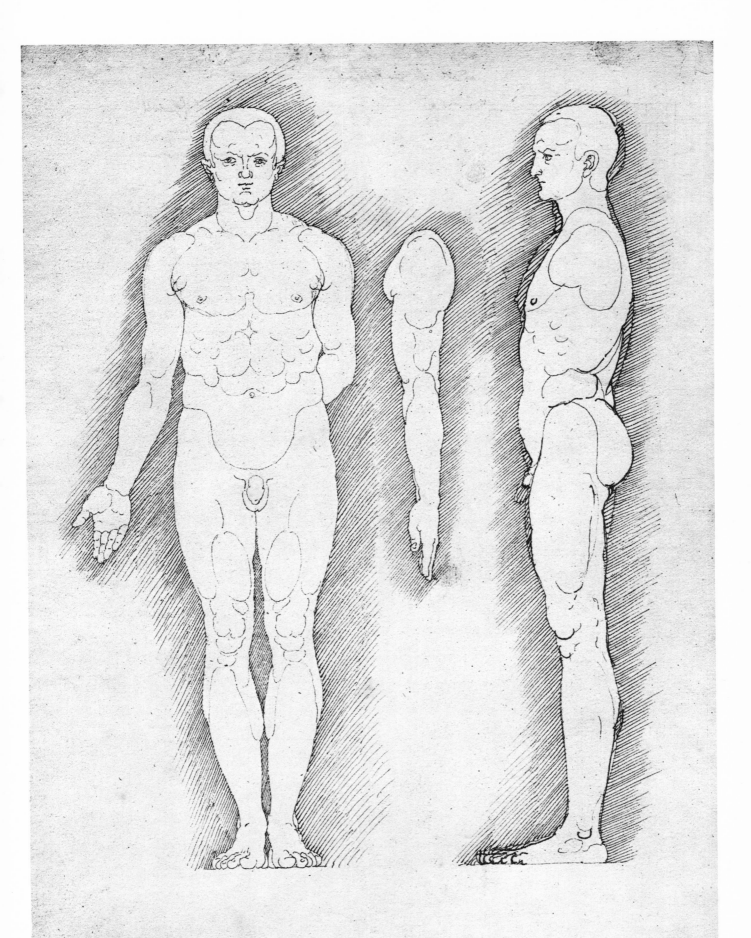

64 Man of eight headlengths, constructed.

293 × 207 mm; 11½ × 8⅛ in.
Watermark: trident.

f.128v; Br.50.
R.II.190: 1513 or thereafter.

Verso of No. 65. The drawing is based on Dürer's system of "progressive proportion," and is therefore to be dated 1513 or later. Probably 1513. The word "rule," referring to "progressive proportion," is found opposite the torso, the thigh, and the shin (cf. No. 56).
 Notations on the right side of the drawing:
 "Top of the head.
 Forehead.
 Chin.
 Low point of the neck.
 Shoulder.
 Armpit.
 Nipples.
 Below the breast.
 Waist.
 Navel.
 Hip.
 Limit of the belly.
 Penis.
 Center.
 Knee.
 Ankle.
 Sole."

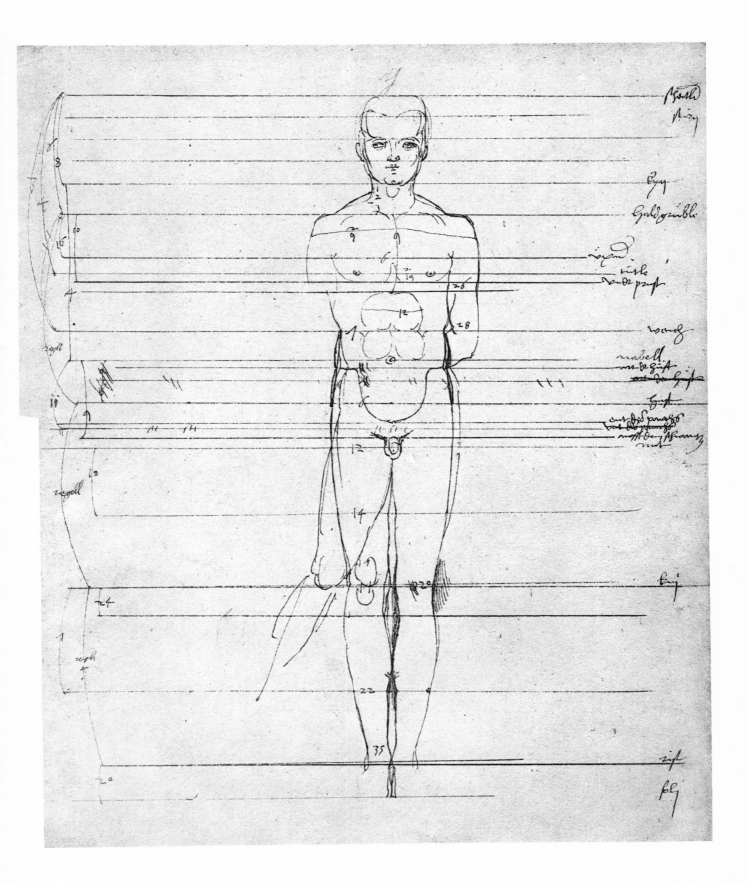

65 Man of eight headlengths, tracing; drapery study.

293 × 207 mm; 11½ × 8⅛ in.
Watermark: trident.

f.128r; Br.51.
R.II.190.

Tracing of No. 64 on the recto.

66 Man of eight headlengths.

283 × 209 mm; 11⅛ x 8¼ in.
No watermark.
Dated 1513.
With Dürer's monogram.

f.102r; Br.15.
R.II.225.

Recto of No. 128 (left).
Inscribed: "The shoulder higher on a level with the chin.
 "Improve the pose as in the one before this; it will be much
 better."

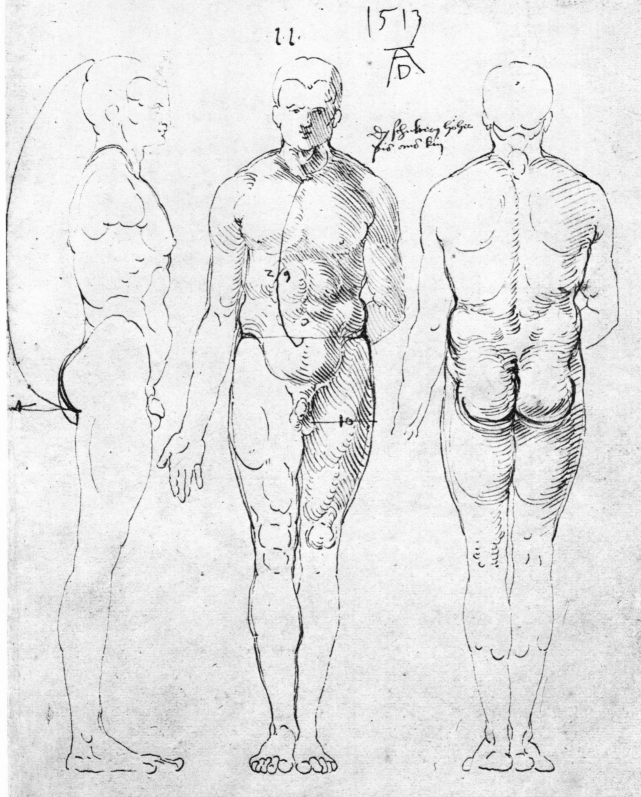

1513

11

102

67 Woman of more than nine headlengths, constructed.

287 × 74 mm; 11¼ × 2⅞ in.
No watermark.

f.118v; Br.68.
R.II.254.

Verso of Nos. 37 and 68.
Inscribed: "Woman with long body—construct it according to the
 inscription."
Akin to Sloane 5230/75, 118, 119, 145; 5228/111.

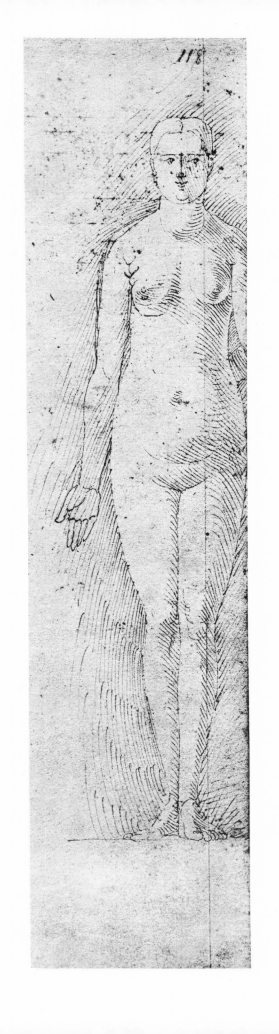

68 Woman of more than nine headlengths, tracing.

287 × 74 mm; 11¼ × 2⅞ in.
No watermark.

f.118r (along with No. 37); Br.68.
R.II.254.

Tracing of No. 67.

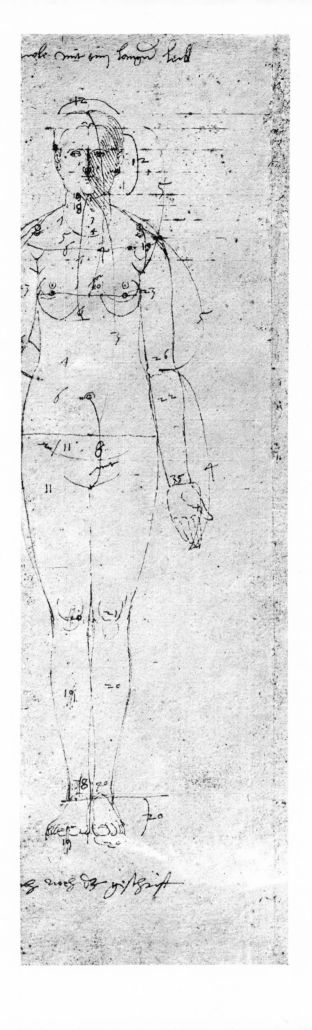

69 Woman of eight headlengths.

294 × 202 mm; 11½ × 8 in.
No watermark.

f.148r; Br.85.
R.II.16: Not by Dürer.

Preparatory for the final printed version in the *Four Books on Human Proportion*, Book I. The triangles mark the joints as in the printed edition, but some of the ratios are changed. Probably by an assistant. The handwriting is not Dürer's. Companion piece to No. 70.

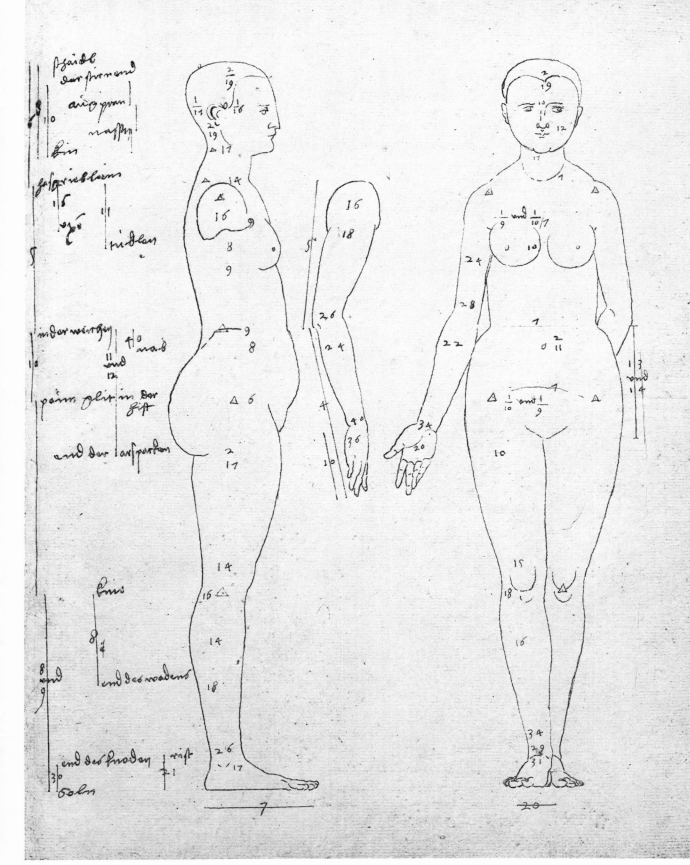

70 Man of eight headlengths.

255 × 198 mm; 10 × 7¾ in.
Watermark: crowned segmented snake (variation not customary for Dürer).

f.147v; Br.40.
R.II.16: Not by Dürer.

Preparatory for the final printed version in the *Four Books on Human Proportion*, Book I. The triangles mark the joints as in the printed edition, but some of the ratios are changed. Probably prepared by an assistant. The handwriting is not Dürer's. Companion piece to No. 69.

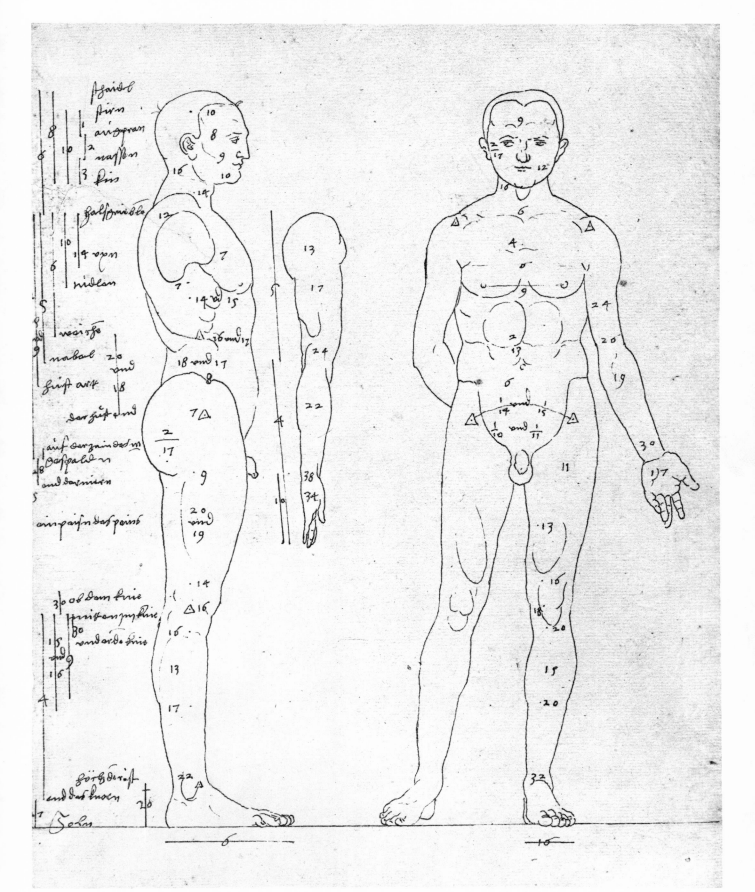

71 Man of eight headlengths.

244 × 189 mm; 9⅝ × 7⅜ in.
No watermark.

f.106r; Br.24.

Recto of No. 72. Based on but not traced from No. 70. The legs
are elongated in this drawing. Triangles mark the joints.

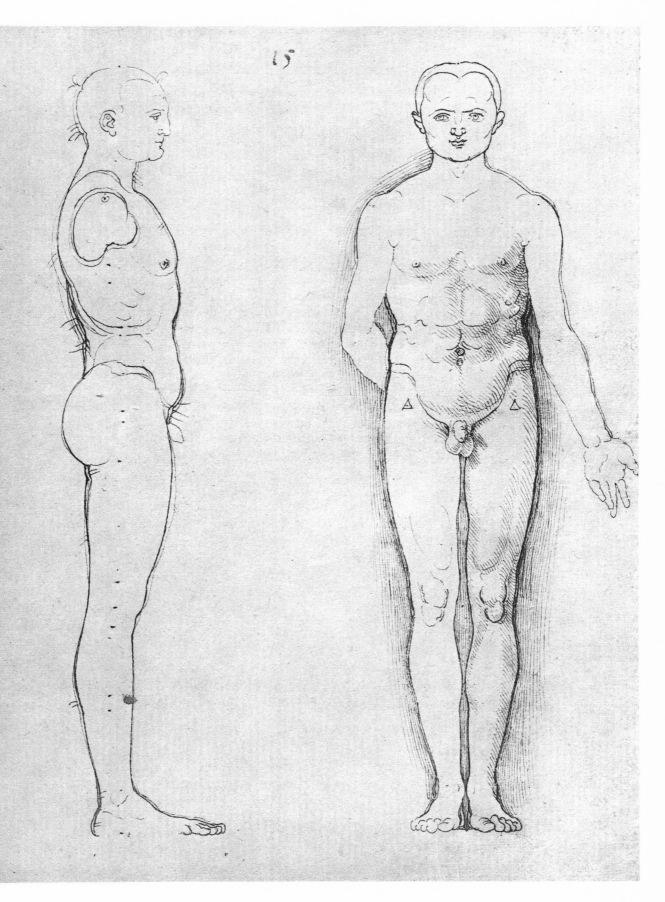

72 Elongation and contraction of measurements
 (text to No. 73)

120 × 190 mm; 4¾ × 7½ in.
No watermark.

f.106v; Br.159 (top).
R.II.425: 1513–15.

Translation: "Here I shall elongate and shorten the aforementioned man by means of the *Verkehrer* (converter). It is shown in the following two sketches, one man very tall, the other very short. I have drawn it especially tall and especially short so that you will discern the difference. The horizontal lines remain unchanged in length in both figures. But when you alter the figure, don't overdo it. Use your judgment. It is the best way. You may use these two figures as a *curiosum,* or use the smaller one for a dwarf. If you wish to use the tall one, you may widen its waist to match the buttocks. It will be better and make him appear less gaunt. You may also wish to extend his calves so that the ankles will not appear to be on too high a level, as you will see in the next figure."

73 A tall and a short man, constructed.

290 × 198 mm; 11⅜ × 7¾ in.
Watermark: trident.

f.103r; Br.16.
R.II.425: 1513–15.

Recto of No. 74.

12 e.

103.

74 A tall and a short man, tracing.

290 × 198 mm; 11⅜ × 7¾ in.
Watermark: trident.

f.103v; Br.17.
R.II.425.

Tracing of No. 73 on the verso.

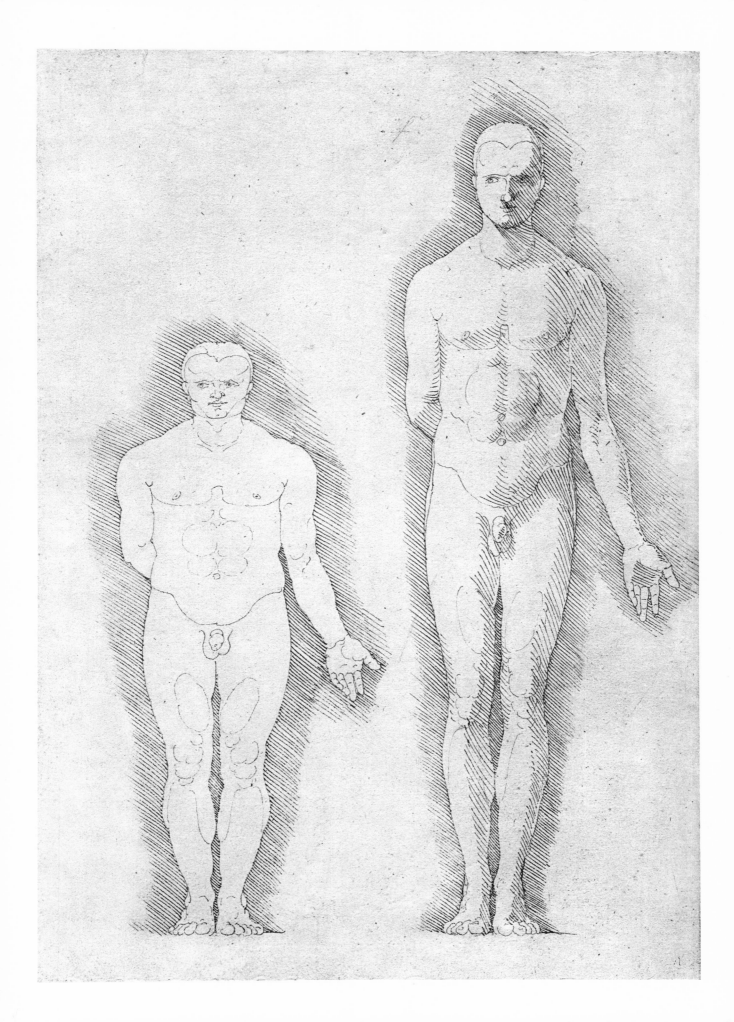

75 Man striding, constructed.

262 × 194 mm; 10¼ × 7⅝ in.
No watermark.

f.109r; Br.30.
R.III.139.

Recto of No. 76, which is dated 1519. Preparatory for Book IV of the *Four Books on Human Proportion* of 1528.

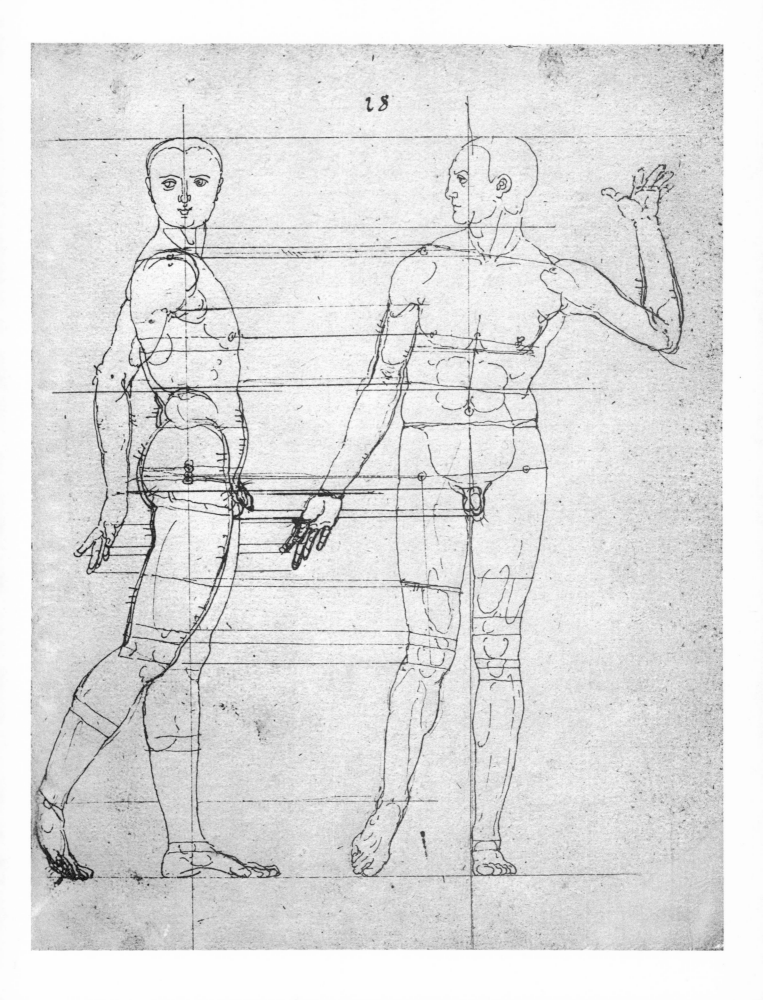

76 Man of more than eight headlengths striding, tracing.

262 × 194 mm; 10¼ × 7⅝ in.
No watermark.
Dated 1519.

f.109v; Br. 31.
R.III.139.

Contours of No. 75 traced on the verso. Preparatory for Book IV
of the *Four Books on Human Proportion*.
 Inscribed:
 "A man measuring more than eight headlengths.
 "The body is wider, seen from the front, thinner seen from
 the side, but the thighs of the figure are thicker seen in profile
 and thinner seen from the front, because of the body's balance."
Book IV of *Four Books on Human Proportion* is concerned with the
motion of bodies, exemplified by this drawing of a man striding.

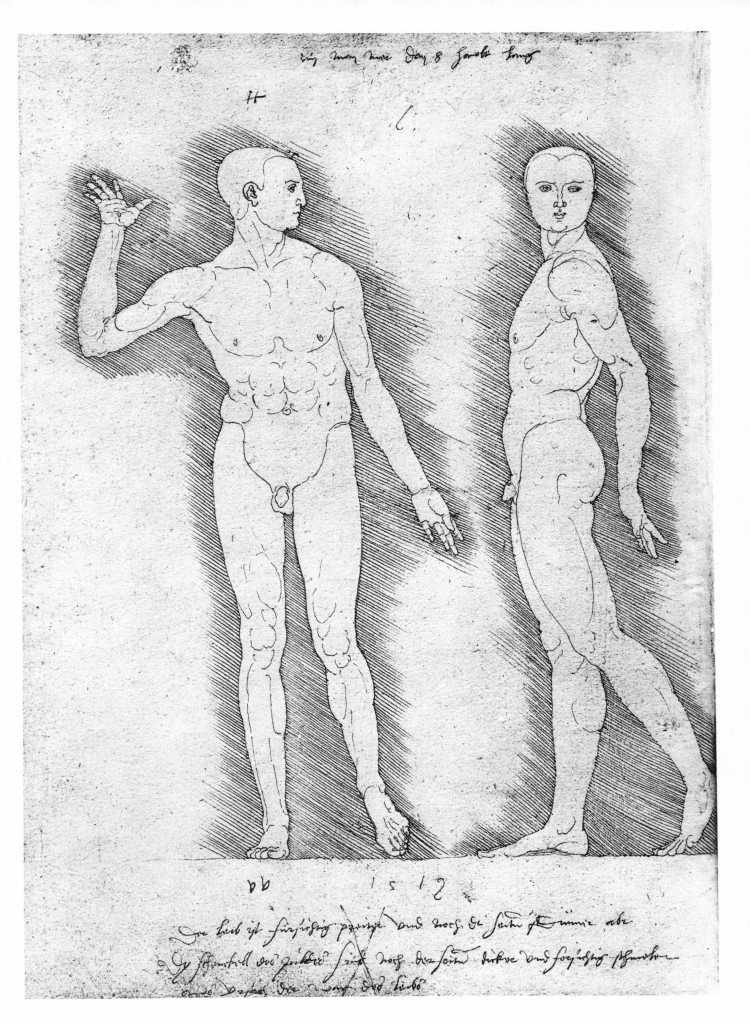

77 Man of seven headlengths leaning, constructed.

267 × 199 mm; 10½ × 7⅞ in.
No watermark.

f.115v; Br.34.
R.III.139.

Verso of No. 78, which is dated 1519. Preparatory for Book IV of the *Four Books on Human Proportion*.

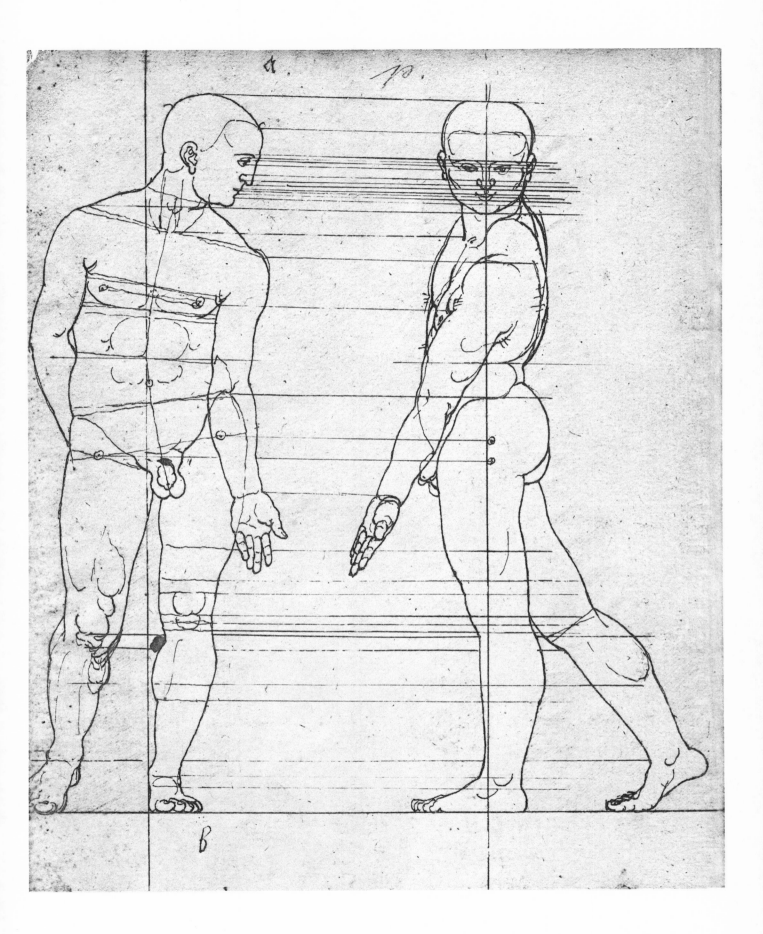

78 Man of seven headlengths leaning, tracing.

267 × 199 mm; 10½ × 7⅞ in.
No watermark.
Dated 1519.

f.115r; Br.35.
R.III.139.

Contours of No. 77 traced on the recto. Preparatory for Book IV of the *Four Books on Human Proportion.*

23

115

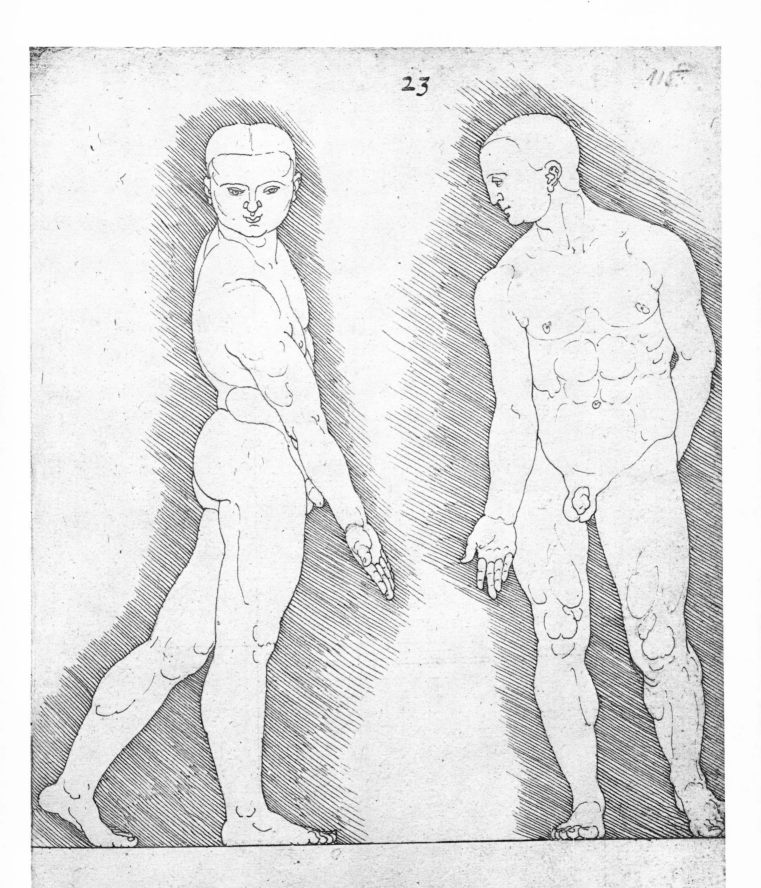

1519

79 A "peasant type man" of seven headlengths, constructed.

292 × 207 mm; 11½ × 8⅛ in.
Watermark: crossbow in circle (Meder 140).

f.111v; Br.32.
R.III.255.

Same figure as No. 77, but not in mirror image of the printed edition. Traced from the printed edition. Not by Dürer. The watermark occurs only in some posthumous impressions of Dürer's works. The handwriting is not Dürer's.

 Annotation: "A peasant type man of seven headlengths—seven heads in length."

Ein peürischen man von 7 haübt lengen

7 heüser hoch lang lan

80 A "peasant type man" of seven headlengths.

293 × 207 mm; 11½ × 8⅛ in.
Watermark: crossbow in circle.

f.114r; Br.33.
R.III.255.

Same figure as No. 78, but not in mirror image; traced from the printed edition. Not by Dürer. See remarks for No. 79.
 Annotation: "Here the construction lines are omitted."

81 A "peasant type woman" of seven headlengths, constructed.

292 × 207 mm; 11½ × 8⅛ in.
No watermark.

f.154v; Br.95.
R.III.255.

Not by Dürer, but traced from Book IV of Dürer's *Four Books on Human Proportion*. Not in mirror image of the printed edition as is the case with preparatory drawings. The handwriting is not Dürer's.

 Annotation: "A peasant type woman of seven headlengths. Seven heads in length."

82 A "peasant type woman" of seven headlengths.

292 × 207 mm; 11½ × 8⅛ in.
Watermark: crossbow in circle.

f.157r; Br.96.
R.III.255.

Not by Dürer, but traced from the printed edition of Book IV of the *Four Books on Human Proportion.* Therefore not in mirror image. The handwriting is not Dürer's.

The annotation reads: "Here the construction lines are omitted."

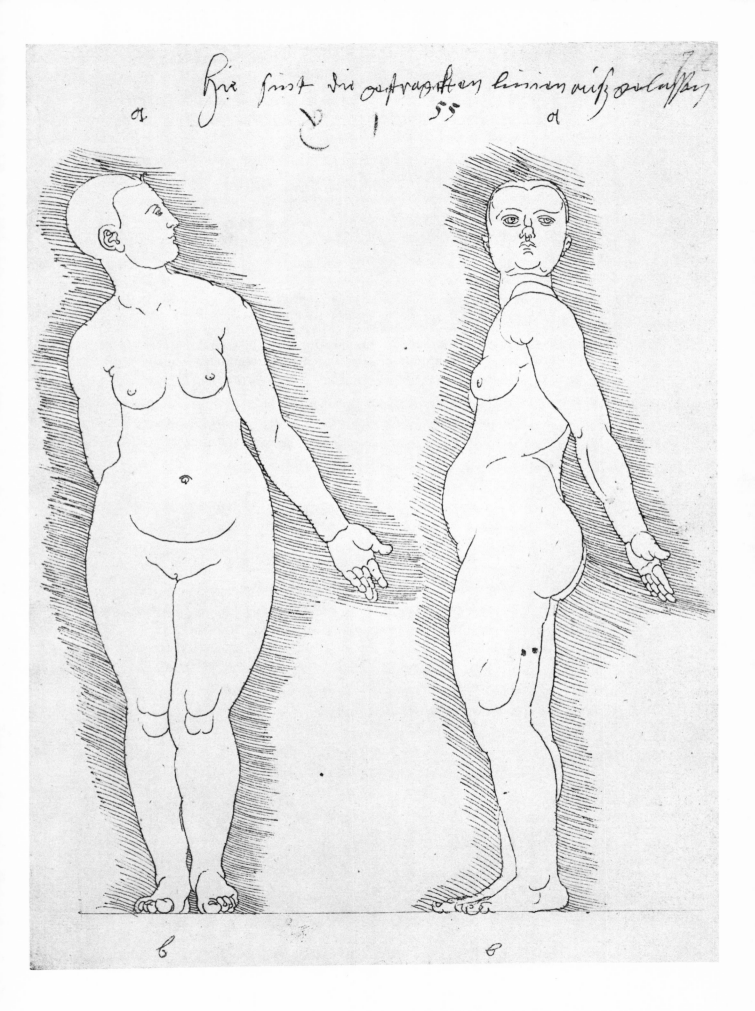

83 Woman leaning on a cane, constructed.

292 × 207 mm; 11½ × 8⅛ in.
Watermark: Cardinal's hat.

f.149r; Br.97.
R.III.139: 1515–19.

Recto, perhaps verso, of No. 84. Preparatory for Book IV of the *Four Books on Human Proportion.* The corrections and the unsteady line of the contours indicate that this drawing may have been executed by an assistant and perhaps traced from the printed edition. The watermark occurs in many of Dürer's drawings.

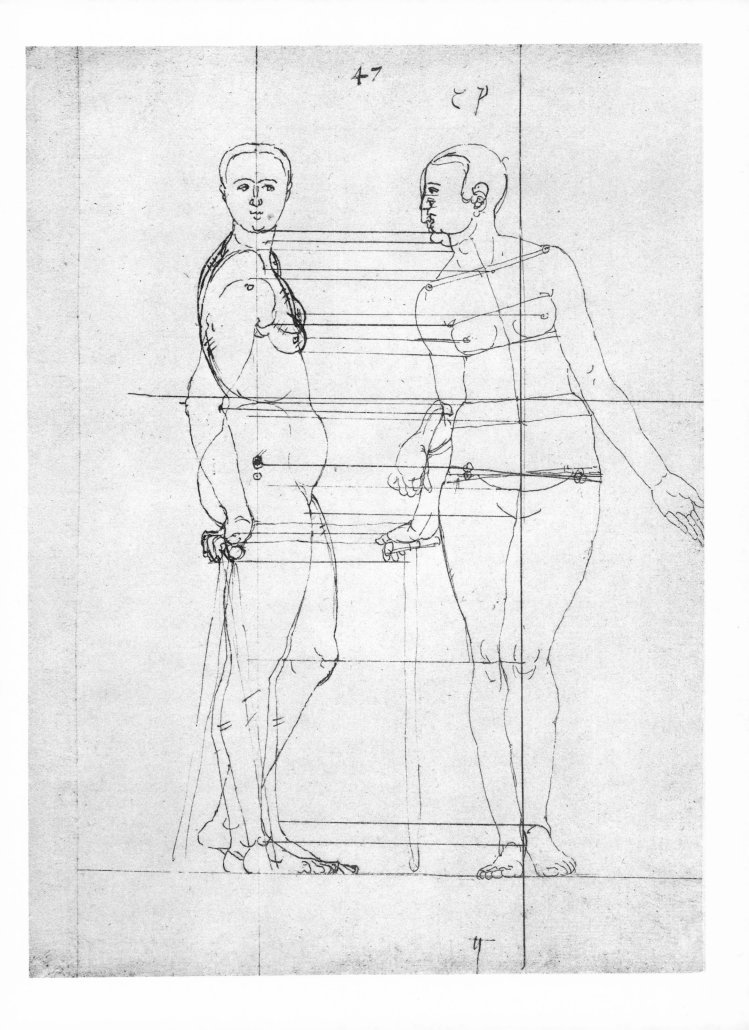

84 Woman leaning on a cane.

292 × 207 mm; 11½ × 8⅛ in.
Watermark: Cardinal's hat.

f.149v; Br.98.
R.III.139: 1515–19.

Verso, perhaps recto, of No. 83. Preparatory mirror image for Book
IV of Dürer's *Four Books on Human Proportion*. The constructed
drawing No. 83 appears to have been traced by an assistant on the
other side of this figure, the lines of construction added subsequently.
The watermark occurs on several related drawings (Sloane 5228/109,
190).

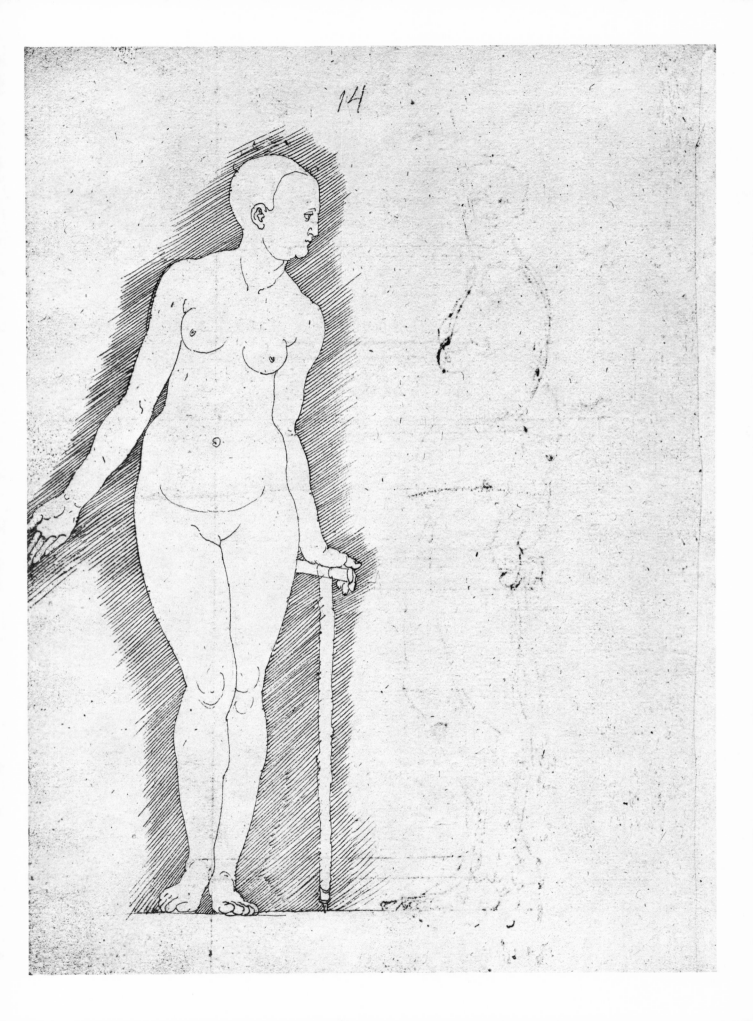

85 Man inscribed in a circle, front view.

293 × 207 mm; 11½ × 8⅛ in.
No watermark.

f.112v; Br.36.
R.III.68: After 1521.

This drawing is typical of those appearing in Book II of Dürer's *Four Books on Human Proportion*. The figures in this book are constructed by the so-called "exempeda (i.e. six feet) method." This system is described in Leon Battista Alberti's *De Statua*, based on the canon of Vitruvius that the foot is one sixth of a man's height. Dürer follows Alberti's system very closely. The body is here measured by a rod divided into ten "numbers," then subdivided into ten "parts," and further divided into three "bits."
Exactly when Dürer became familiar with this system is not established. A short tract based on Alberti's writings was published in Nuremberg in 1511 under the title *Das Buch von der Malerei*. A copy of a manuscript of Alberti's was brought to Nuremberg by the astronomer Regiomontanus, who had cast Alberti's horoscope. It eventually found its way into Dürer's possession in 1523. The watermarks of the paper of the preparatory studies for Book II, many of which are preserved at London, indicate that Dürer worked on these prior to his journey to the Netherlands in 1520–21. Watermarks which are typical of the years after this journey, such as the coat-of-arms of Burgundy and a crowned crest with the fleur-de-lis and an attached *b*, do not occur on any of these sheets.

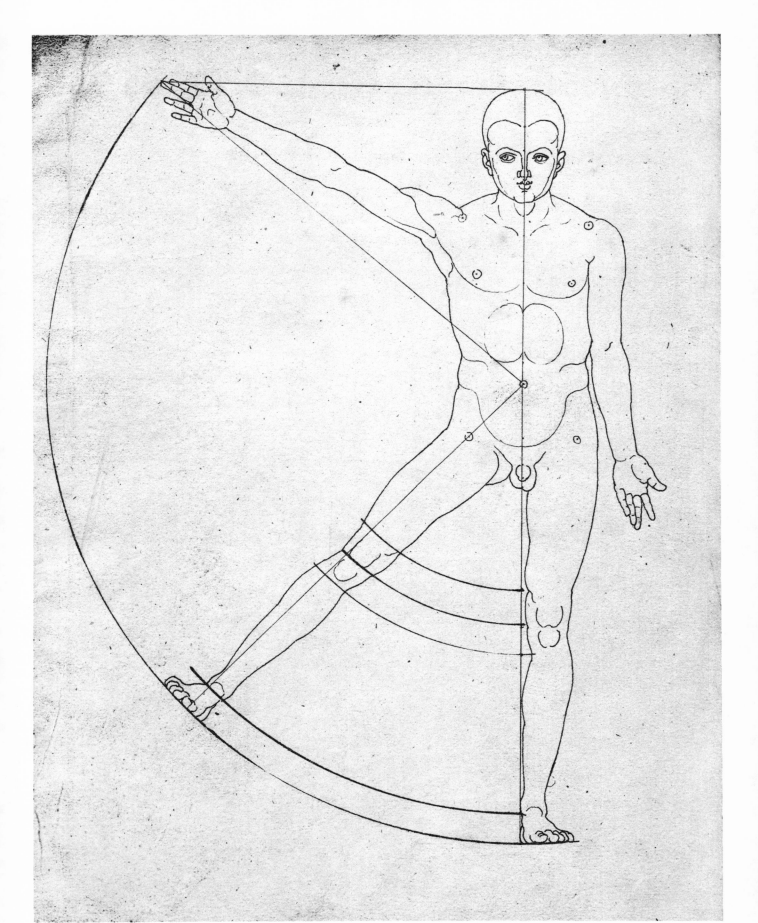

86 Man inscribed in a circle, seen from behind.

293 × 207 mm; 11½ × 8⅛ in.
No watermark.

f.113r; Br.37.
R.III.68: After 1521.

Remarks as for No. 85.

87 Man with arm extended; elderly man in profile.

293 × 207 mm; 11½ × 8⅛ in.
No watermark.

f.108v; Br.29.
T.472: About 1511.
P.1082: 1520–21, rather than about 1511. Style like W.752.

The figure is closely akin to Nos. 85 and 86. The identity of the elderly man has not been established. Bruck saw a resemblance to Pirckheimer. Springer suggested Emperor Maximilian. The style of the drawing is closely akin to Dürer's sketchbook of his journey to the Netherlands in 1520–21.

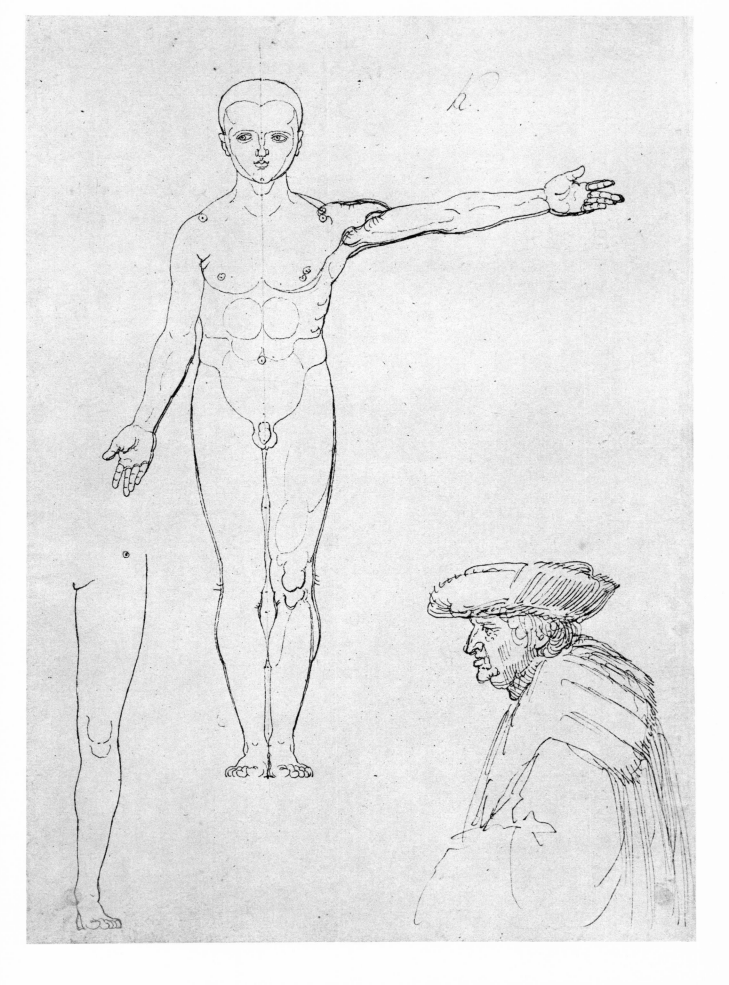

88 Two men of nine headlengths, constructed.

250 × 190 mm; 9¾ × 7½ in.
No watermark.

f.129r; Br.22.

Recto of No. 89. This figure forms a group with the three following drawings. The proportional divisions are indicated by dots. Perhaps based on Alberti, if so 1523. (Cf. No. 89.)

33

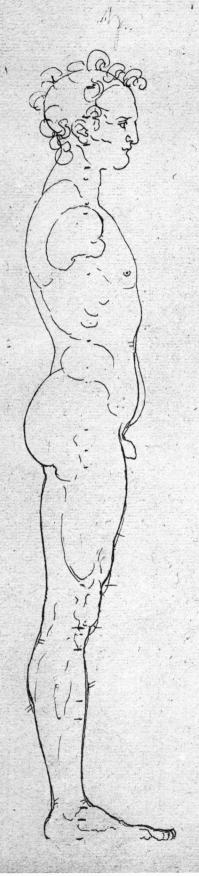
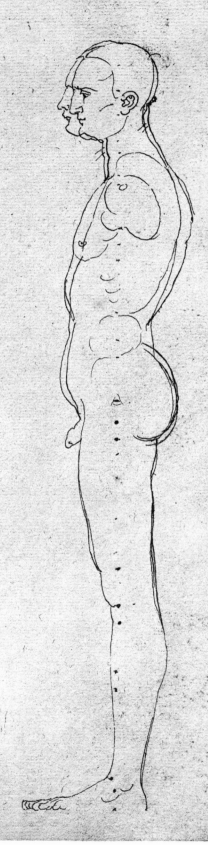

89 Two men in profile, nude and dressed.

250 × 190 mm; 9¾ × 7½ in.
No watermark.

f.129v; Br.23.
T.469: About 1511.
P.1623: About 1523, rather than about 1511.

Contours of No. 88 traced on the verso. Probably drawn in 1523. The costume is superimposed on the outline of the nude figure. Tietze quotes Alberti's instructions: "First draw the man in the nude, then add the garments" (cf. remarks for No. 85).

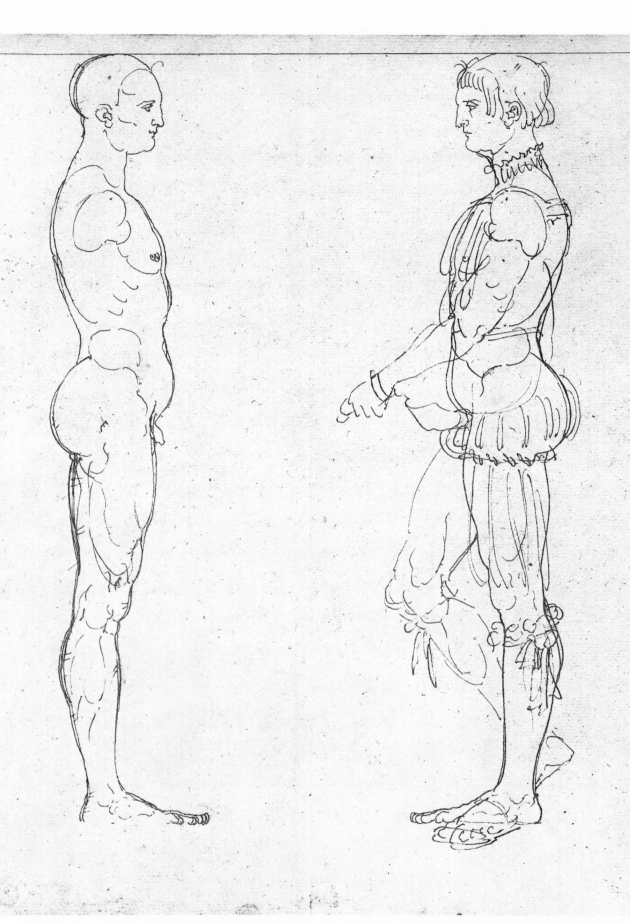

90 Two men of nine headlengths, constructed.

259 × 194 mm; 10⅛ × 7⅝ in.
No watermark.

f.116v; Br.38.
R.II.16: Not by Dürer.

Verso of No. 91. About 1523. The proportional divisions are indicated by dots as on No. 88.

 Inscribed:
 "9 Headlengths.
 Top of head.
 Chin.
 Shoulder.
 Low point of the neck.
 Armpit.
 Nipple.
 On the chest.
 Waist.
 Navel.
 Hip.
 Penis.
 Buttocks.
 Crotch.
 Groin.
 Outside.
 Inside.
 Center of the knee.
 Outside.
 Inside of calves.
 Ankle.
 Anklebone.
 Sole."

Closely akin to Nos. 88 and 89. Rupprich's rejection of the authenticity is hard to reconcile with the acceptance by Tietze and Panofsky of the authenticity of Nos. 88 and 89.

91 Two men of nine headlengths, tracing.

259 × 194 mm; 10⅛ × 7⅝ in.
No watermark.

f.116r; Br.39.
R.11.16: Not by Dürer.

Contours of No. 90 traced on the recto. The curly hair as in Nos. 88 and 90.

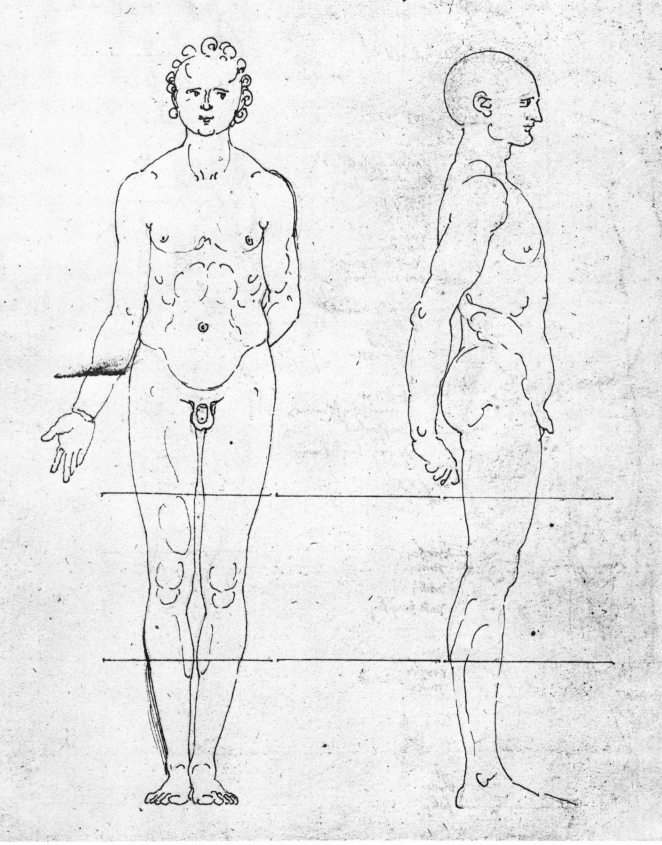

z4

92 Man of eight headlengths, one arm extended.

268 × 184 mm; 10½ × 7¼ in.
Watermark: trident.

f.134v; Br.55.

Verso of No. 42. This and the following two drawings are partial sketches.

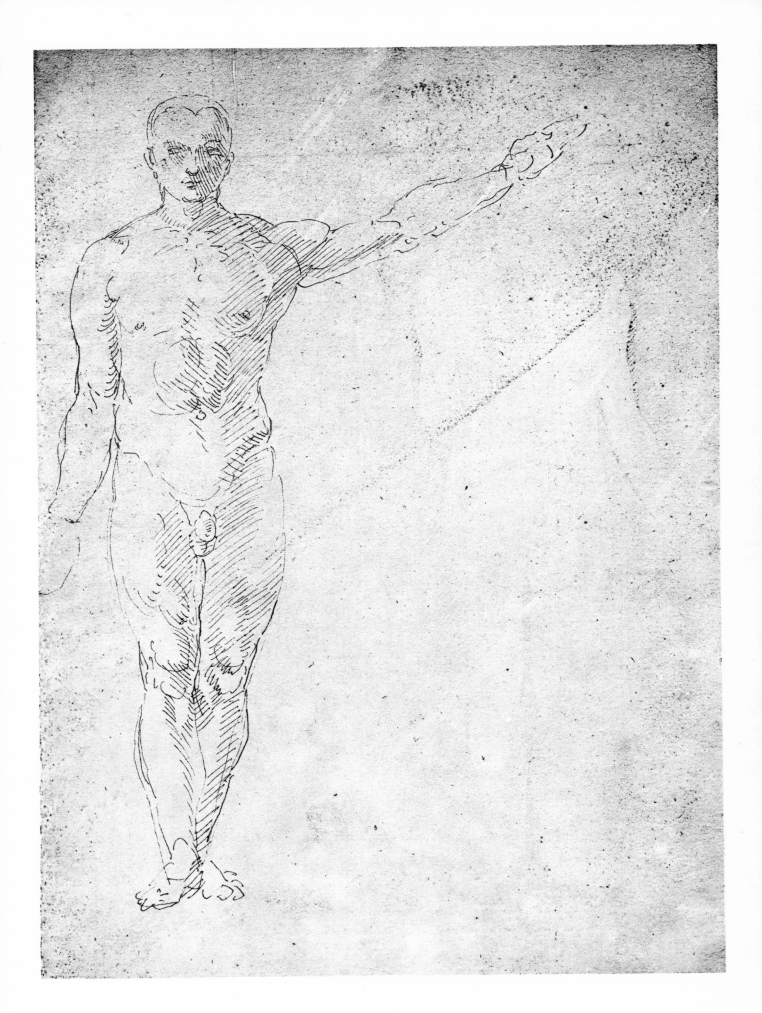

93 Part of a nude woman.

257 × 183 mm; 10⅛ × 7⅛ in.
Watermark: Waterwheel with letter P (Briquet No. 13450, Meder
 No. 175).

f.159v; Br.102.

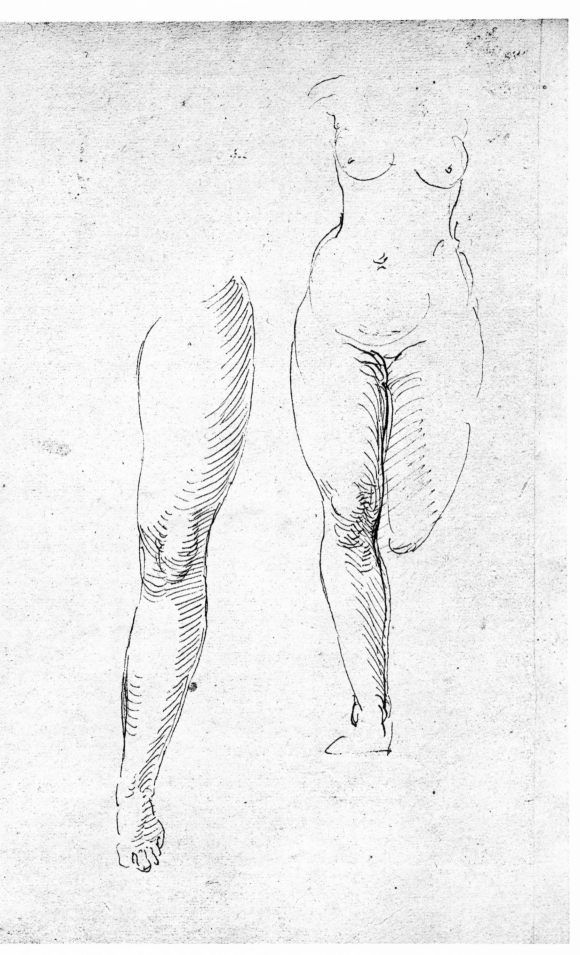

94 Part of a woman, seen from behind.

202 × 137 mm; 8 × 5⅜ in.
No watermark.

f.136r; Br.69.
R.III.157.

Recto of No. 102.

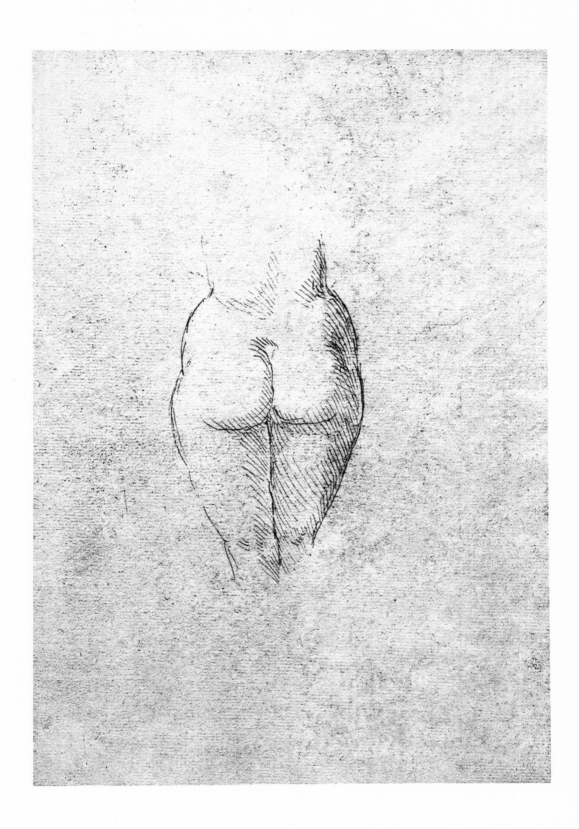

95 Nude seen from behind; legs; stereometric man.

293 × 207 mm; 11½ × 8⅛ in. (in this case the total sheet size is
 given).
Watermark not discernible.

f.166v; Br.101.
R.III.158: About 1515.

Verso of No. 146. Two small sheets of paper pasted onto a larger
one. The stereometric drawing must be dated after 1521, probably
1527, because of the watermark of the paper used for the related
drawings (cf. No. 96).

 Inscriptions:
 Beneath the nude seen from behind: "This back is fine."
 Beneath the stereometric drawing: "The diameter of the cube
 is based on three."

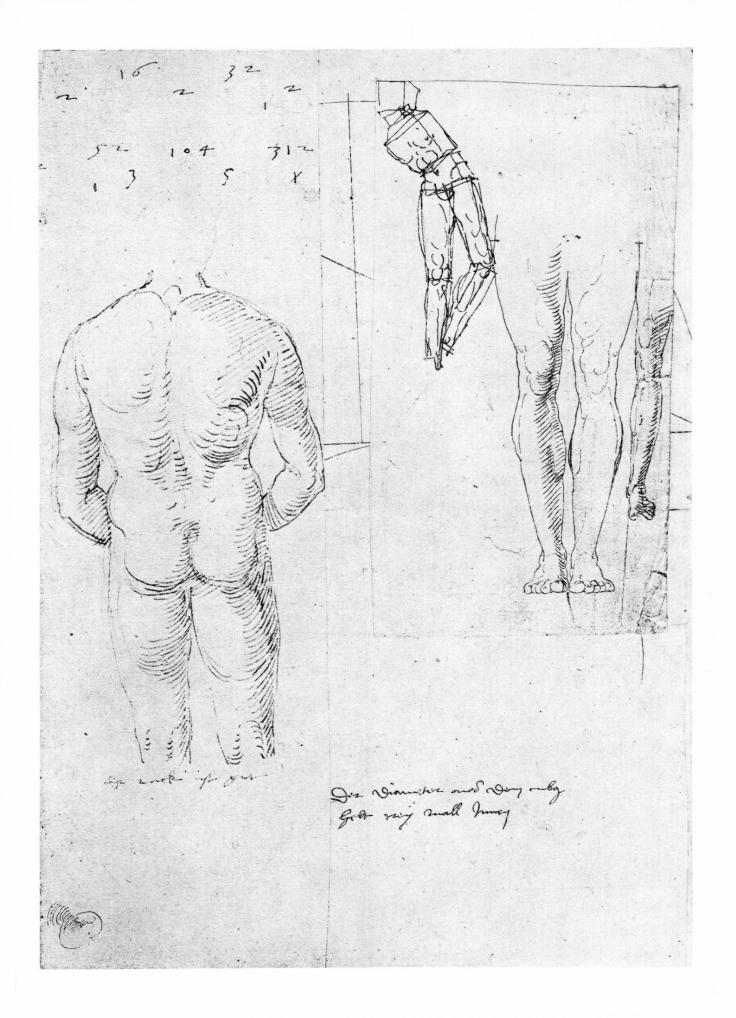

96 Stereometric man; jointed mannequin.

293 × 208 mm; 11½ × 8⅛ in.
Watermark: crowned coat-of-arms with attached *b*.

f.143r; Br.62.
P.1656.
R.III.157: Before 1519.

Recto of No. 103. This drawing forms part of a group of stereometric constructions preparatory for the final section of Book IV of Dürer's *Four Books on Human Proportion*. Dürer died before he could complete this section. The final pages were edited by his friend Pirckheimer with only a fragmentary text.

This particular drawing shows the transition from Dürer's sketches of jointed mannequins (W.929, W.931), dated 1526 on paper with the same watermark. Probably to be dated 1527.

Rupprich is mistaken in dating this drawing before 1519. Dürer began using paper with this watermark only during his journey to the Netherlands, 1520–21, and continued using it until his death (Meder, watermark No. 314; Heller, p. 46; Hausmann, p. 129).

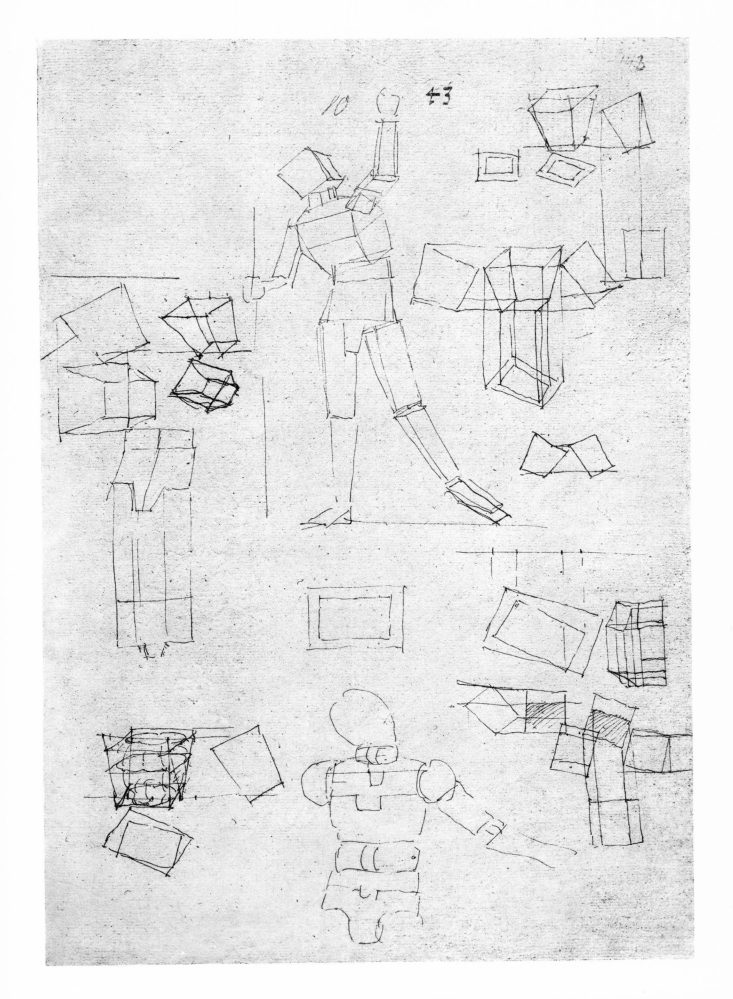

97 Stereometric man.

215 × 135 mm; 8⅜ × 5¼ in.
No watermark.

f.137r; Br.65.
P.1654: Probably about 1523.
R.III.158: 1519 or thereafter.

Recto of No. 98. About 1527. Remarks as for No. 96. Closely akin to Sloane 5218/115 (W.654). The seal in the upper right-hand corner is the collector's stamp of Cornill d'Orville of Frankfurt/M. This drawing was for a great number of years in his collection but has since been returned to Dresden. According to a kind communication from Helmut Deckert of the Sächsische Landesbibliothek, a second version of this drawing was formerly attached to folio 160.

Inscribed: "Nicklas am Rossmargt" (Nicholas at the Horse Market). A Niklas Dürr lived at that address, now Adlerstrasse, in Nuremberg, during Dürer's time.

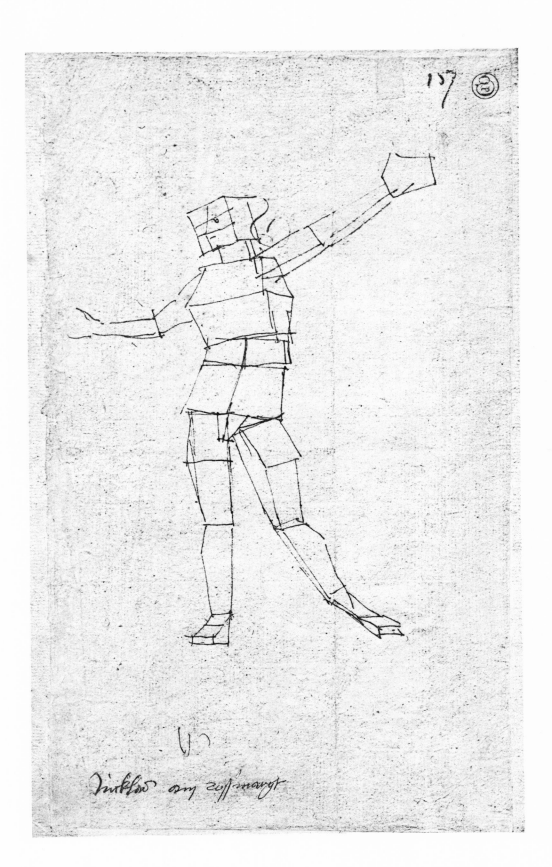

98 Letter to Wolff Stromer.

70 × 200 mm; 2¾ × 7⅞ in.
No watermark.

f.137v; Br.15 (bottom).
R.I.83, R.III.436.

Verso of No. 97. Translation:

"Dear Herr Wolff Stromer: My gracious Lord of Salzburg has
sent me a letter carried by his glass painter. I shall be glad to be of
service to him, as he is to purchase glass and materials here. He
told me that near Freystadt he was robbed and had 20 guilders taken
from him. He has asked me to direct him to you, as his gracious
Lord has instructed him to get in touch with you, in case he needed
anything. I am sending him to your Wisdom with my servant. With
respects,

 Your humble
 A. Dürer."

Stromer (1471–1552), a member of a well-known Nuremberg
family, was in the service of Cardinal Matthaeus Lang of Salzburg,
the Imperial Chancellor.

Libe her wolff stromer mein gnedigster her von salczburg hat mir bey seim glas maler
ein brief zu geschikt. was Jch Jm fürderlich bey sein weil Jch gern thon den es
sol Jm glas vnd zeug kauffen So zeigt er mir an wÿ er beim Schürstettleÿn
beczalt vnd Jm 2 · fl genomen seÿ worden hat an mich begert Jch sol Jm zu
euch weisen den seÿ B · h · hab Jm befolhen so er etwas bedarff sol ich ewch ewch
langen lassen bey scheik Jch mit meinem knecht zu euch weshir befilch euch gott

E · w ·
A · dürer

99 Stereometric man; drapery study.

293 × 207 mm; 11½ × 8⅛ in.
No watermark.

f.138v; Br.66.
R.III.157: About 1519.

Verso of No. 137. Variation of Nos. 96 and 97.

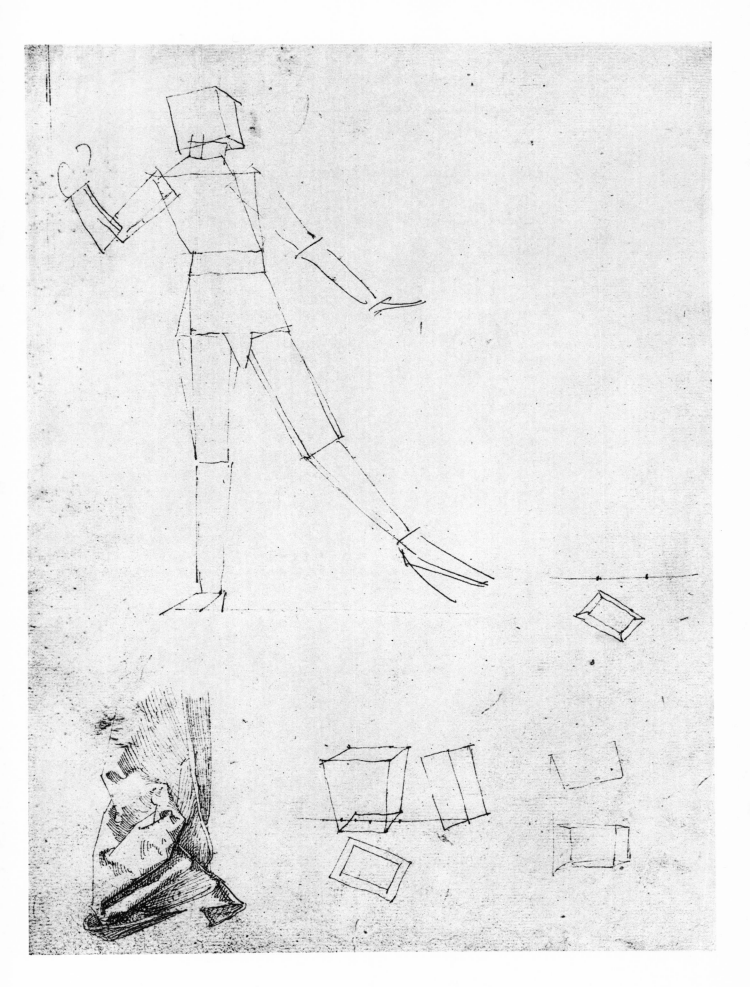

100 Stereometric man; thirteen cross sections of the body.

290 × 203 mm; 11⅜ x 8 in.
Watermark: small jug.

f.144v; Br.63.
P.1655: Probably about 1523.

Verso of No. 101. Probably 1527. The cross sections at various levels of the body are preparatory for illustrations in Book IV of the *Four Books on Human Proportion*.

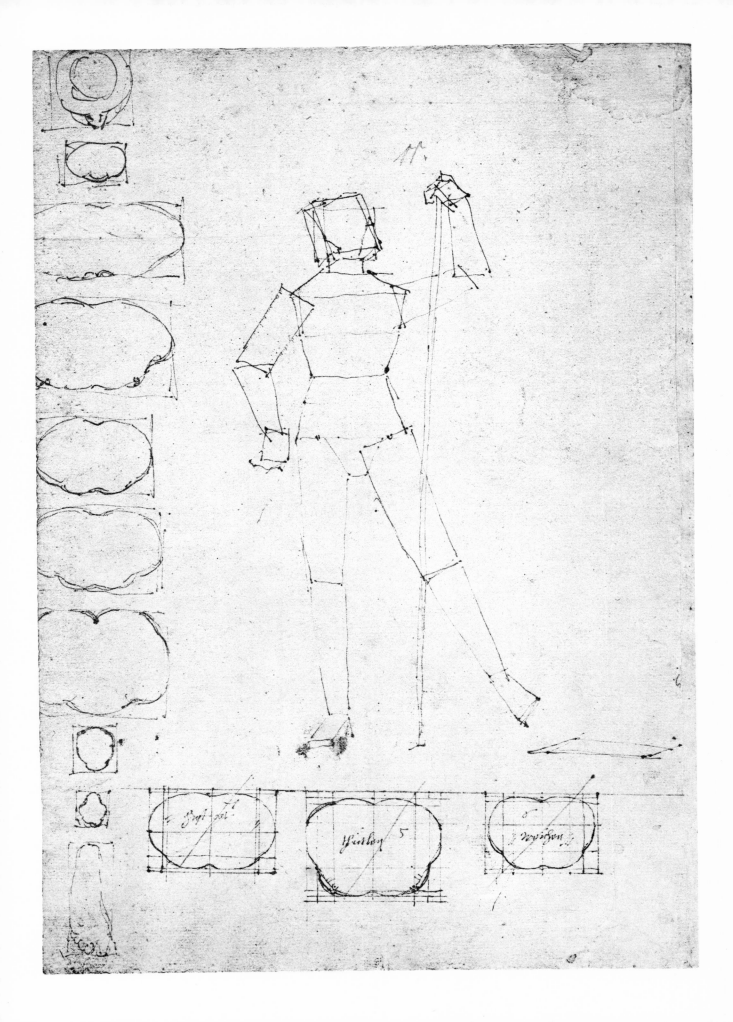

101 Stereometric man; two body sections.

290 × 203 mm; 11⅜ x 8 in.
Watermark: small jug.

f.144r; Br.61.
R.III.157: Before 1519.

Recto of No. 100. The stereometric construction is here, for the first time, drawn with the help of a ruler. The superimposed cross sections of various levels of the body represent an improvement over the early sketch on No. 12.

 Inscribed:
 "Chin.
 Shoulder level.
 Low point of the neck.
 Nipple.
 Waist.
 Hip.
 Ankle.
 Ankle bone.
 Sole."

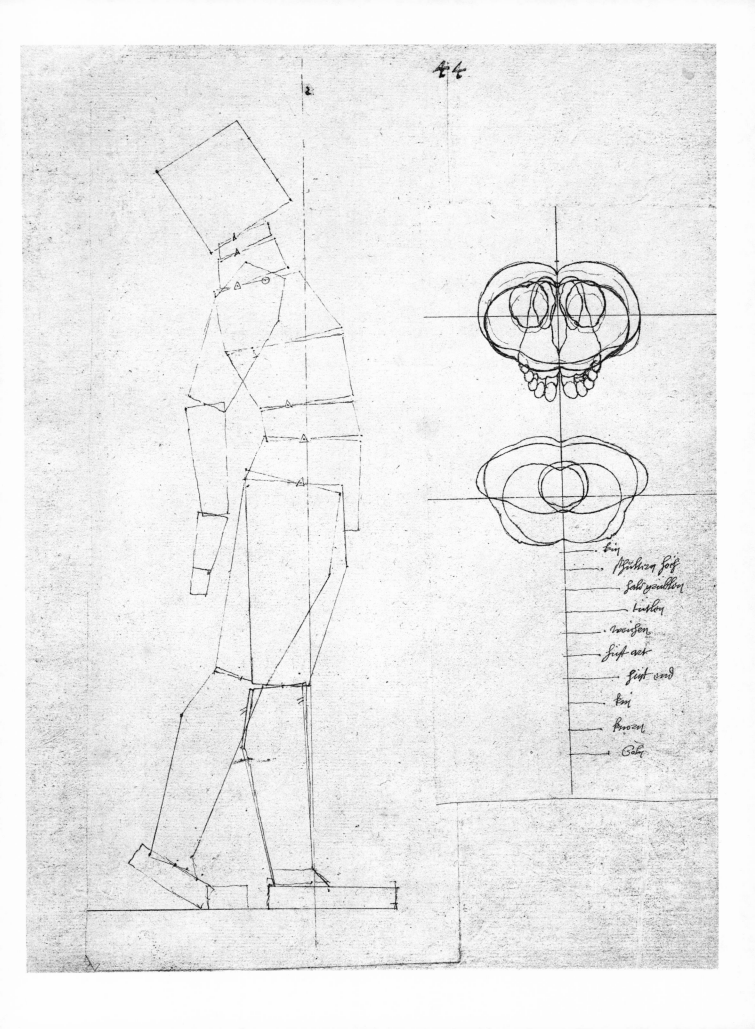

44

 hin
Schrittlicher Hals
Halsgrüblen
luxben
wichen
Hüft art
Hüft end
kni
knozn
Gohr

102 Stereometric man.

290 × 203 mm; 11⅜ × 8 in. (in this case, total sheet size).
No watermark.

f.136v; Br.64.
R.III.157: Before 1519.

Verso of No. 94. Probably 1527. The figure, drawn with the help of a ruler, is on a separate sheet of paper, pasted onto the larger one which has an identical figure drawn freehand. Closely akin to the drawing at London, Sloane 5218/115 (W.654).

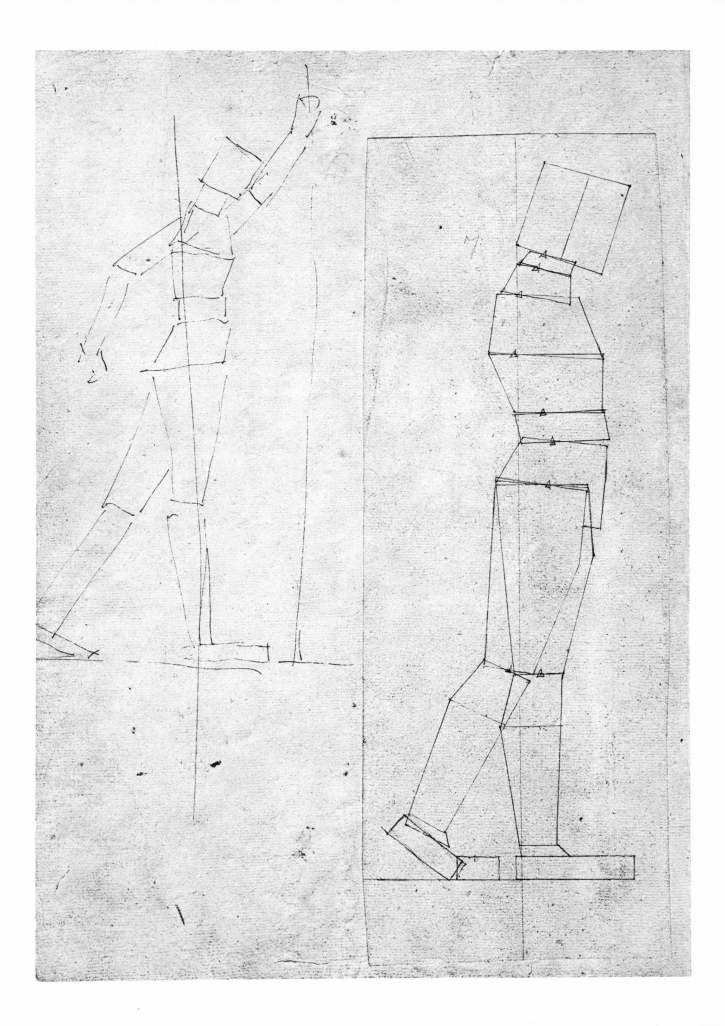

103 Stereometric man, with text.

293 × 208 mm; 11½ × 8⅛ in.
Watermark: crowned coat-of-arms with attached *b*.

f.143v; Br.60.
R.III.157: Before 1519.

Verso of No. 96. Probably 1527. Ruler drawn.

Text: "At first, position two cubes as the two sections of a man you wish to draw. First as seen from the front and then draw it in profile. Then use the same type of cubes and place them in profile next to the former, seen from the front or from behind. You will be able to transfer the position to another position by means of horizontal lines and compare one with the other. You will then be able to see the rectangular surfaces from all sides which can be circumscribed with the contours of the body. Once this is done, the two cubes seen from the front can be moved along their joints. But wherever they join, the contours of the body, if these are added, must be divided. In the same manner as I have done here with two cubes, I proceed with an entire figure, likewise divided throughout, as shown in the following."

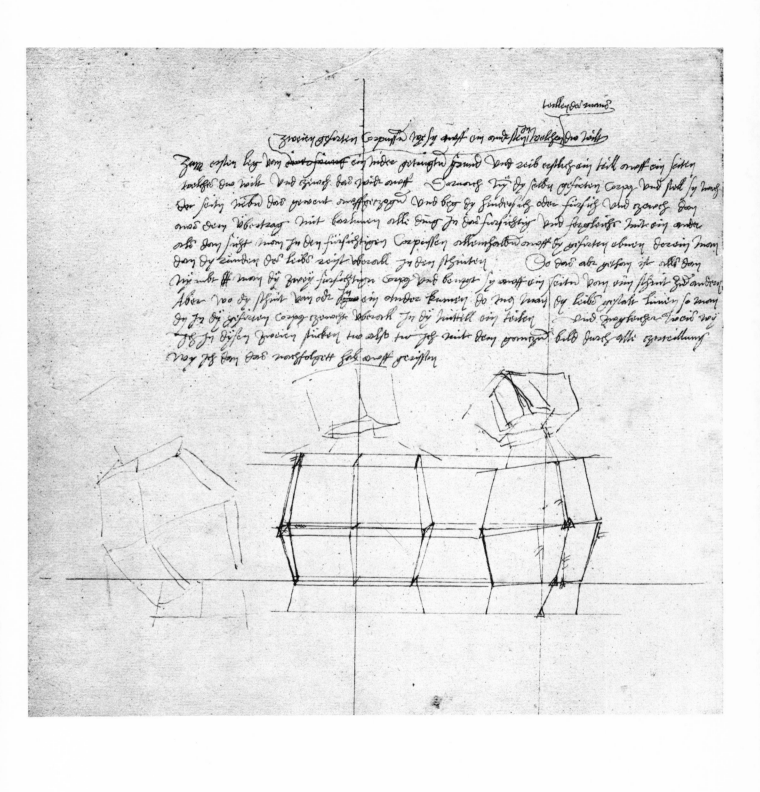

104 Stereometric man, front view, profile, ground plan.

293 × 207 mm; 11½ × 8⅛ in.
No watermark.

f.141r; Br.58.
R.III.261.

Preparatory drawing, perhaps fair copy, for the illustration in Book
IV of the *Four Books on Human Proportion.*

In the printed edition Dürer remarks in connection with this illus-
tration that "this method may be useful for sculptors beginning to
learn this craft who intend to cut a figure from wood or stone. In
order to copy a figure exactly they can chop away from the square
surfaces what is necessary, without cutting off too much or leaving
too much. But an experienced craftsman will not require this in
every case, unless his project is very large."

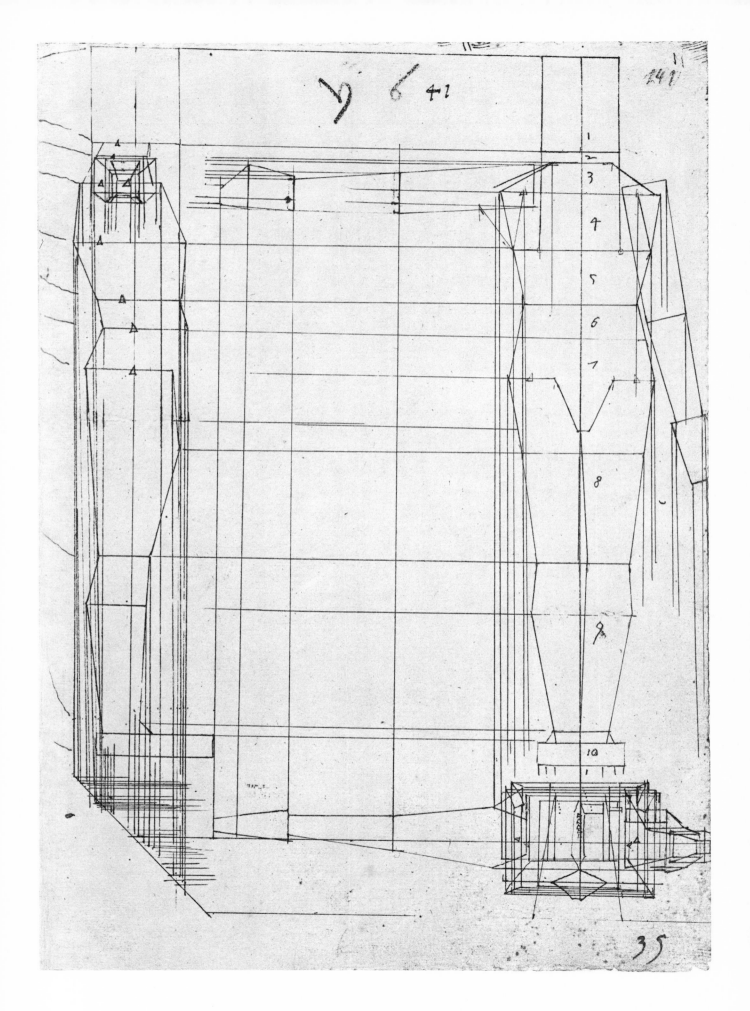

105 Stereometric man, contours.

293 × 208 mm; 11½ × 8⅛ in.
Watermark: crowned coat-of-arms with attached *b*.

f.142r; Br.59.
R.III.147: To be dated 1515–19.

Preparatory for No. 106. Probably 1527. (Cf. No. 96.)

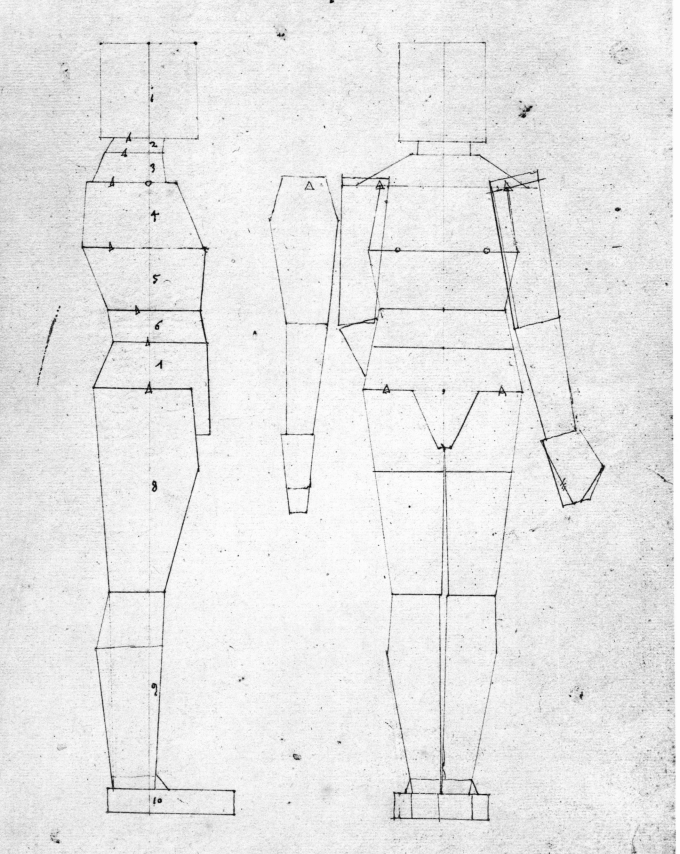

106 Male figure circumscribed by stereometric contours.

293 × 208 mm; 11½ × 8⅛ in.
No watermark.

f.139r; Br.56.
R.III.147: To be dated 1515–19.

Preparatory for Book IV of the *Four Books on Human Proportion*,
superseded by No. 107. Probably 1527.

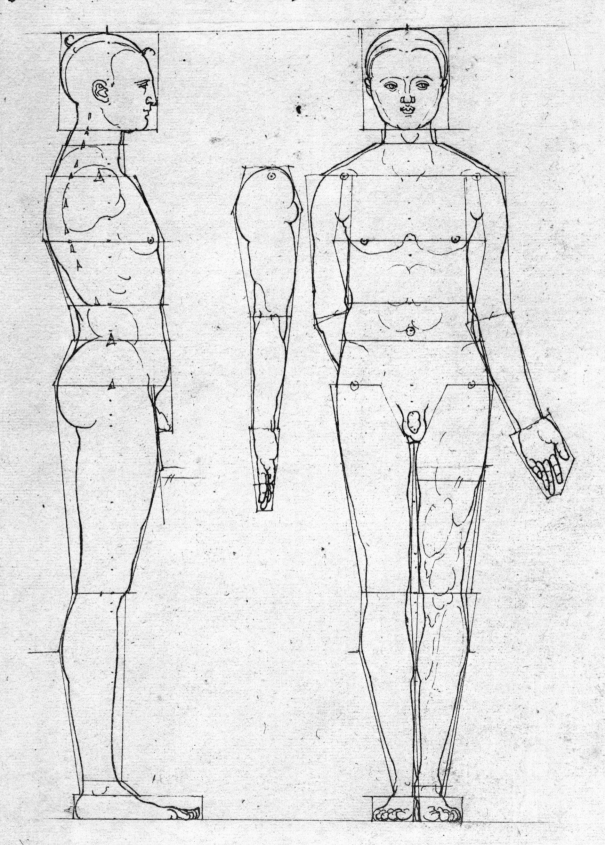

107 Male figure circumscribed by stereometry.

293 × 208 mm; 11½ × 8⅛ in.
Watermark: star in circle.

f.140r; Br.57.
R.III.261.

Fair copy for the illustration in Book IV of the *Four Books on Human Proportion*. Based on Nos. 105 and 106.

40.

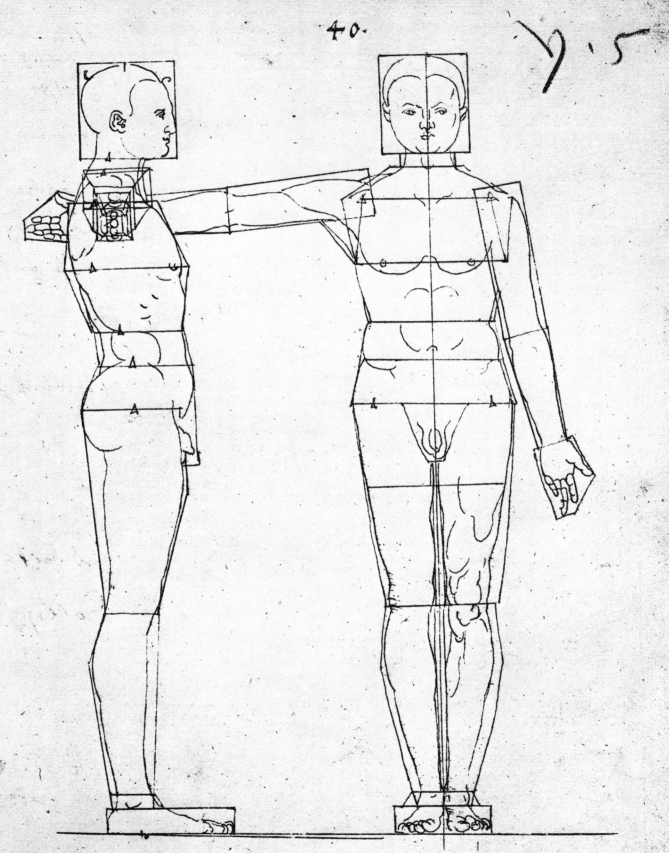

108 Stereometric outline of the neck; quarry.

292 × 207 mm; 11½ × 8⅛ in.
No watermark.

f.176v; Br.127.
R.III.154: Before 1519.

Verso of Nos. 135 and 159. Preparatory for Book IV of the *Four Books on Human Proportion*. Probably 1527. Drawings of other parts of the body for this final section of Book IV are on paper with the watermark depicting a coat-of-arms with an attached *b,* indicative of a later date than that suggested by Rupprich (cf. No. 96).

Inscribed on the margin: "Jacob Keser" (cf. No. 152).

Text: "Then take another cube in which the neck is to be placed and follow the procedure indicated above for the head. But incline it a little less. Likewise, turn it a little toward the right, and bend it a little less to the right than the head. Mark the four corners on top A B C D and the ones at the bottom 1 2 3 4. Then you will see them in cross section and built up from their ground plans in D E. Proceed likewise with other cubes, always bending the lower one less than the upper one. Also turn the lower one less toward the right in each case than the upper one, so that they are all skillfully placed one on the other. When you get to the part between the breast and the waist, let it be in a vertical position, but turn it slightly to the right, properly positioning it."

Related drawings: London, Sloan 5229/109; 5231/120, 121, 139, 159, 160–170. Nuremberg, City Library, Cent. V., App. 34/54–57.

The parallel shading of the rocky landscape appearing on the right is akin to that in the engraving "St. Philip" (Bartsch 46), dated 1526.

109 The head constructed by means of the "parallel method."

295 × 206 mm; 11½ × 8⅛ in.
No watermark.

f.91v; Br.117.
P.1674: Probably 1507.

Verso of No. 110. About 1507. Probably copied from an Italian model. The features of the head are here transferred from the front view to its profile, and then to its ground plan by means of parallel lines. This method is described by Piero della Francesca in his *Prospectiva pingendi.* In later drawings Dürer used an improved system, the "transfer method."

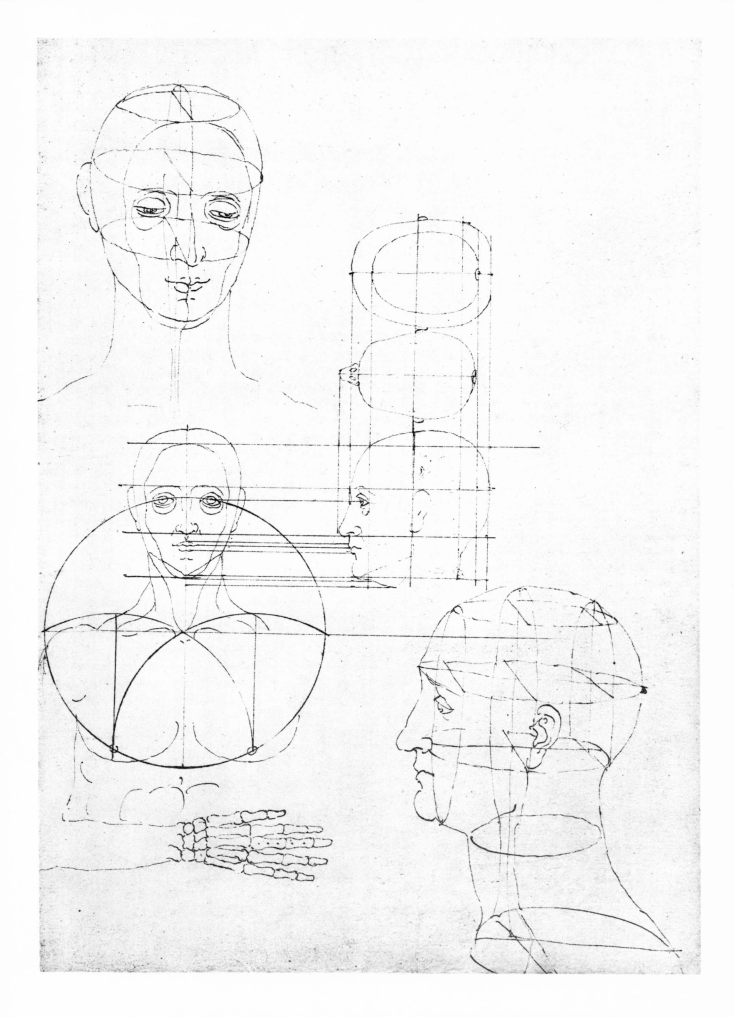

110 The head constructed by means of the "transfer method."

295 × 206 mm; 11½ × 8⅛ in.
No watermark.
Dated 1512.
With Dürer's monogram.

f.91r; Br.116.
R.II.304.

This drawing on the recto of No. 109 is apparently a later addition. It is based on the "transfer method" *(Übertrag)*. A triangular grid is used to "reflect" each measurement at right angles from its original plane. The origin of this system is still undetermined. The use of a simple grid for the transfer of designs is already described in *Geometria Deutsch*, which was published before 1490. The method was also known to Pacioli. This drawing was used in Book I of *Four Books of Human Proportion*, Nuremberg, 1528, with the rear view of the head inserted in the empty rectangle.

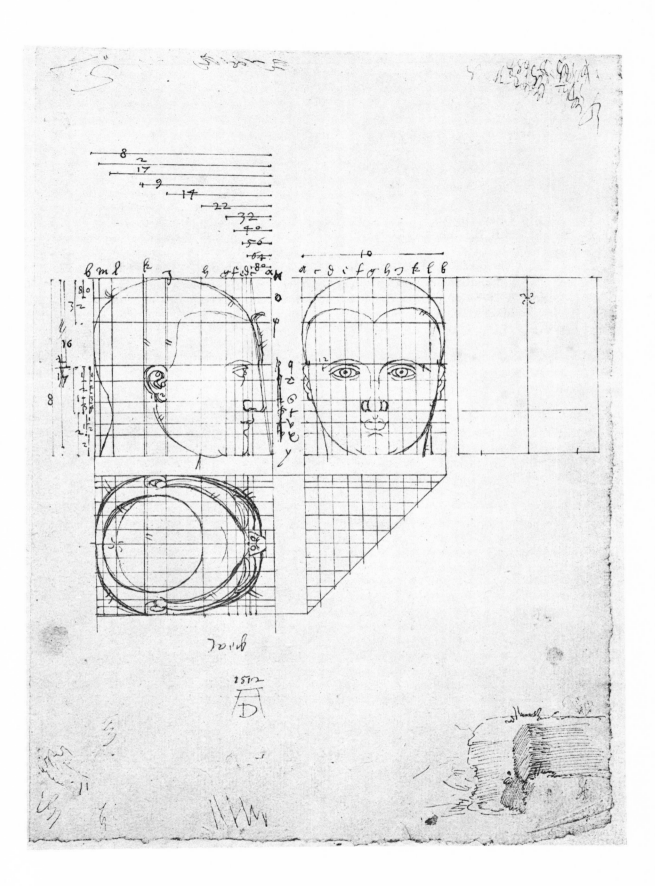

111 Four constructed heads.

294 × 206 mm; 11½ × 8⅛ in.
No watermark.

f.92v; Br.118.
R.II.51: About 1506–08.

Verso of No. 112. Experimental drawing related to Nos. 110 and 112.
 Notation on right margin at lower left: "3 equal parts."
 Notation below the head at lower left: "1/18th of the entire length."

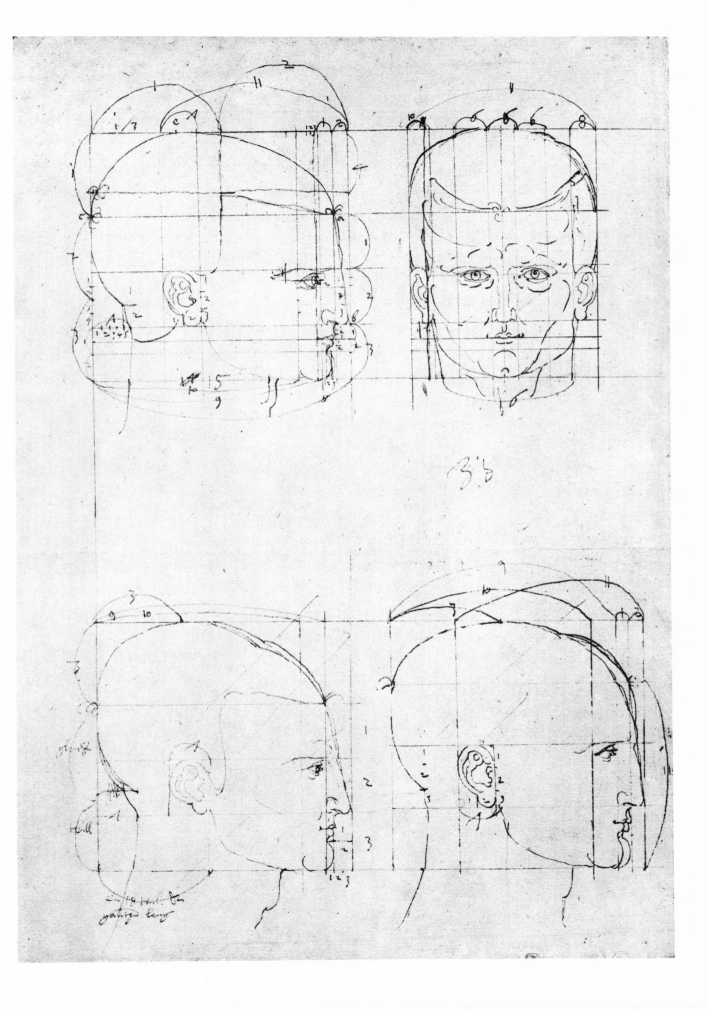

112 Six heads.

294 × 206 mm; 11½ × 8⅛ in.
No watermark.

f.92r; Br.119.
R.II.51: About 1506–08.

Partial tracing on the recto of No. 111.

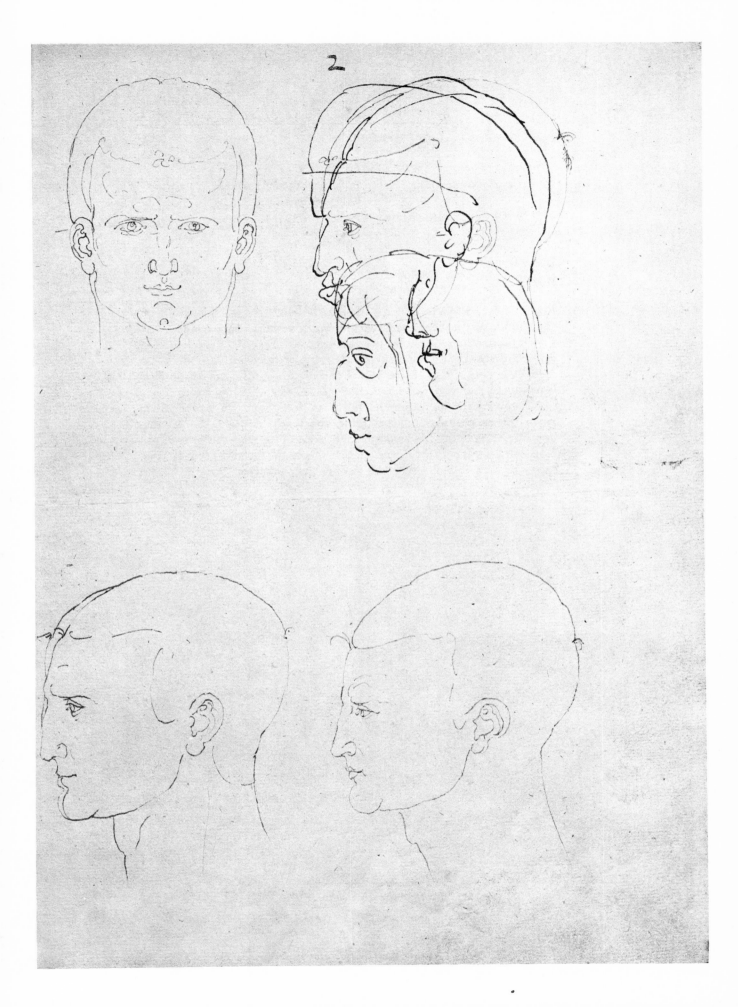

113 The head constructed by means of the "transfer method."

291 × 201 mm; 11⅜ × 7⅞ in.
No watermark.

f.93r; Br.120.
R.II.294: 1512–13.

Recto of No. 114. Inscribed: "If you desire to reduce the width of the profile of the head, remove the width *gl* and bring *g* and *l* together on one line. Thereby the ear is moved closer to the eye. Also draw the cheekbone accordingly and reduce the width of the neck below the chin. Also condense the top of the head. Everything else leave alone and you will have changed the shape of the head.

"If you desire to widen the head, as seen from the front, then move the ears further apart, adding one tenth of the width on the line of the point of the hair. Leave everything else the way it is. Now turn the sheet over and you will see the head traced on the other side, as it looks without the construction lines."

3

3/6/xxvii

8
9
10
15
11
14
11
11
12
12
11

10
16

8

2

1

3

m
n
o
p
q

114 Six heads; a head seen from below.

291 × 201 mm; 11⅜ × 7⅞ in.
No watermark.

f.93v; Br.121.
R.II.294: 1512–13.

Partly traced on the verso of No. 113.

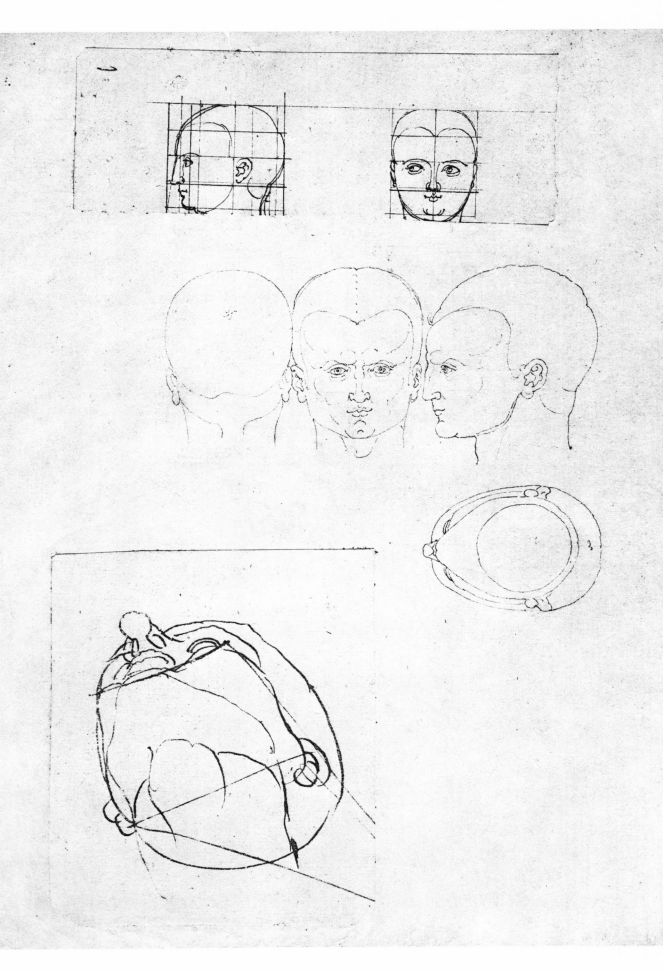

115 Six constructed heads, studies in physiognomy.

294 × 206 mm; 11½ × 8⅛ in.
Watermark: crowned snake.

f.101r; Br.124.
R.III.234.

Recto of No. 116, which see. About 1526–27. Fair copy for Book III of the *Four Books on Human Proportion*.

10 C.

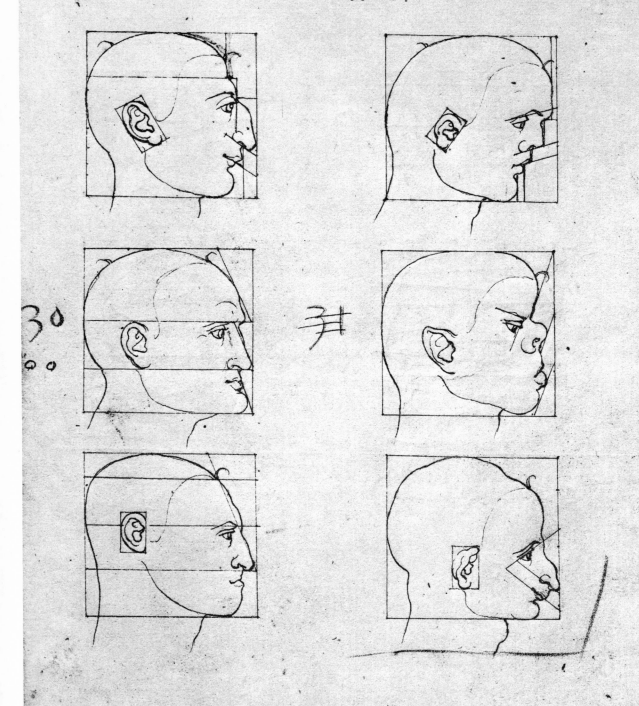

116 Four constructed heads; two faceted heads; St. Peter.

294 × 206 mm; 11½ × 8⅛ in. (total sheet size).
Watermark: crowned snake.

f.101v; Br.125.
T.732.
P.839.
R.III.142.

Verso of No. 115. About 1526–27. The four studies in physiognomy, constructed by introducing oblique lines into the constructional grid, are preparatory for Book III of the *Four Books on Human Proportion*.

The two faceted heads and St. Peter are on a separate sheet of paper, dated 1519, pasted onto the bottom of folio 101v.

These faceted heads were not used in the printed edition. The cubistic impression is akin to that of the cityscape in the background of Dürer's engraving "St. Anthony" (Bartsch 58), also dated 1519.

The sketch of St. Peter, identified by the large key, may have been intended for use in an engraving to continue the series of Apostles begun in 1514 (Bartsch 48 and 50).

The upper part of this sheet is drawn in black ink, the lower part in brown ink.

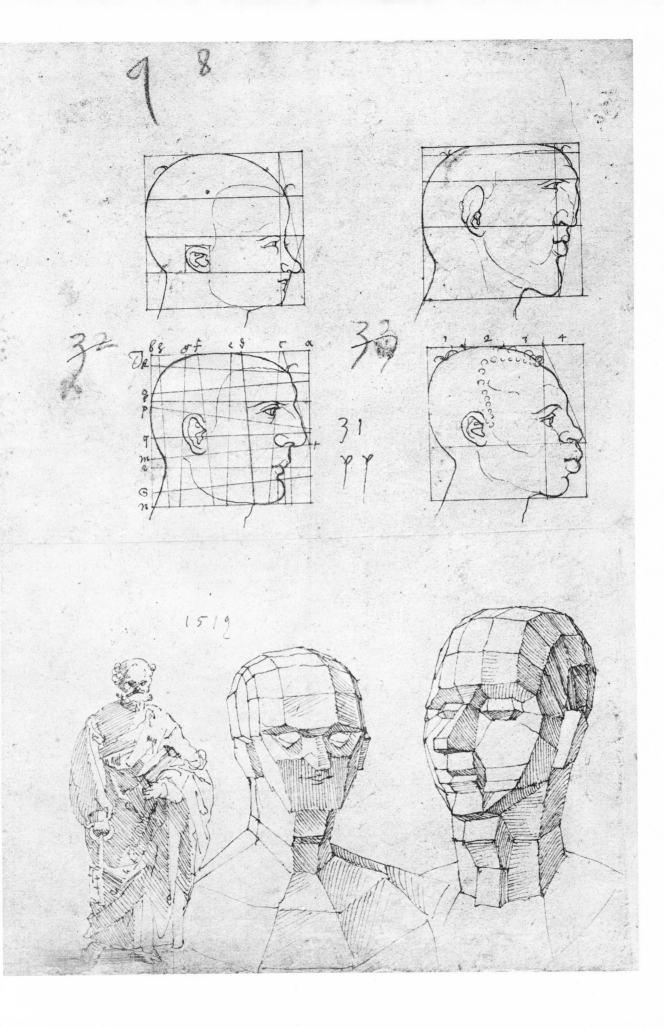

117 Fifteen constructed heads, studies in physiognomy.

292 × 206 mm; 11½ × 8⅛ in.
No watermark.

f.94r; Br.122.
R.II.472: 1513–15.

Recto of No. 118. Preparatory study of uncertain date for Book III of the *Four Books on Human Proportion*. Drawn in brown ink with corrections in grey ink.
 Related to the drawings at London, Sloane 5231/82, 83.

Inscribed:
"This is the first conversion by means of only three horizontal lines.
This is the second conversion [behind it].
This is the third conversion, opposite to the preceding one.
This is the fourth conversion [above it].
This is the fifth conversion, opposite to the preceding one [below it].
This is the sixth conversion.
This is the seventh conversion, opposite to the preceding one [straight].
This is the eighth conversion [behind and above the ear].
This is the ninth conversion, opposite to the preceding one [slanted ear].
This is the tenth conversion [long].
This is the eleventh conversion, opposite to the preceding one [short].
The twelfth conversion.
The thirteenth conversion, opposite to the preceding one.
The 15th square is provided for you so that you can draw lines according to your whim. Keep it to the end.
The 14th square."
Notations in square brackets pertain to the ears.

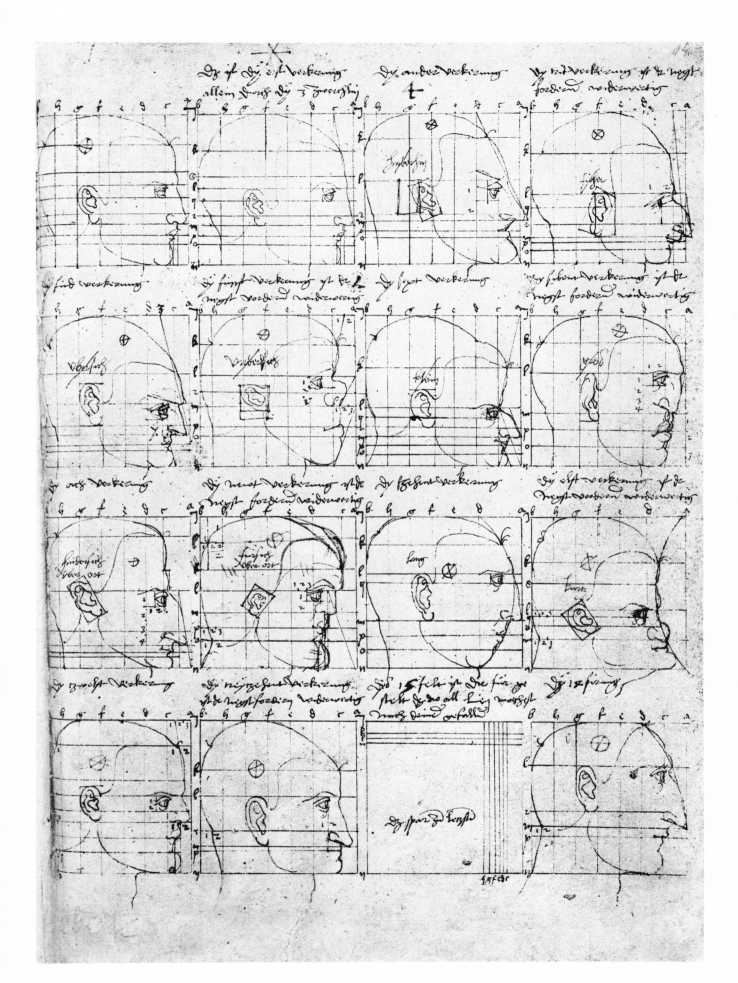

118 Fifteen heads, studies in physiognomy, tracing.

292 × 206 mm; 11½ × 8⅛ in.
No watermark.

f.94v; Br.123.
R.II.472.

Tracings of No. 117 on the verso.

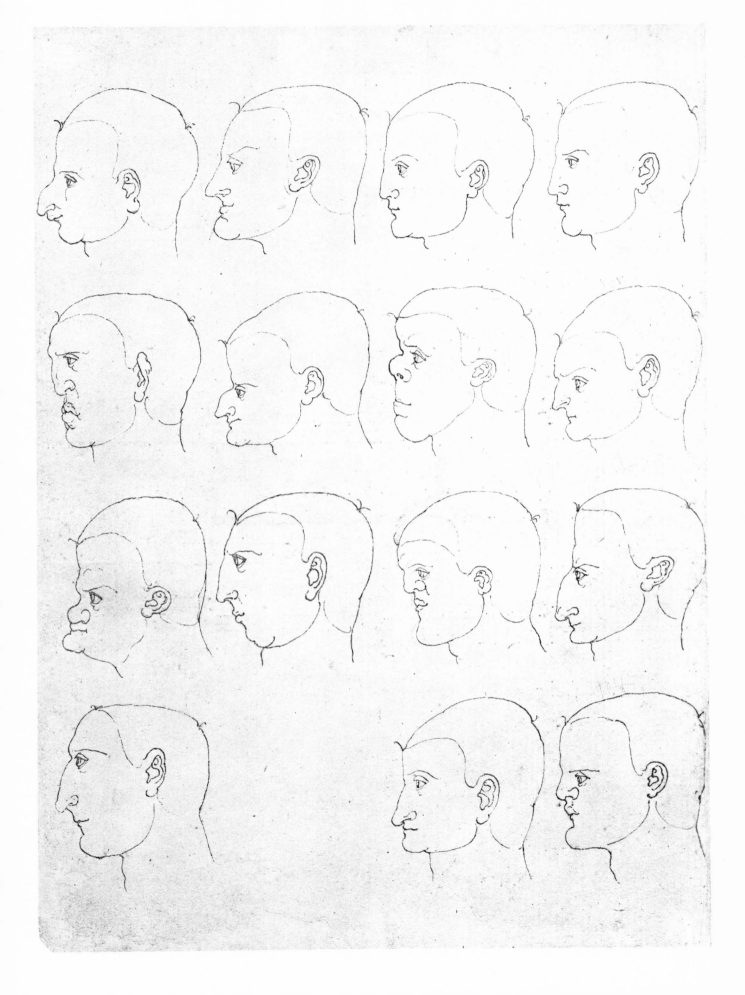

119 Two constructed heads, studies in physiognomy.

160 × 181 mm; 6¼ × 7⅛ in.
Watermark: trident.

f.180r; Br.146 (top).

Recto of No. 150.

120 Two heads; figure with stereometric contours; drapery study.

288 × 202 mm; 11¼ × 7⅞ in.
No watermark.

f170r; Br.115.
T.565: About 1514; akin to Leonardo da Vinci.
W.III.XIX:*1510–20.
P.1126: About 1513.
R.III.158.

Recto of No. 20. These sketches are difficult to date, but surely later than the drawing on the verso (No. 20). The caricature-like profiles are akin to the "Four Profiles" (W.657), dated 1513, and the "Ten Profiles" (W.656).

 * This refers to Plate XIX of the Supplement *(Anhang)* of Vol. III of the Winkler work (only the two heads are illustrated).

68

121 Dürer's left hand.

294 × 208 mm; 11½ × 8⅛ in.
No watermark.

f.100r; Br.106.
T.570: About 1513.
P.1650: About 1513.
R.II.310: 1511–1513.

Inscribed on the thumb: "A third part."
 Inscribed on the back of the hand: "The length of the longest finger equals this width."

 According to the detailed analysis of K. Gerstenberg (see Bibliography), the hand is that of Dürer's when he was about forty, therefore about 1513.

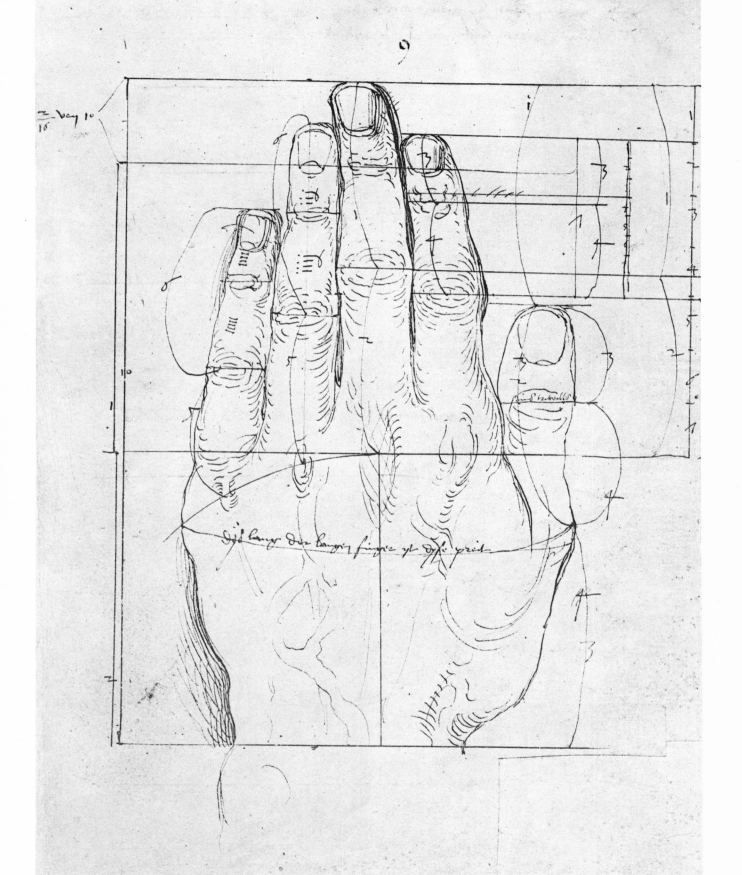

122 Left hand, constructed.

184 × 192 mm; 7¼ × 7½ in.
No watermark.

f.96r; Br.105.
R.II.313: 1513 or shortly thereafter.

Inscription:
"Tip of the ring finger.
Tip of the forefinger.
Tip of the little finger.
The little finger.
First joint.
Second joint of the ring finger.
The second joint of the ring finger.
This part is 1/9.
Center.
Here the width of the hand is equal to the length of the fore-
 finger.
Here the width of the hand is equal to the length of the middle
 finger.
Tip of the middle finger.
Tip of the forefinger.
First joint of the forefinger.
Second joint of the middle finger.
Second joint of the forefinger.
This line touches the tip of the thumb.
First joint of the thumb.
Bottom joint of the middle finger and forefinger.
Bottom joint of the thumb.
Wrist joint."

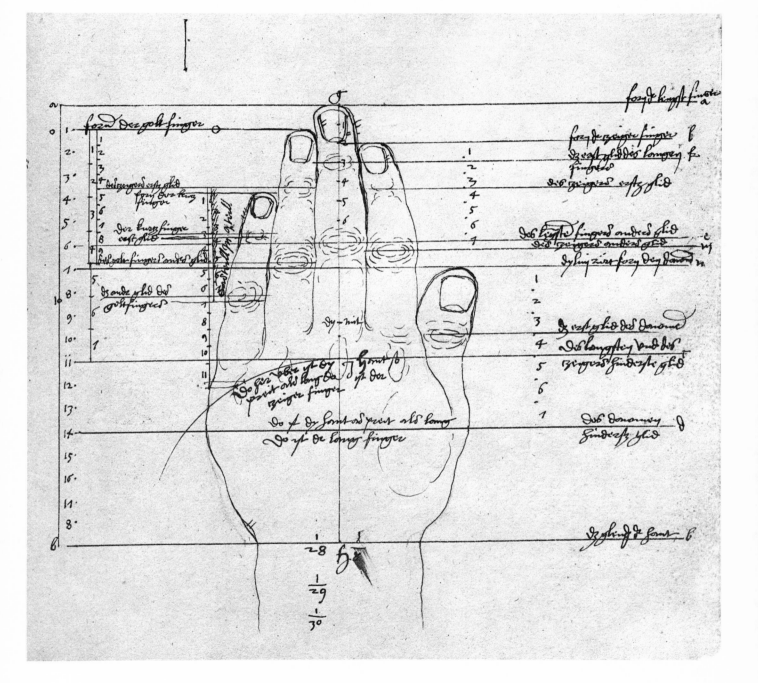

123 Right and left hand, top view and profile.

294 × 209 mm; 11½ × 8⅛ in.
No watermark.
With Dürer's monogram.

f.95r; Br.104.
R.II.320.

Preparatory for Book I of the *Four Books on Human Proportion*. In black ink, but the monogram in brown ink.

Inscriptions: (top)
 "The middle finger.
 The third finger.
 Forefinger.
 Little finger.
 The thumb.
 Thumb, second joint.
 Joint of the forefinger and middle finger.
 Bottom joint of the thumb."

(bottom)
 "Here the length of the forefinger's two top joints is equal to this width."

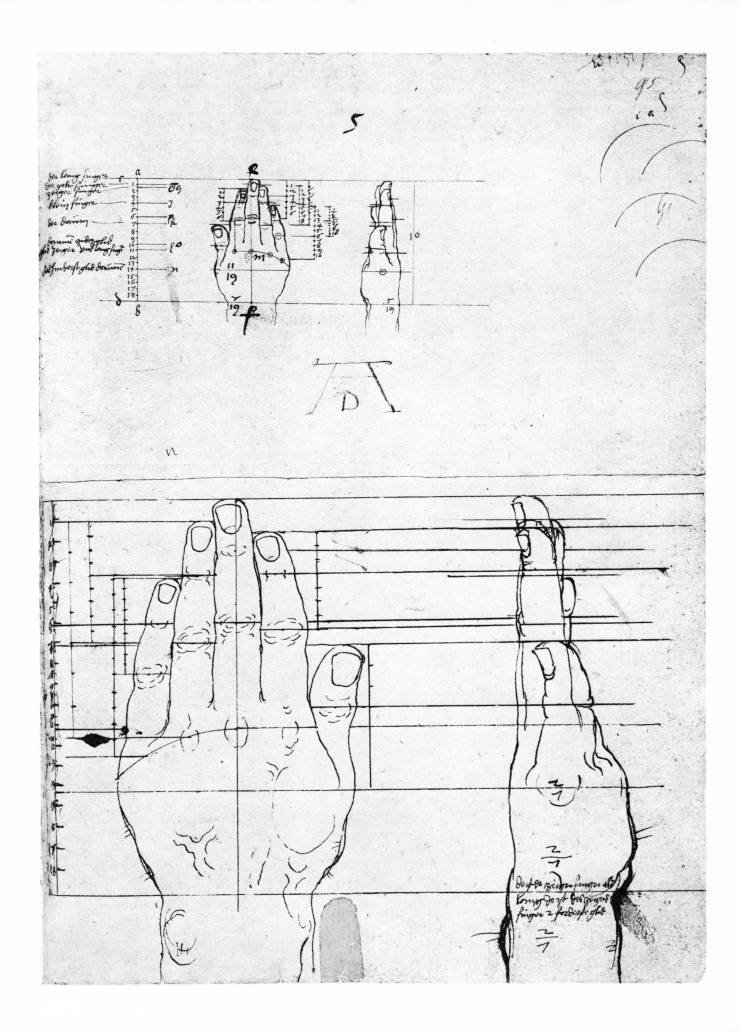

124 Right arm; leg; drapery study.

294 × 208 mm; 11½ × 8⅛ in.
Watermark: trident.

f.146v; Br.103.
R.II.233.

Verso of No. 23.

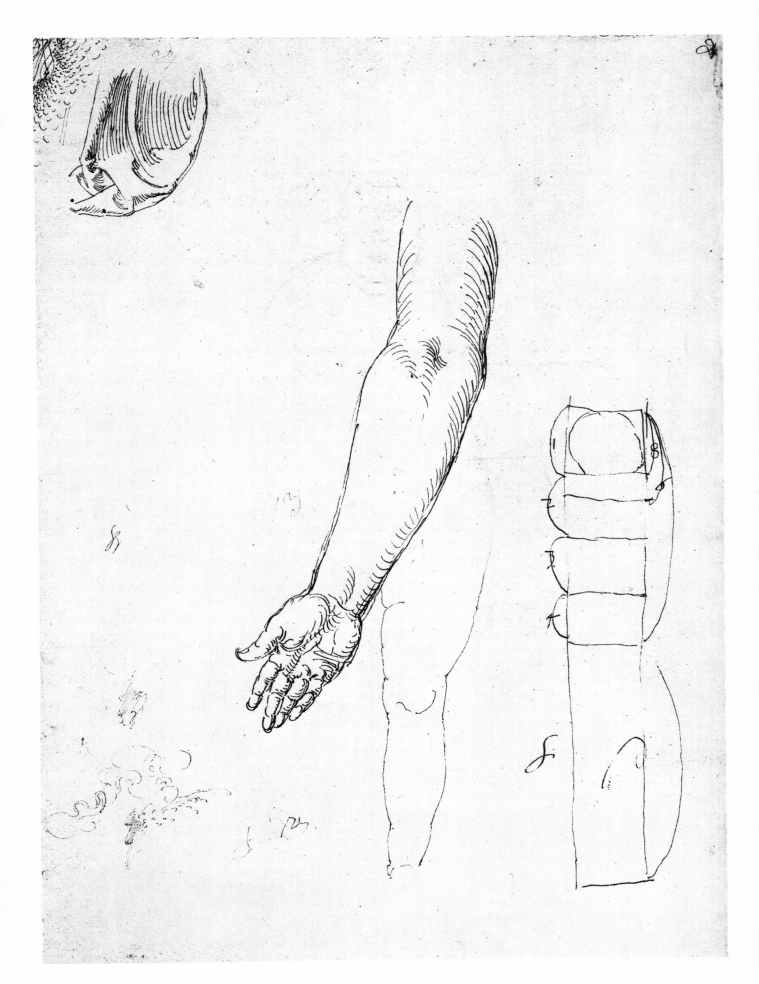

125 Left foot, constructed.

293 × 208 mm; 11½ × 8⅛ in.
No watermark.

f.97r; Br.110.
R.II.330: 1513 or shortly thereafter.

Seen from the top; seen from behind; in profile; two cross sections.
Counterpart of "Right Foot," London, Sloane 5228/188–189.

 Preparatory for the illustration, in reduced size, in Book I of the
Four Books on Human Proportion.

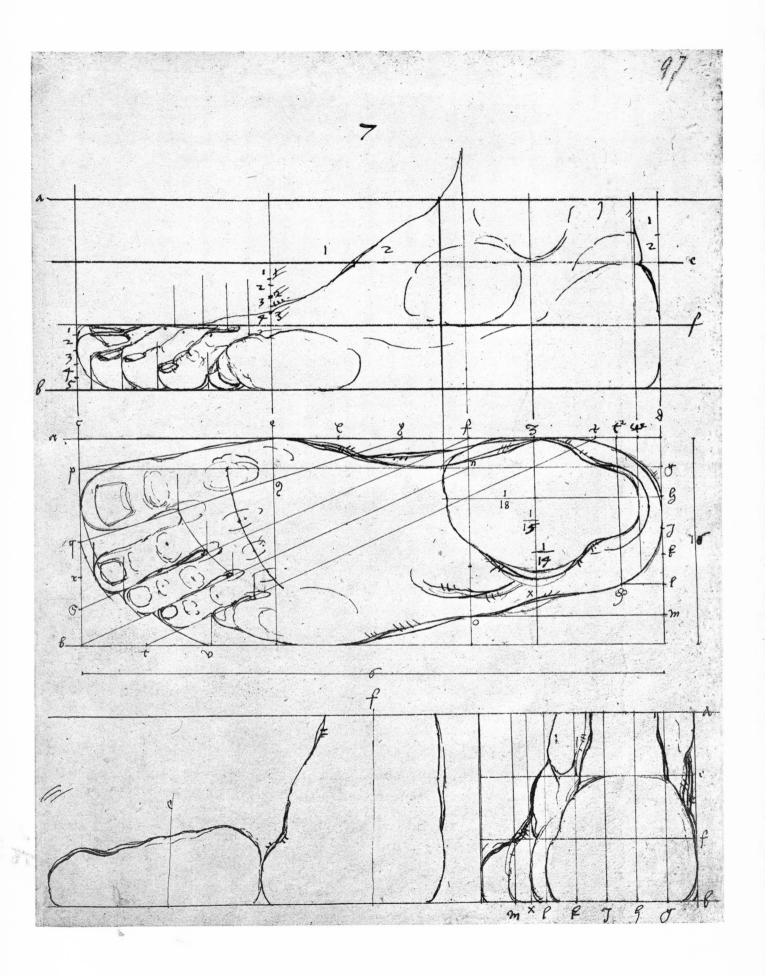

126 Right foot seen from below; arched doorway.

201 × 264 mm; 7⅞ × 10⅜ in.
No watermark.

f.99v; Br.113.
R.III.327: About 1514–15?

Verso of No. 149. The tendons are indicated on the lower foot. The constructed arched doorway, drawn in perspective, was perhaps intended for Dürer's *Underweysung der messung (Manual of Measurement)* of 1525. An early drawing of an arched doorway is preserved at the Hamburg Kunsthalle (W.259).

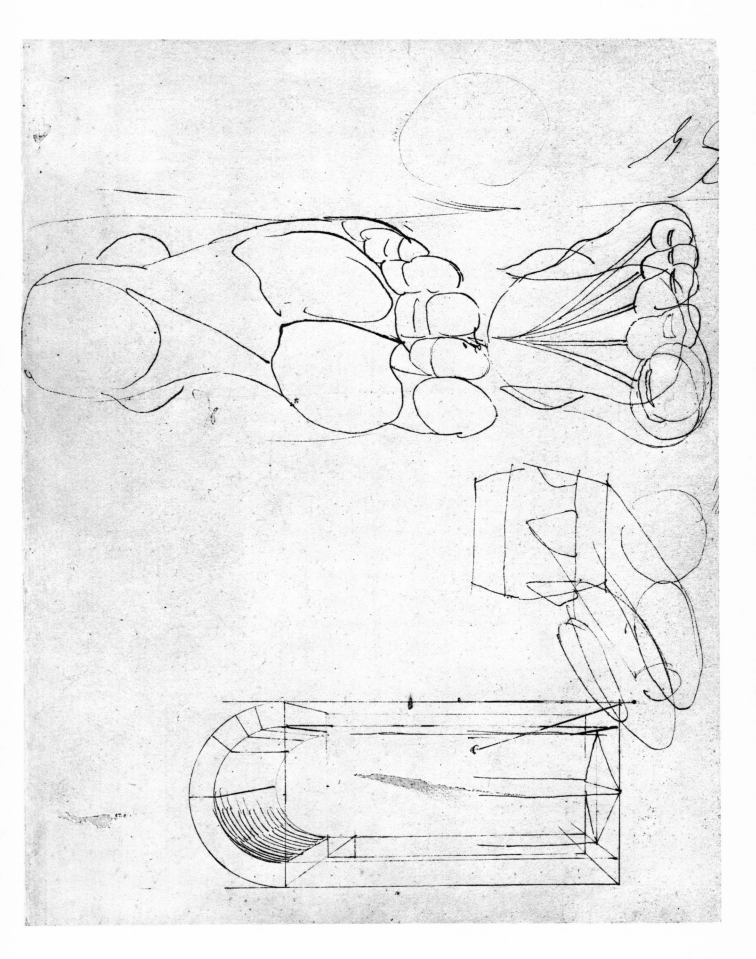

127 Two feet, four legs.

278 × 155 mm; 10⅞ × 6⅛ in.
No watermark.

f.98r; Br.111.

Recto of No. 129. Date undetermined.

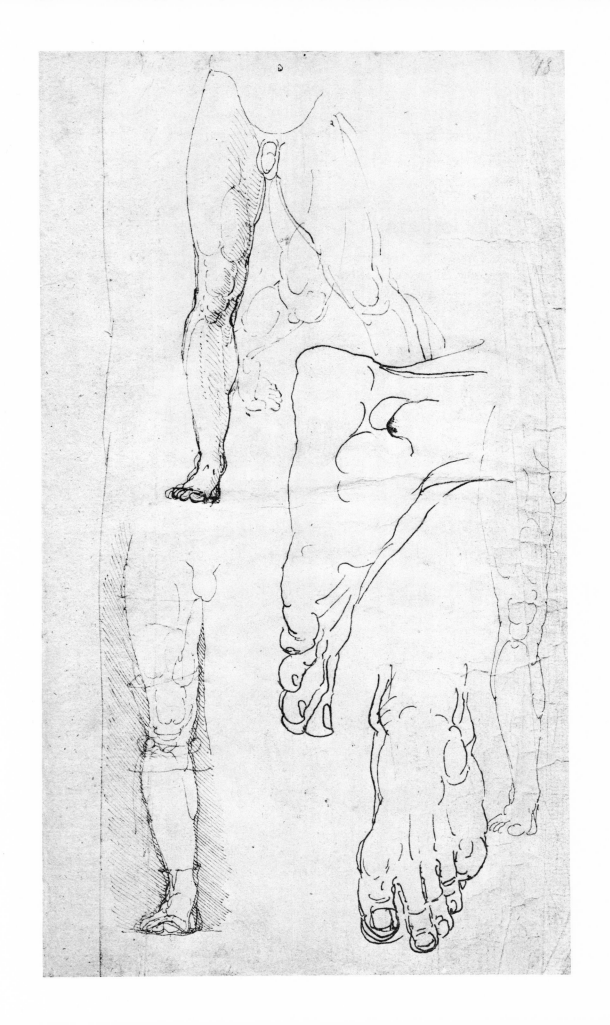

128 Two legs.

158 × 77 mm; 6¼ × 3 in.
No watermark.

Left: f.102v (verso of No. 66); Br.114 (along with Nos. 39, 138, and 146). Right: f.169r (along with No. 39; recto of No. 38); also on Br.114.

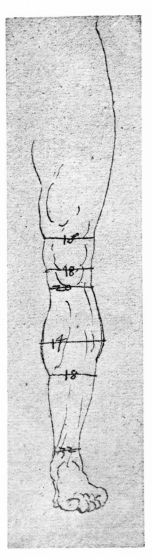 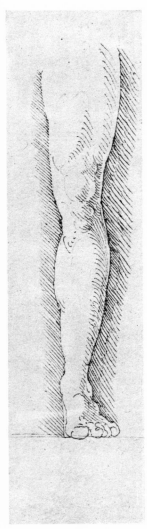

129 Foot in profile; right leg seen from behind.

278 × 155 mm; 10⅞ × 6⅛ in.
No watermark.

f.98v; Br.112.
R.III.446.

Verso of No. 127. The same words, although in a different sequence, appear on one of the pages of the Sloane manuscript in London (5229/61r). The meaning of this combination of words in Nuremberg dialect is obscure.

130 Anatomical studies: hand, arms, legs.

298 × 288 mm; 11⅝ × 11¼ in.
Watermark: trident.
Dated 1517.

f.130v; Br.107.
P.1663.

Copied or traced after a drawing by Leonardo da Vinci. The number
of bones in the wrist is incorrect. The date may have been added by
Dürer subsequently. See the works by Weixlgärtner and Sudhoff in
the Bibliography.

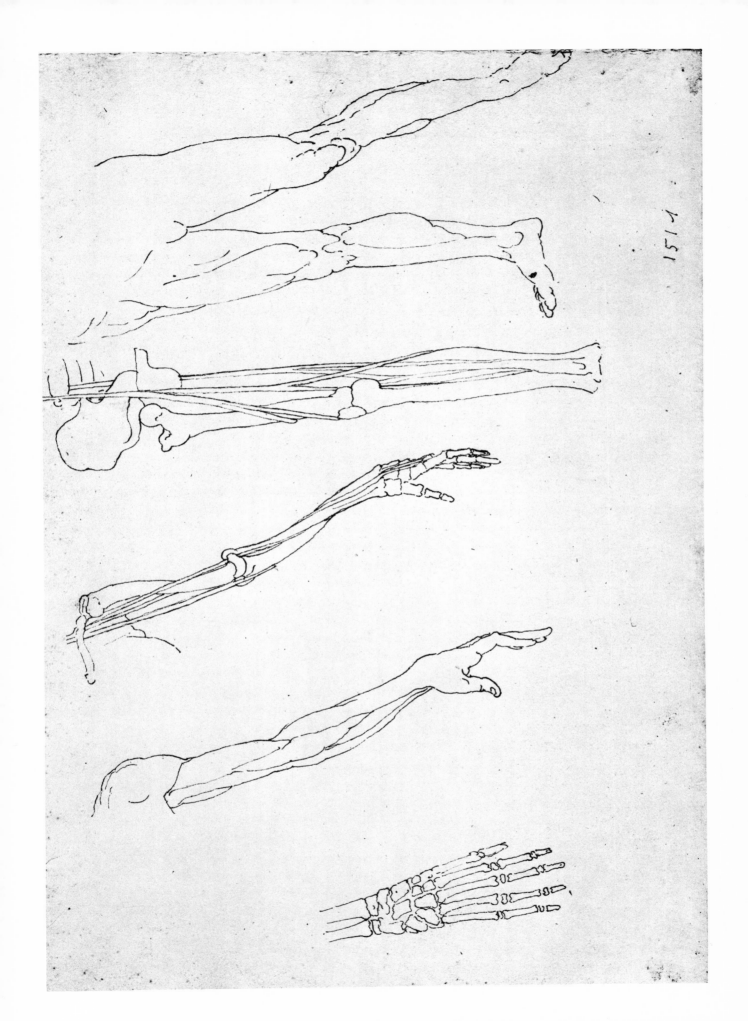

131 Anatomical studies: arms, part of the thorax.

213 × 149 mm; 8⅜ × 5⅞ in.
No watermark.

f.133v; Br.108.
P.1664: 1517?

Verso of No. 43. Remarks as for No. 130. The humerus is drawn too large (Bruck, p. 32). The drawing is akin to Sloane 5230/66 (P.1662). Dürer paid particular attention in this drawing to indicate the tendons correctly.

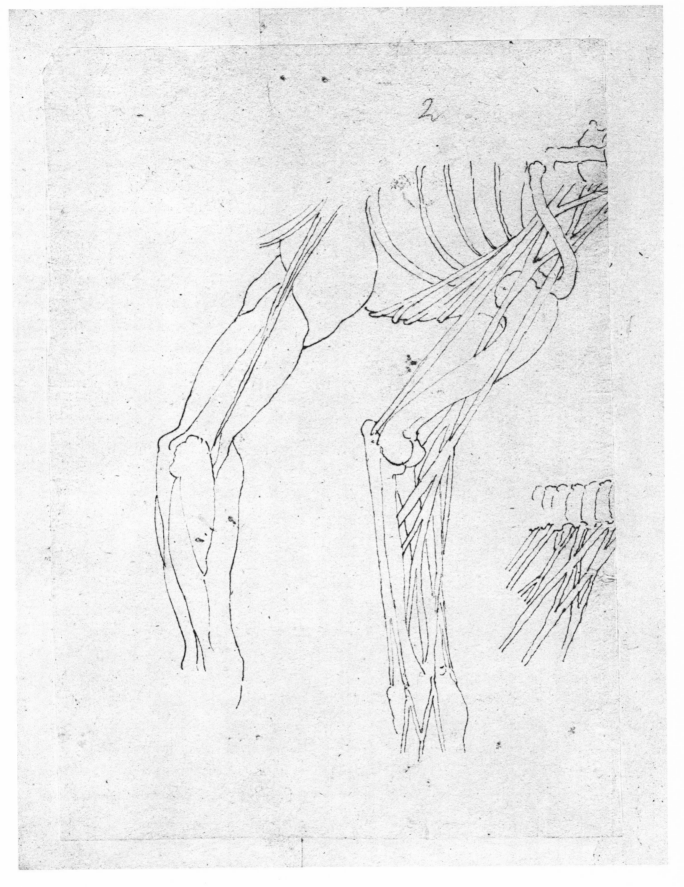

132 Anatomical studies of legs.

195 × 288 mm; 7⅝ × 11¼ in.
No watermark.

f.131r; Br.109.
(P.1664.)

Closely related to Nos. 130 and 131. Based on Leonardo da Vinci.

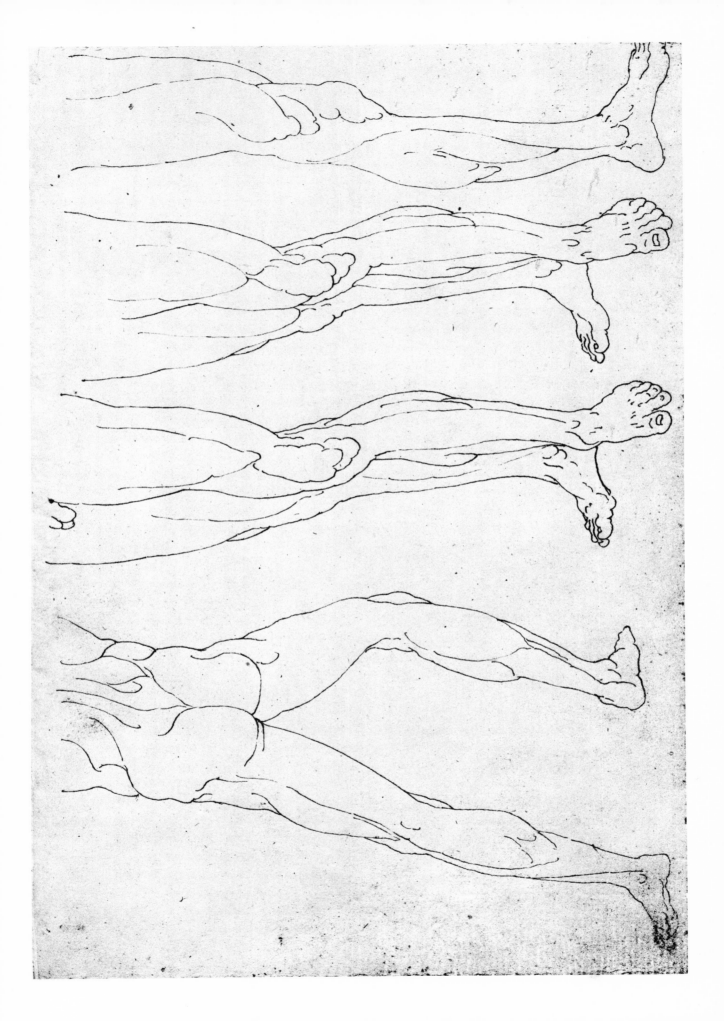

II. STUDIES OF ANIMALS

133 Studies of horses.

285 × 162 mm; 11⅛ × 6⅜ in.
Watermark: trident.
Dated 1517.

f.175v; Br.128.
T.694a.
P.1326.

Verso of No. 148. Based on, perhaps traced from, Leonardo da Vinci, like Nos. 130–132. Ephrussi (p. 131) reproduced a very similar drawing by Leonardo da Vinci, then in the Emile Galichon collection.

The head of the horse at the bottom bears considerable resemblance to that in the engraving "Knight, Death and Devil."

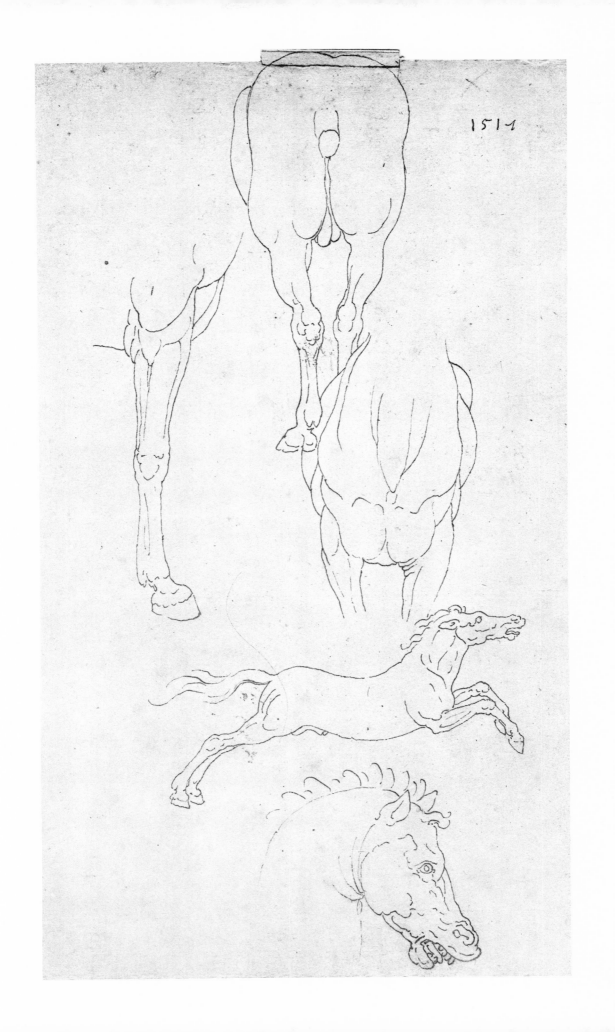

1511

134 Boar.

120 × 189 mm; 4¾ × 7⅜ in.
No watermark.
With Dürer's monogram.

f.177r (along with No. 140); Br.129 (top).
T.A294: Not by Dürer.
P.1307: Perhaps a tracing from a Dürer drawing of about 1496.

Recto of No. 144. The drawing is perhaps preparatory for Dürer's engraving "The Prodigal Son" of 1495. It is drawn on a separate piece of paper, pasted on the upper half of folio 177r.

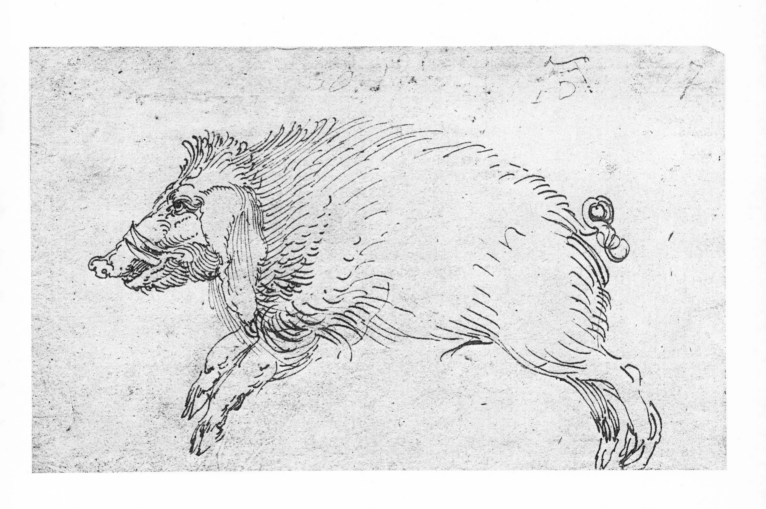

135 Dragon.

98 × 173 mm; 3⅞ × 6¾ in.
No watermark.
With Dürer's monogram (not authentic).

f.176r (along with No. 159); Br.130 (bottom).
T.A293: Not by Dürer.
P.1316: Not by Dürer.

Recto of No. 108. Although a resemblance to some of the drawings which Dürer made for the *Prayer Book* of Emperor Maximilian has been noted, the style of the drawing speaks against authenticity. Dürer had in his possession a number of drawings made by other artists which he collected for his reference. The annotation "ein lindwurmb" (a dragon) is not in Dürer's handwriting. Drawn on a separate piece of paper, pasted onto folio 176r.

The drawing is lightly colored with watercolors. Wings and legs pinkish-yellow; head, body, and tail greenish-blue; the eyes black; eyelids and tongue red; teeth and claws white.

The head of the dragon and the monogram are rendered in a similar manner in "Fountain with Standard Bearer." This drawing seems to be a copy of an almost identical rendering in London (Sloane 5219/41).

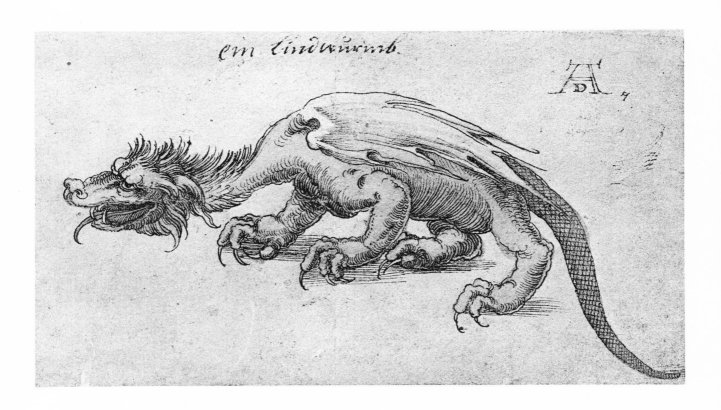

III. GEOMETRICAL, ARCHITECTURAL, AND PERSPECTIVE STUDIES

136 Ionian capitals; pentagon in perspective.

242 × 195 mm; 9½ × 7⅝ in.
No watermark.

f.184r; Br.148.

Recto of No. 137. This drawing is very closely related to the "Portico with Two Ionian Columns" at London (Sloane 5229/153). The drawing at London is on paper with the watermark depicting crossed arrows that Dürer used during his journey to Italy in 1505–06.

These sketches appear to be based on the writings of Piero della Francesca (then unpublished), who particularly describes the construction of columns.

We know that Dürer traveled to Bologna toward the end of the year 1506 for the purpose of studying the theory of perspective. In his *Manual of Measurement*, published in 1525, he does not include the pentagon or triangle in a perspective rendering. In the second edition of this work, however, he describes the perspective construction of a square within a cube. The diagram accompanying that description uses the same construction by means of a diagonal line as the one described by Piero della Francesca.

This sheet of sketches therefore presumably derives from Dürer's visit to Bologna in 1506.

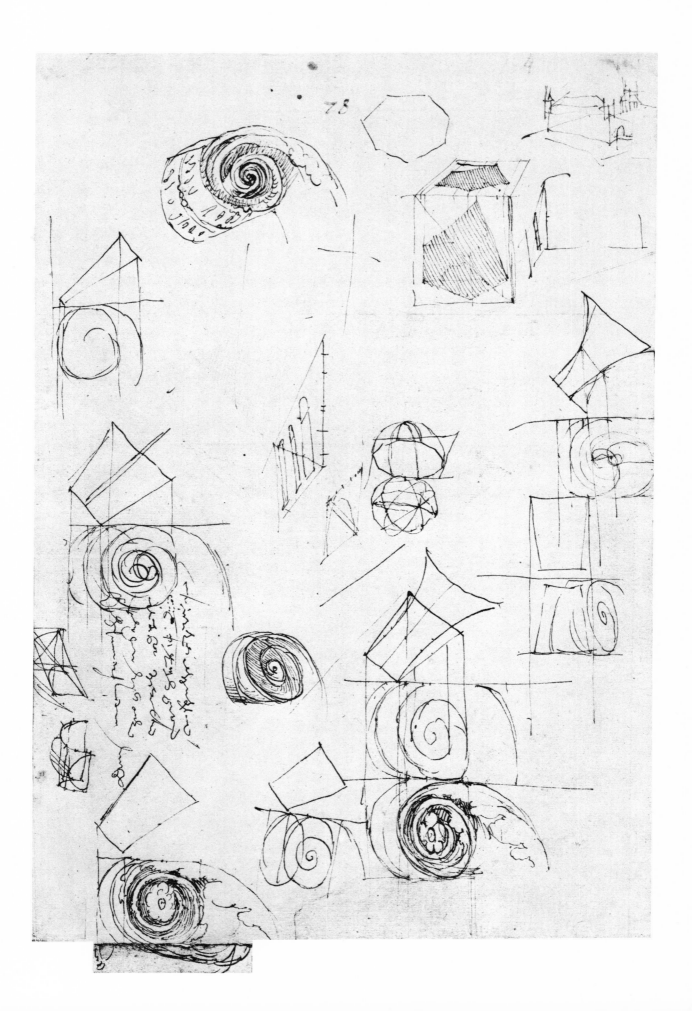

137 Triangle and polygon in perspective.

242 × 195 mm; 9½ × 7⅝ in.
No watermark.

f.184v; Br.138.

See No. 136, of which this is the verso. Also see p. 38 of Panofsky's
Dürer's Kunsttheorie.

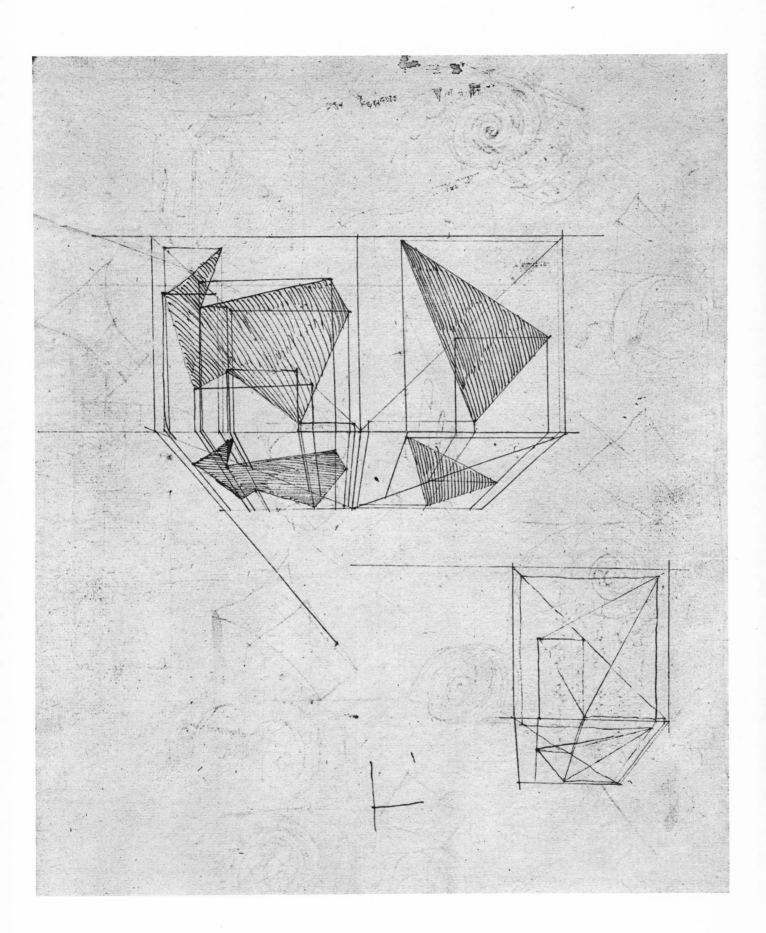

138 A cube in perspective.

110 × 102 mm; 4⅜ × 4 in.
No watermark.

f.168v; Br.114 (along with Nos. 39, 128, and 146).

Verso of No. 142. The lower segment of the cube is sectioned by
diagonals.

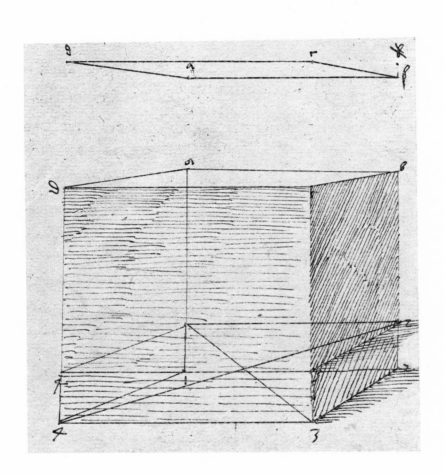

139 A truncated cube on a pedestal.

202 × 193 mm; 7⅞ x 7½ in.
Watermark: waterwheel with letter *p* (Briquet No. 13450).

f.183v; Br.131 (bottom).
T.585: 1514; the animal on the base is a dog.
P.1701: 1514; the animal is a fox; a truncated rhomboid.
R.III.347.

Preparatory for the engraving "Melencolia I" (Bartsch 74), dated 1514. The vanishing point is indicated by an eye. The diagonally opposite corners of the cube have been cut off, and it rests on one of the resulting truncated surfaces. An optical illusion is created by which it appears to be a polyhedron with pentagonal sides, partly because the point of sight is off center.

The fox on the pedestal is similar to that in the drawing "The Madonna with a Multitude of Animals" (W.296).

The animals are drawn in black ink; the rest of the drawing in brown.

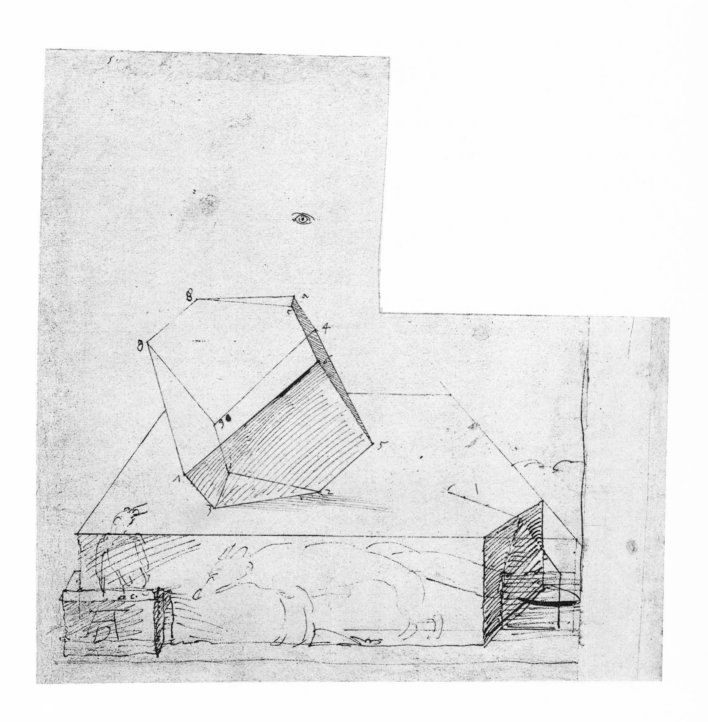

140 Spiral construction.

140 \times 176 mm; 5½ \times 6⅞ in.
No watermark.

f.177r (pasted on, along with No. 134); Br.129 (bottom).

Recto of No. 144.

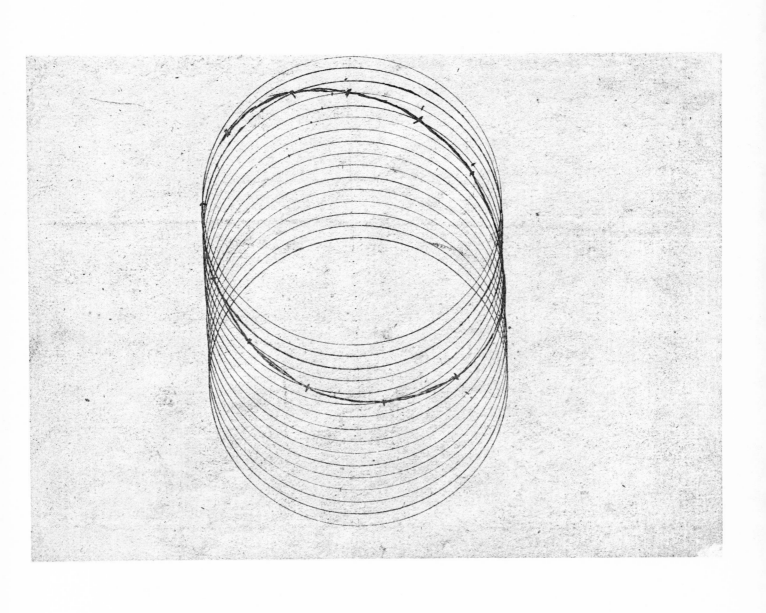

141 Four compasses; molder's form; drapery study.

200 × 265 mm; 7⅞ × 10½ in.
No watermark.

f.171v; Br.134.
T.586: 1514.
P.1444: 1514.
R.III.326.

Verso of Nos. 143 and 145a. One of the compasses and a variation of the molder's form were used in the engraving "Melencolia I" (Bartsch 74), dated 1514.

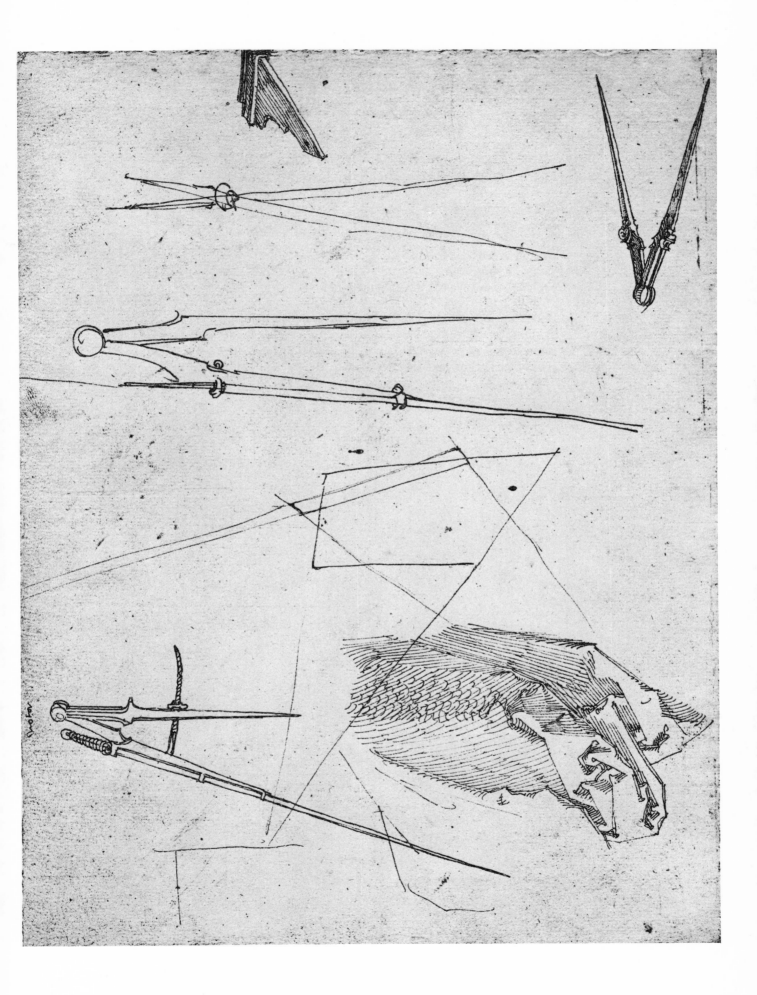

142 Circle in perspective; head looking upward.

152 × 142 mm; 6× 5⅝ in.
No watermark.

f.168r; Br.126 (bottom).
T.564: About 1514.
P.1131: About 1520, rather than about 1514.

Pasted on the recto of No. 138. According to Bruck, the head is akin
to the faceted heads, No. 116. According to Tietze, the head is syn-
thesized out of polygons. Panofsky prefers to relate the head to the
stereometric drawings like No. 100.

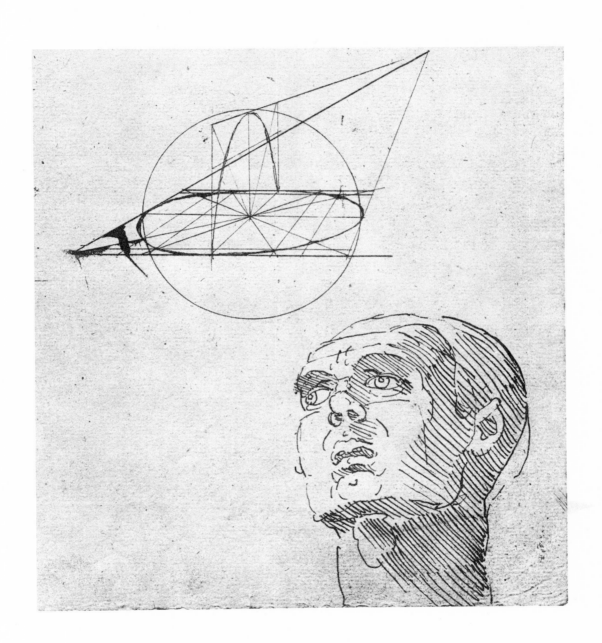

143 Geometrical designs; drapery study.

290 × 200 mm; 11⅜ × 7⅞ in.
No watermark.

f.171r (along with No. 145a); Br.133.
R.III.326.

Recto of No. 141.

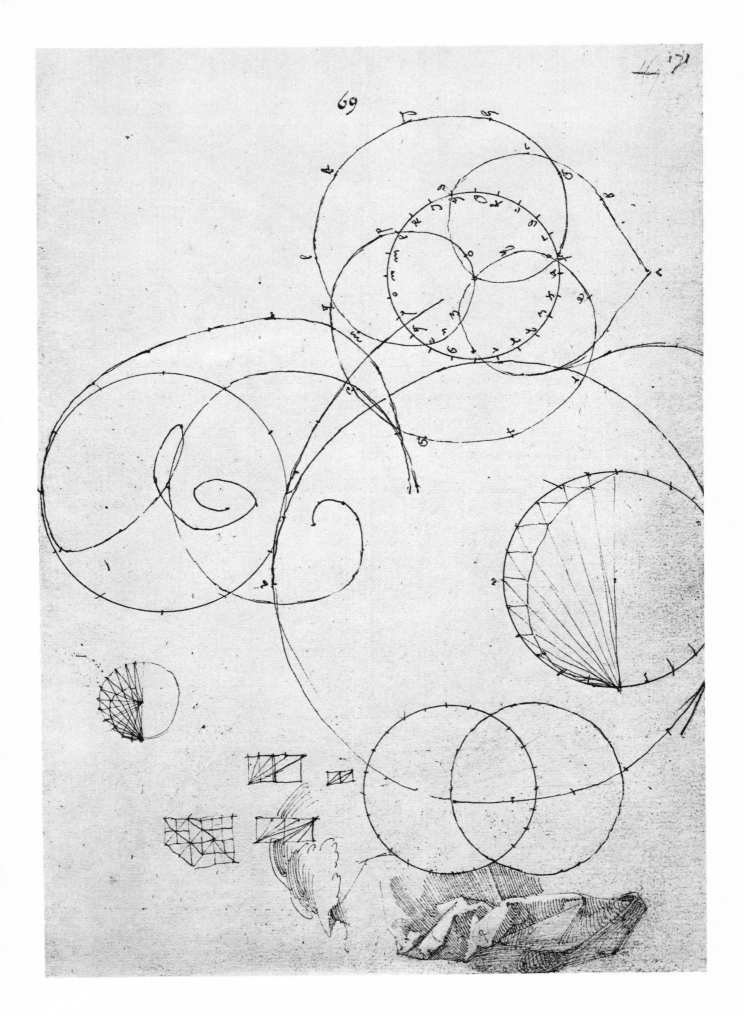

144 Perspective apparatus.

228 × 187 mm; 9 × 7⅜ in.
Watermark: anchor in circle.
Dated 1514.
With Dürer's monogram.

f.177v; Br.135.
T.622.
P.1705.

Verso of Nos. 134 and 140. Preparatory for the woodcut illustration in Dürer's *Manual of Measurement*, 1525. A drawing showing this apparatus with some improvements is at London (Sloane 5229/131).

145 Triumphal chariot; study in perspective; folding pattern.

205 × 288 mm; 8 × 11¼ in.
No watermark.

f.167v; Br.139.
T.513: About 1512; not preparatory for Lippmann 528.
W.672: Preparatory for the carved wooden plaque commemorating
 the double wedding of the Emperor Maximilian's grandchildren
 at Vienna in 1515 (Louvre, Paris).
P.952: About 1512, rather than 1515, used subsequently for the com-
 memorative plaque at the Louvre.

Verso of No. 147. Tietze, Winkler, and Panofsky concern themselves
only with the triumphal car on this sheet of sketches. The study in
perspective is obviously based on Viator's *De Artificiali Perspectiva*.
A plagiarized edition of this work had appeared at Nuremberg in
1509. The folding pattern of a polyhedron is the earliest sketch of
this type of construction, which is fully described by Dürer in his
Manual of Measurement of 1525.

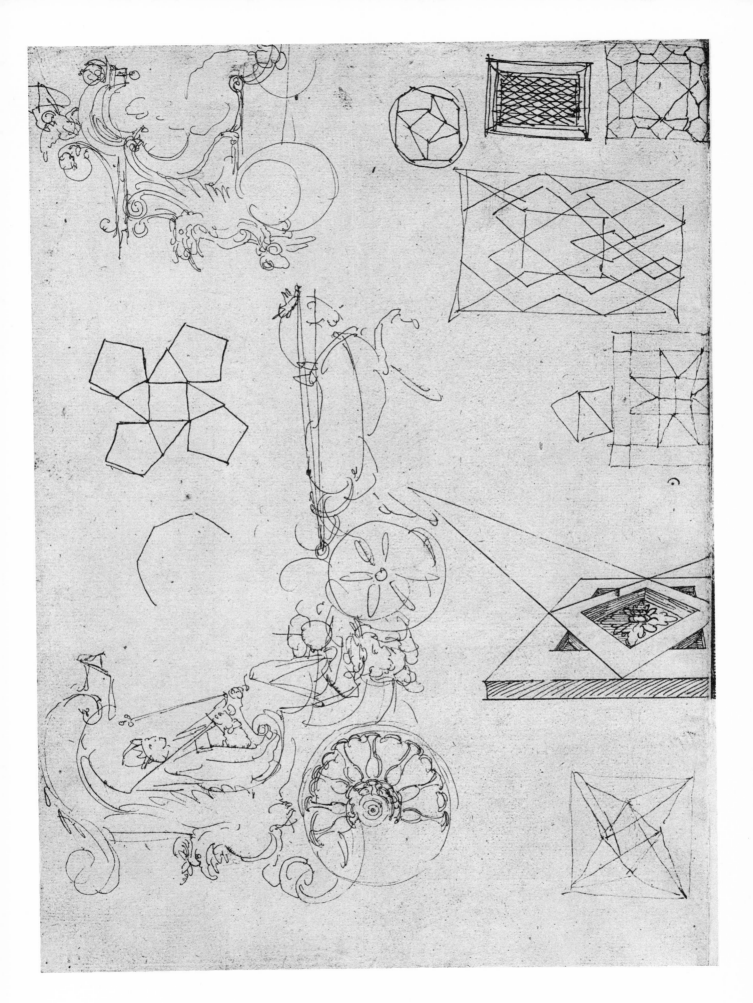

145 *a* Reconstruction of the study in perspective on No. 145.

(B.126 top).

The right-hand portion, on a separate slip of paper, is pasted onto f.171r.

146 Drapery studies; ornamental flourish.

162 × 97 mm; 6⅜ × 3¾ in.
Watermark: anchor in circle.

f.166r; Br.114 (along with Nos. 39, 128, and 138).

Pasted on the recto of No. 95.

147 Two columns crowned by goats; ornamental flourish; cap-
 ital; plant ornament; geometrical study.

288 × 202 mm; 11¼ × 8 in. (total sheet size).
No watermark except for the geometrical study, which has the
"anchor in a circle."

f.167r; Br.142.
T.637: Akin to the drawings in Emperor Maximilian's *Prayer Book*
 by Dürer, 1515.
P.1530: About 1515.

Recto of No. 145. Composite sheet with separate slips of paper
pasted onto it.

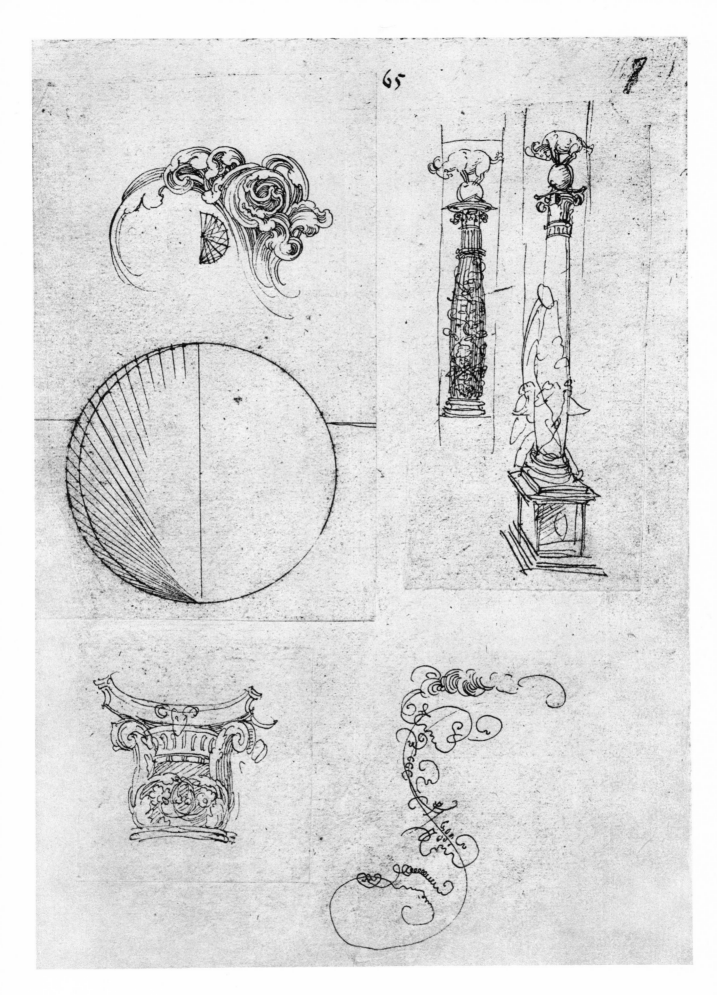

148 Ground plans of columns; drapery study.

288 × 202 mm; 11¼ × 8 in.
No watermark.

f.175r; Br.147.

Recto of No. 133. Preparatory for Book III of Dürer's *Manual of Measurement*, 1525.

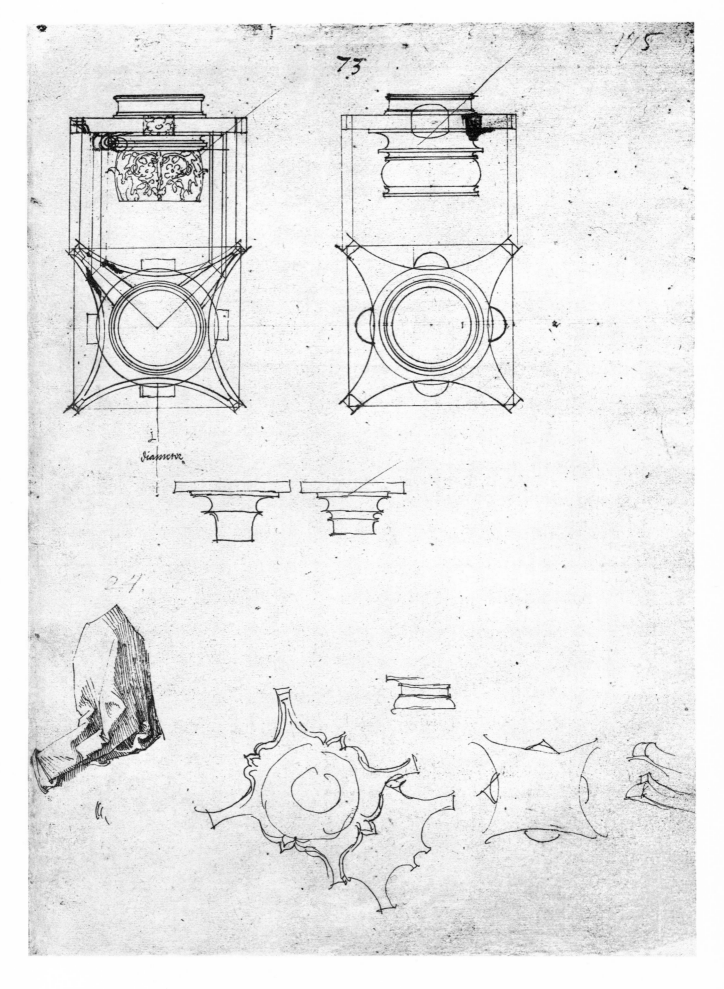

diameter

27

149 Geometrical study; drapery; part of a stove.

292 × 215 mm; 11½ × 8⅜ in.
No watermark.

f.99r; Br.132.
R.III.327: The small sketch perhaps a part of an organ.

Recto of No. 126. The sketch on top probably is meant to illustrate the flow of air through a fireplace or stove, rather than an organ.

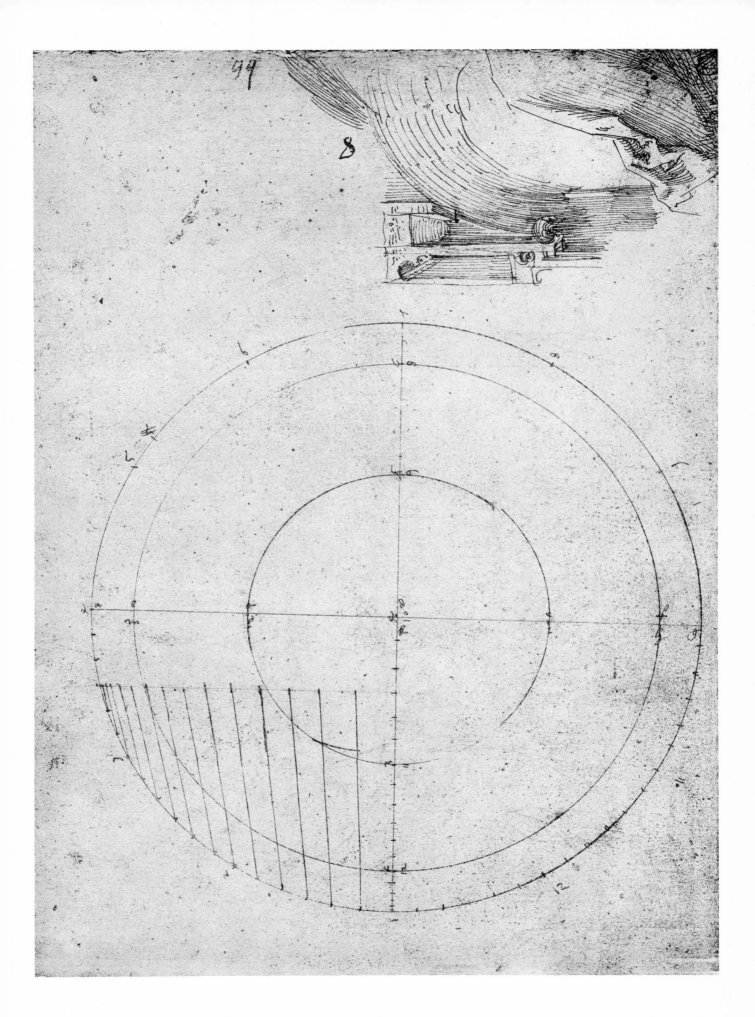

150 Ornamental cornices; three-dimensional cross.

145 × 188 mm; 5¾ × 7⅜ in.
Watermark: trident.
With Dürer's monogram.

f.180v; Br.143 (top).

Verso of No. 119. The sketches in the lower portion are akin to the pedestal of No. 139.

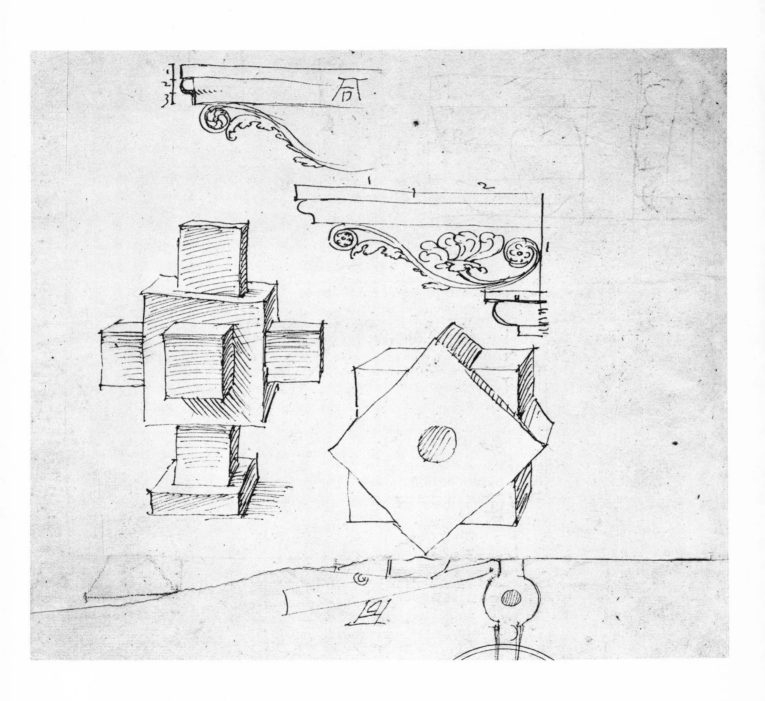

151 German Renaissance tower; twisted column.

288 × 216 mm; 11¼ × 8⅜ in.
No watermark.

f.182r; Br.144.
T.936: About 1525.
P.1686: About 1525.
R.III.347: About 1525.

Recto of No. 160. The tower is related to the one described in Book III of Dürer's *Manual of Measurement*, 1525. Related drawings are at London (Sloane 5229/175–181).

According to Peltzer (1905, p. 53), this drawing was probably utilized by Count Palatine Frederick II for the renovation of the "Bell Tower" of Heidelberg Castle.

Inscriptions, reading from top to bottom:
"Of height equal to the part below.
One and a half squares in height, each square 1/4 of a roof level.
The height of one roof level.
The width of this roof equals 3/4 of its height up to the vaulting.
This octagon measures twice its height in width.
One square high.
Two squares high."

On the octagonal ground plan:
"Window. Window."

Next to the twisted column:
"The foundation of the tower."

152 Perspective apparatus.

195 × 296 mm; 7⅝ × 11⅝ in.
Watermark: crowned coat-of-arms with attached *b*.

f.179r; Br.137.
T.934: About 1525.
W.936.
P.1707: About 1525.
R.II.386.

Inscribed:
 "The front sight.
 The peep hole.
 The string."

Preparatory for the woodcut illustration of the "Man Drawing a Vase" which was added to the second edition of Dürer's *Manual of Measurement* (Nuremberg, 1538).

This device was invented by one Jacob Keser, whose name appears on the margin of No. 108. Dürer describes his method of drawing in a manuscript at London (Sloane 5229/130):

"Note further an additional easier way that can be used instead of the one described before. It was found out and discovered by Jacobus Keser. And because it is very good and useful, in fact easier to use than the one described before, I shall for the common good and in honor of the inventiveness of Herr Jacob Keser, praised be God, describe it as follows.

"It is easy to trace a flat object, placed close to the eye, on a glass pane, as it will not be distorted. If, however, you wish to draw a lute or various other objects close to the observer by sighting their points, this will result easily in distortion.

"If, for example, you wish to draw a lute with its fingerboard pointed toward the observer, its body will be out of proportion. Likewise with other objects. For the things close to the eye always appear larger than those further away.

"It is also true of the former method that if the thing I wish to draw is placed far from my eye, I would have to hold the glass on which it is to be traced so close to my eye that I could reach it with my hand. Therefore the thing I am to draw will appear very small on the glass pane. If I placed the glass closer to the object that I wish to draw, in order to make it appear larger, I would be unable to reach the glass with my hand because of the distance. For this reason another method must be used that saves much trouble and permits any object to be drawn on the glass pane, regardless of size.

"First place the thing that you wish to draw in large size next to

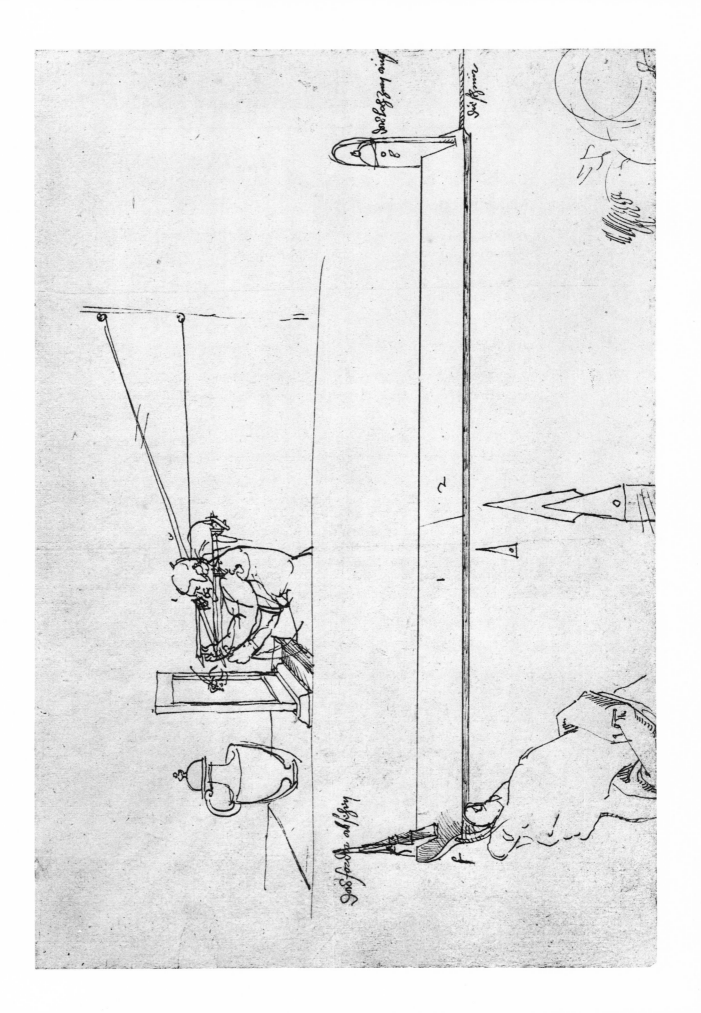

153 Man drawing a vase.

187 × 204 mm; 7⅜ × 8 in.
Watermark: crowned coat-of-arms with attached *b*.

f.178r; Br.136.
T.935: About 1525.
W.937.
P.1708.
R.II.386.

Remarks as for No. 152. The point of sight is indicated by a small eye. The lower sketch is almost identical with the woodcut of the printed edition.

(continued from page 310)

the glass pane so that the copy will not be much smaller than the thing itself.

"Then take a point of sight two or three rods away, or as distant as you desire. This point mark with an *o* and attach to a wall. Now it is not possible to stay with one's head or eye at point *o* and still reach the glass pane, which is further away, with one's hand. For this purpose Jacob Keser invented the following:

"He takes a long, thin silk string, as long as required, and attaches one end to the point of sight *o*. It is for him as useful as if his right eye were in its place. It is as if his right eye were looking at the object to be drawn. To this string he now attaches an instrument that has a pointed vertical member in front and a peephole in the back through which he looks. I shall draw it below.

"First take a board of triangular profile about a span and a half in length. Make a small triangle about 1/20 of its length, but its lower side only half as wide as the other two. Then drill a small hole lengthwise through the board, next to the narrow side of the triangle, so that the string can be pulled to and fro easily. On this board place a pointer up in front of the same height as the triangle. Mark this point *a*. Below, where the string emerges from the hole, make a mark *f*. Now you must place the peephole that is used for sighting at the proper height whenever the instrument is moved up or down or back and forth.

"You will find this as follows: Fasten the instrument and stretch the string so that *f d o* are in a straight line. Then draw a line *ao*. At the point where a vertical line drawn from *d* touches *at*, make a mark *b*. This is the correct height of the little hole to sight point *a*."

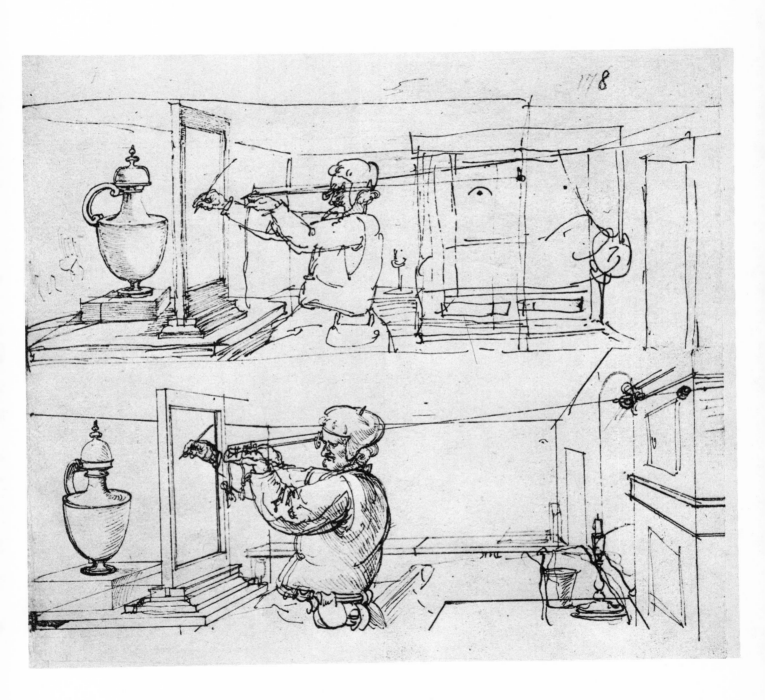

IV. MISCELLANEOUS STUDIES

154 Drapery study; left leg; scholar; constructed head; head
 of a youth looking upward; Philip the Handsome.

296 × 202 mm; 11⅝ × 8 in. (total sheet size).
No watermark.

f.173r; Br.141.
T.395: 1509 (refers to the head of a youth only).
T.528: 1512–13 (refers to the scholar only).
P.1122: About 1509; perhaps preparatory for the "Descent from
 the Cross" (Bartsch 42) of the *Small Passion* series of woodcuts
 (refers to the head of a youth only).
P.1262: 1523–25 rather than about 1512–13 (refers to the scholar
 only).

This sheet is typical of those sheets of the *Dresden Sketchbook* onto
which a number of sketches on small slips of paper have been pasted.

The king may have been drawn in connection with the *Prayer
Book* illustrations for Emperor Maximilian I in 1515.

The figure of the scholar was used in the woodcut explaining the
"short-cut method" of perspective in Book IV of the *Manual of
Measurement*, 1525.

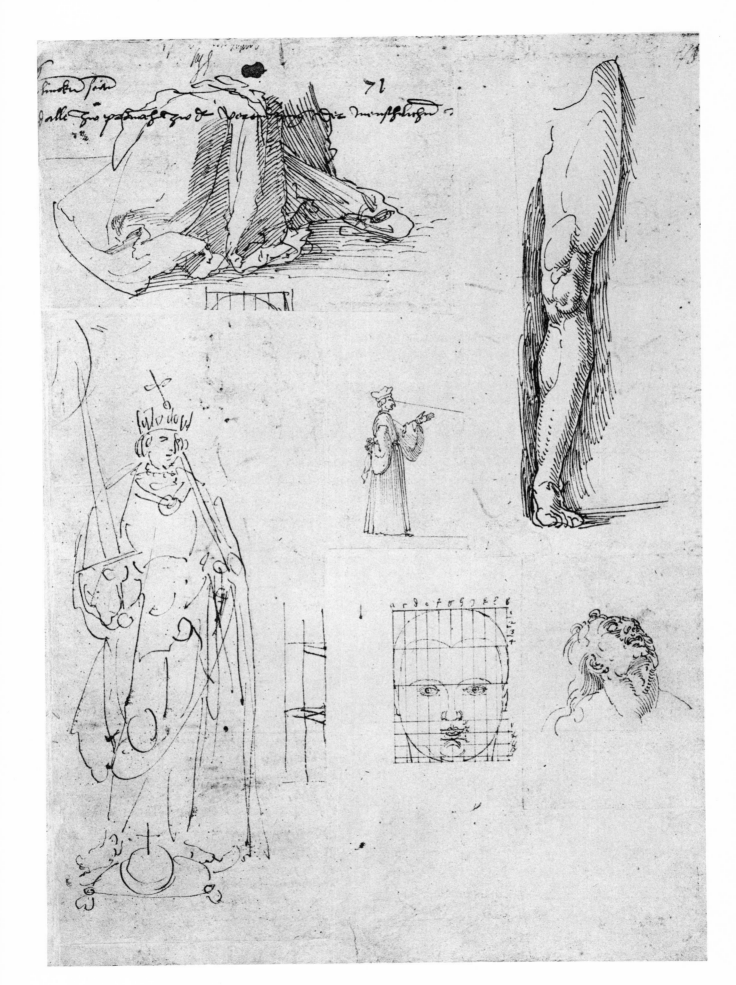

155 Seven drapery studies.

296 × 202 mm; 11⅝ × 8 in. (total sheet size).
No watermark.

f.172v; Br.140.
T.481: (Refers to sketch at upper left) 1511 because akin to Lipp-
 mann 524.
T.519: (Refers to sketch at upper right) about 1512.
T.596 and T.598: (Refer to sketches at center left) about 1514 be-
 cause akin to Lippmann 532 and 795.
T.597: (Refers to sketch at bottom left) about 1514; akin to Lipp-
 mann 797.
T.599: (Refers to sketch at bottom right) about 1514.
P.1459–1464.

Separate sketches pasted onto a larger sheet of paper. The geometric
designs in the top row are akin to those done in 1514, as in No. 142.
The cloth in the sketch at center right (not listed in T.) is draped over
a hoop-like object. The sketch at bottom right includes a calligraphic
flourish and the entrance to a cave.

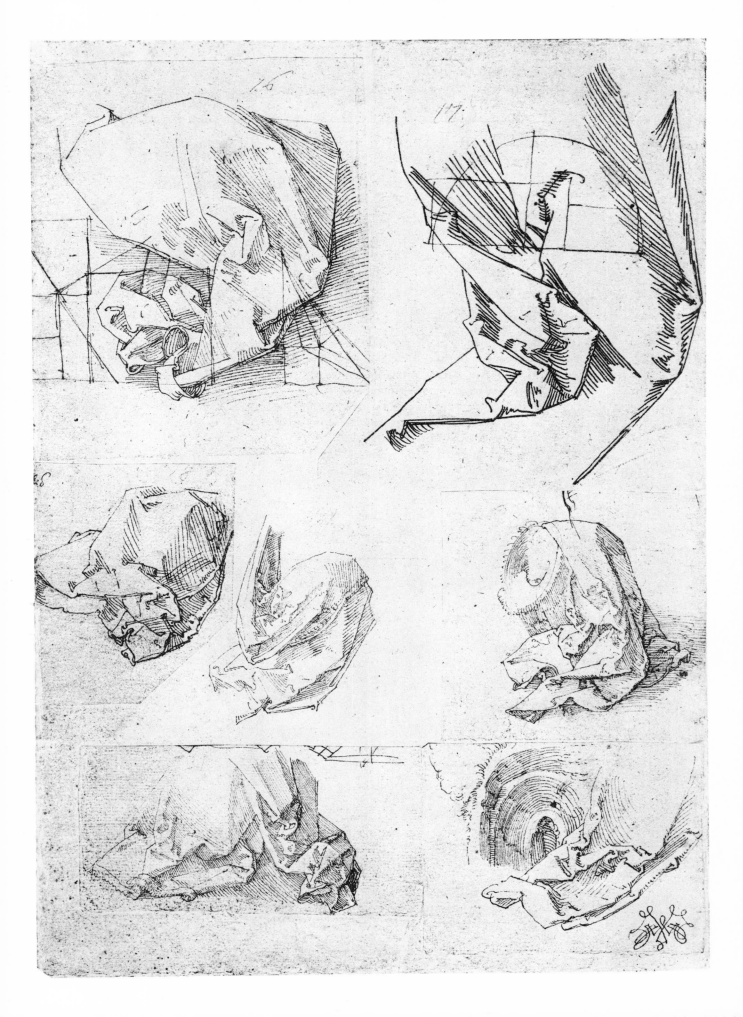

156 The continence of Scipio Africanus; tower; world globe.

296 × 196 mm; 11⅝ × 7¾ in.
Watermark: anchor in circle.

f.174r; Br.145.
W.IV.XV.*
T.872: About 1521.
P.1550: About 1521.

"The Continence of Scipio Africanus" was probably intended as a
decoration for the south wall of the Great Chamber of the City Hall
of Nuremberg. Dürer was commissioned to provide the decorations
by an order of the City Council dated August 11, 1521. This sketch
is pasted on top of the design for the construction of a tower.

The construction of a tower is related to No. 151. It is inscribed:
"This roof is two squares in height."

The annotation next to the small sketch of a globe is not in Dürer's
handwriting.

 * This refers to Plate XV of the Supplement (*Anhang*) of Vol. IV of the
Winkler work.

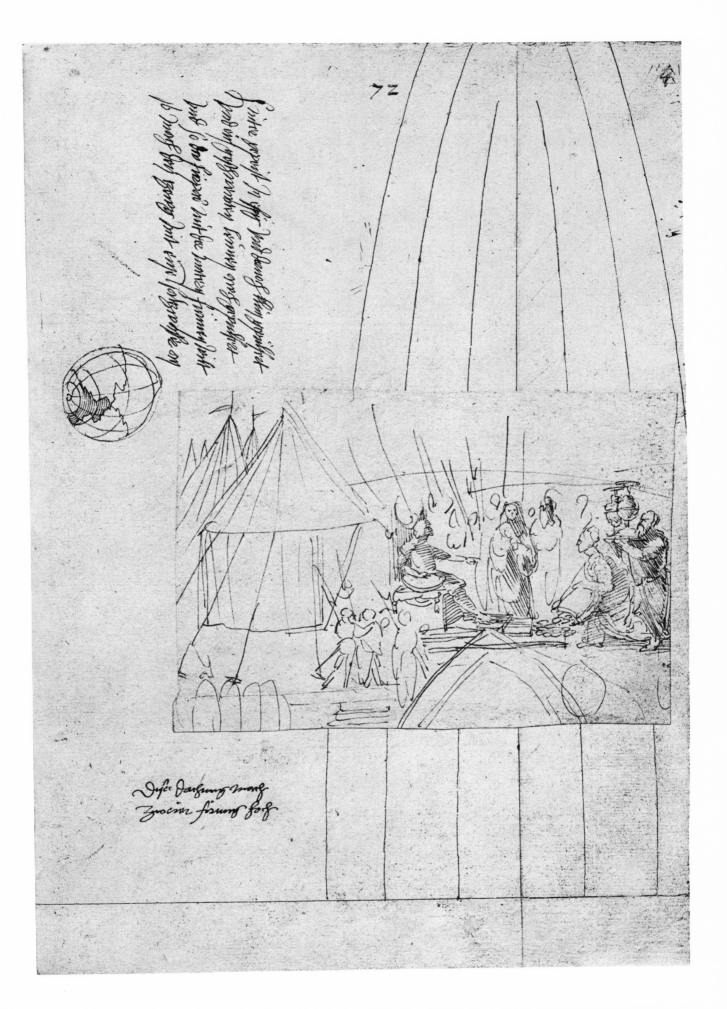

157 Field cannon.

128 × 178 mm; 5 × 7 in.
No watermark.

f.181v; Br.143 (bottom).
R.III.423: 1526–27.

Verso of No. 158. Dürer's monogram added later by someone else. Preparatory for the illustration on the folding plate in Dürer's *Underricht der befestigung (Manual of Fortification)*, printed in 1527.

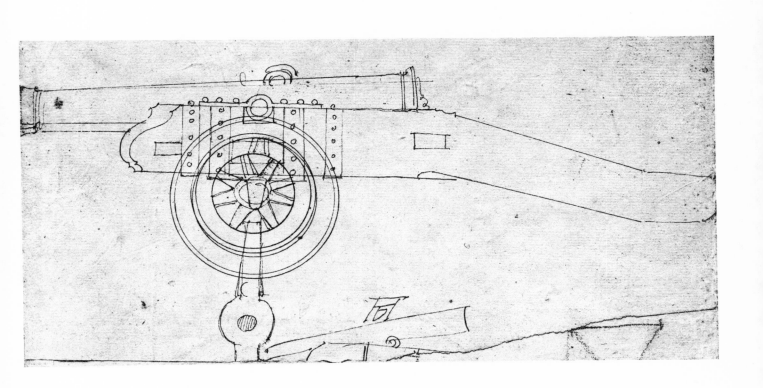

158 Ground plan of a house.

121 × 180 mm; 4¾ × 7⅛ in.
No watermark.

f.181r; Br.146 (bottom).
R.III.423.

Recto of No. 157.

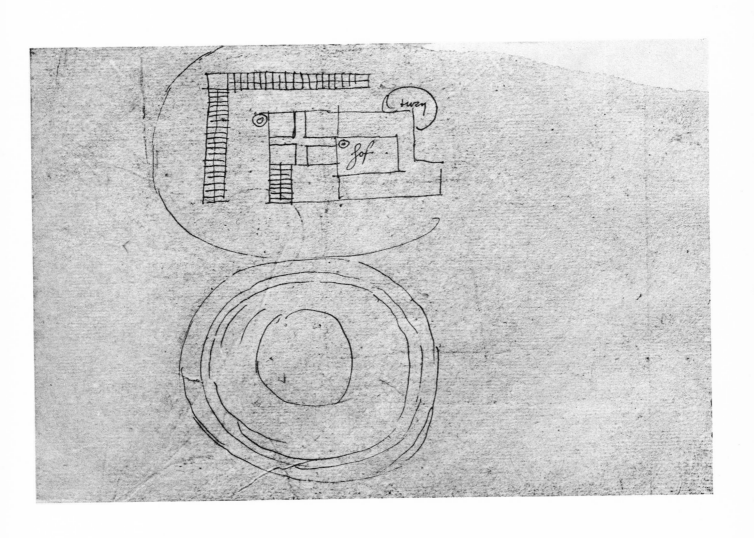

159 Two beer mugs; sketch of a blackamoor.

151 × 199 mm; 6 × 7⅞ in.
No watermark.

f.176r (along with No. 135); Br.130 (top).

Recto of No. 108. The blackamoor appears on the coat-of-arms of
the Tucher family of Nuremberg and remains to this day the emblem
of the brewery of that name.

74

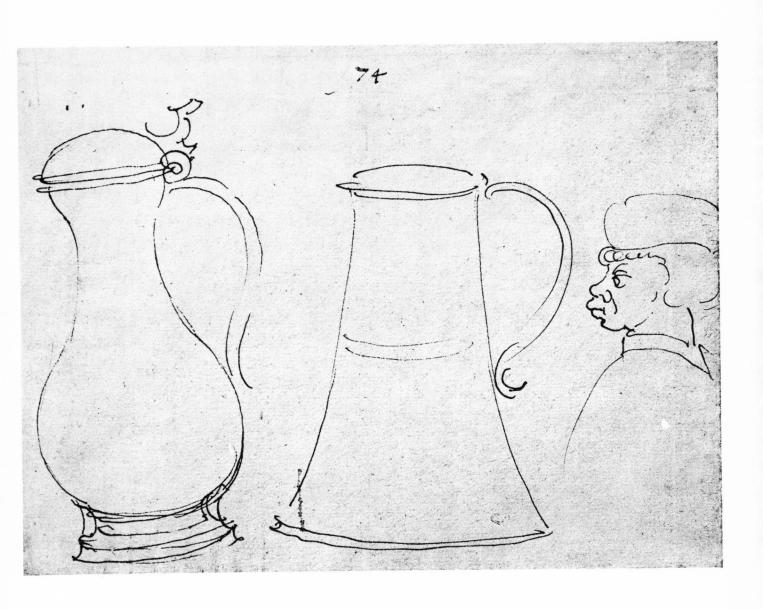

160 Interior seen through an open door.

166 × 85 mm; 6½ × 3⅜ in.
No watermark.

f.182v; Br.131 (top).
T.515: About 1512.
W.643: 1510–20.
P.1702: 1514; related to No. 139.

Verso of No. 151. The drawing is closely akin to the woodcut "St. Jerome in his Cell" (Bartsch 114) of 1512, and particularly to the preparatory drawing for that woodcut (W.590).

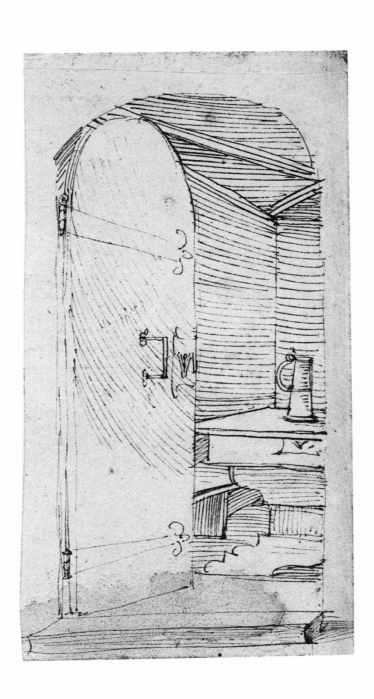

161 Four pewter decanters; pewter mug, inkwell, staircase.

On two sheets, each 104 × 188 mm (4⅛ × 7⅜ in.).
No watermark.

f.189r; Br.155.
T.589: Not a weight, as had been assumed, but a portable inkwell.
T.679: Four pewter flasks, about 1516.
P.1445: Four pewter flasks, 1521–25, rather than about 1516.
P.1446: Tankard and portable inkwell, about 1514.

Related to No. 160.

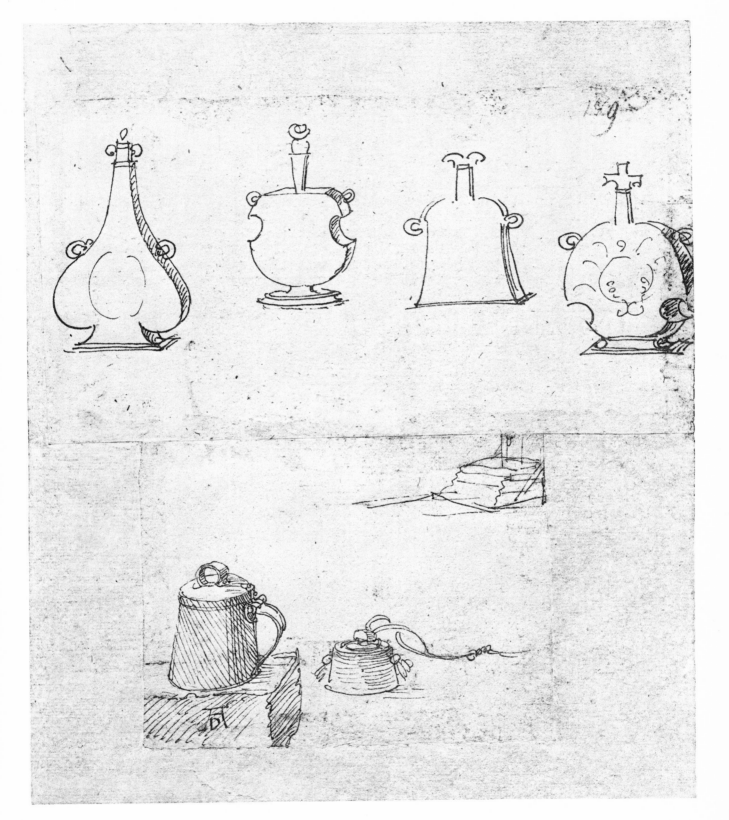

162 Six goblets.

200 × 285 mm; 7⅞ × 11⅛ in.
No watermark.

f.193r; B.156.
T.215: About 1502–03.
P.1566: About 1500.

Inscribed: "Tomorrow I shall draw more of these."

Similar goblets appear in the woodcut "The Whore of Babylon" (Bartsch 73) from the *Apocalypse* series published in 1498, and in the painting "The Adoration of the Magi" of 1504.

Probably intended for use in Albrecht Dürer the Elder's goldsmith's shop. He opened a small retail establishment, rented from the municipality for only five guilders per annum, in 1486. He operated it until the year of his death, 1502.

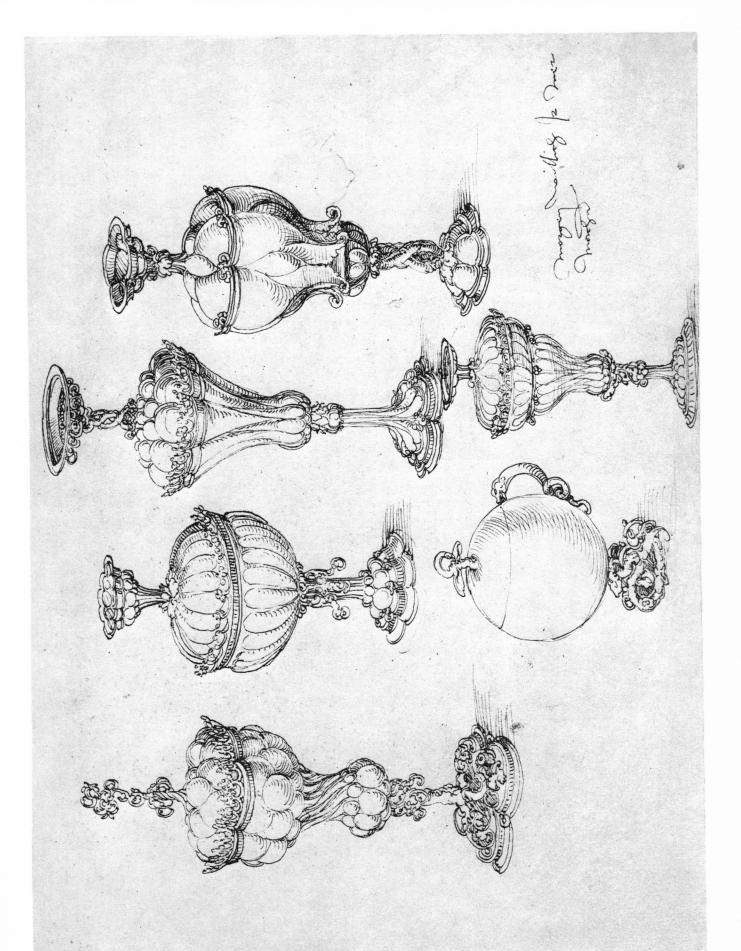

163 Design for a goblet.

175 × 160 mm; 6⅞ × 6¼ in.
Watermark: crowned coat-of-arms with attached *b*.

f.195r; Br.158.
T.A296: Not by Dürer.
P.1568: About 1525.

The watermark points to a date after 1521.

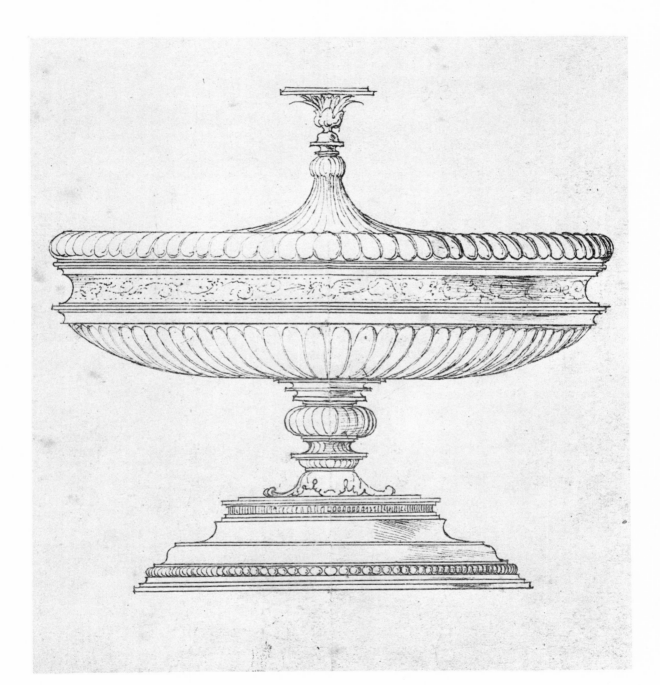

164 Designs for goblets.

270 × 195 mm; 10⅝ × 7⅝ in.
No watermark.

f.194r; Br.157.
T.A295: Not by Dürer.
P.1569: About 1525.

165-170 Six designs for bottles.

Each sheet 260 × 190 mm (10¼ × 7½ in.).
Watermarks:
 165—no watermark.
 166—Cardinal's hat.
 167—no watermark.
 168—Cardinal's hat.
 169—no watermark.
 170—Cardinal's hat.

f.185v, 186r, 187v, 188r, 190v, 191r; Br.149–154.

The designs are drawn with the help of a compass. Each bottle has loops for the insertion of a carrying strap. The cross section shown on No. 170 suggests that these flasks may have been intended for use as canteens.

PLATE 165

PLATE 166

PLATE 167

PLATE 168

PLATE 169

91

PLATE 170

Bartsch, Adam von, *Le Peintre-Graveur*, vol. VII, pp. 1–197, Vienna, 1808; Leipzig, 1866.

Briquet, Charles Moïse, *Les filigranes. Dictionnaire historique des marques du papier*, 4 vols., Paris 1907; Hilversum, 1952.

Bruck, Robert, *Das Skizzenbuch von Albrecht Dürer in der königlichen öffentlichen Bibliothek zu Dresden*, Strassburg, 1905.

Conway, William Martin, *Literary Remains of Albrecht Dürer*, Cambridge, 1899; London, 1958.

De Hevesy, A., "Albrecht Dürer und Jacopo de Barbari," *Festschrift der Internationalen Dürerforschung*, Leipzig-Berlin, 1928.

Dürer, Albrecht, *Etliche Underricht zu befestigung der Stett, Schloss, und flecken* (= *Manual of Fortification*), Nuremberg, 1527.

——, *Hierinn sind begriffen vier Bücher von menschlicher Proportion* (= *Four Books on Human Proportion*), Nuremberg, 1528.

——, *Underweysung der messung mit dem zirckel un richtscheyt, in Linien ebnen unnd gantzen corporen* (= *Manual of Measurement*), Nuremberg, 1525.

Ephrussi, Charles A., *Durer et ses dessins*, Paris, 1882.

Flechsig, Eduard, *Albrecht Dürer, sein Leben und seine künstlerische Entwicklung*, 2 vols., Berlin, 1928 and 1931.

Gerstenberg, Kurt, "Dürers Hand," *Monatshefte für Kunstwissenschaft* V, December 1912, pp. 524–526.

Giesen, Josef, *Dürers Proportionsstudien*, Bonn, 1930.

Hausmann, B., *Dürers Kupferstiche, Radirungen, Holzschnitte und Zeichnungen*, Hannover, 1861.

Heller, Joseph, *Das Leben und die Werke Albrecht Dürers*, vols. II and III (vol. I was never published), Bamberg, 1827; Leipzig, 1831.

Ivins, William M., Jr., *On the Rationalization of Sight*, Metropolitan Museum of Art Papers No. 8, New York, 1938.

Justi, Ludwig, *Konstruierte Figuren und Köpfe A. Dürers*, Leipzig, 1902.

Kurthen, J., "Zum Problem der Dürerschen Pferdekonstruktion,"

Repertorium für Kunstwissenschaft XLIV, June 1923, pp. 77–106.

Lippmann, Friedrich, *Zeichnungen von A. Dürer in Nachbildungen*, 7 vols., Berlin, 1883–1929.

Meder, Joseph, *Dürer-Katalog*, Vienna, 1932.

Oehler, Lisa, "Die Grüne Passion, ein Werk Dürers?," *Anzeiger des Germanischen Nationalmuseums*, Nuremberg, 1960, pp. 91–127.

Panofsky, Erwin, *Dürers Kunsttheorie*, Berlin, 1915.

——, *The Codex Huygens and Leonardo da Vinci, Studies of the Warburg Institute* XIII, London, 1940.

——, *Albrecht Dürer*, 2 vols., Princeton, 1943 and 1948.

——, Raymond Klibansky, and Fritz Saxl, *Saturn and Melancholy*, London, 1964.

Rapke, K., *Die Perspektive und Architektur auf den Dürerschen Handzeichnungen, Holzschnitten, Kupferstichen und Gemälden*, Strassburg, 1902.

Rupprich, Hans, *Dürers schriftlicher Nachlass*, 3 vols., Berlin, 1956–1969.

——, "Die kunsttheoretischen Schriften L. B. Albertis und ihre Nachwirkung bei Dürer," *Schweizerische Beiträge zur allgemeinen Geschichte* 18/19, 1960, pp. 219–239.

Schunke, Ilse, "Zur Geschichte der Dresdner Dürerhandschrift," *Zeitschrift des Deutschen Vereins für Kunstwissenschaft* VIII, 1941, pp. 37ff.*

Schuritz, Hans, *Die Perspektive in der Kunst Dürers*, Frankfurt/M., 1919.

Springer, Jaro, review of F. Lippmann's *Zeichnungen von A. Dürer*, in *Repertorium für Kunstwissenschaft* XXIX, 1906, p. 570.

* Schunke develops an elaborate theory that the *Dresden Sketchbook* came into the possession of Emperor Rudolph II in 1589 from the estate of Cardinal Antoine Granvella, the secretary of Emperor Charles V. It was then, according to Schunke, bound together at Prague with the fair copy of Book I of Dürer's *Four Books on Human Proportion* that supposedly had belonged to Christoph Coler. Coler had been one of the sponsors of the posthumous translation into Latin of Dürer's book. Coler's son had sold that manuscript of Book I to Willibald Imhof, whose heirs in turn sold it to the Emperor in 1588/89. While it is known positively that the Elector Maximilian of Bavaria bought a part of the Emperor Maximilian's *Prayer Book*, which had been decorated by Dürer, from the estate of Cardinal Granvella, the exact nature of the purchases from this source by Rudolph II is not known. Schunke's theory must therefore remain conjectural in several respects. It can only be said with certainty that the *Dresden Sketchbook* came into the possession of von Brühl during the eighteenth century.

Sudhoff, K., "Dürers anatomische Zeichnungen in Dresden nach Leonardo da Vinci," *Archiv für Geschichte der Medizin* I, 1928, p. 317.

Tietze, Hans, and Erika Tietze-Conrat, *Kritisches Verzeichnis der Werke Albrecht Dürers*, 3 vols., Augsburg, 1928; Basel-Leipzig, 1937 and 1938.

Von Eye, A., "Dürersche Handschriften und Handzeichnungen in Dresden," *Anzeiger und Kunde der deutschen Vorzeit*, Neue Folge No. 17, 1870, p. 270.

——, *Die Handzeichnungen Albrecht Dürers in der Königlichen Bibliothek zu Dresden*, Nuremberg, 1871.

Weixlgärtner, Arpad, "Das Skizzenbuch von Albrecht Dürer in der Königl. öffentl. Bibliothek zu Dresden. Herausgegeben von Dr. Robert Bruck. Strassburg i. E., J. H. Ed. Heitz, 1905," review, *Kunstgeschichtliche Anzeigen* (Beiblatt des Instituts für österreichische Geschichtsforschung), No. 2, 1906, pp. 17–32.

——, "Die Vorlagen von Dürers anatomischen Studien im Dresdner Codex," *Mitteilungen der Gesellschaft für vervielfältigende Kunst* XXIX, 1906, pp. 25–26.

Winkler, Friedrich, *Die Zeichnungen Albrecht Dürers*, 4 vols., Berlin, 1936–1939.

Wolf, A., "The Apollo Drawing L.741 and its Relationship with Dürer," *Art in America* XXIX, 1941, p. 23.

CONCORDANCE TO DRESDEN FOLIO NUMBERS

Folio	Strauss	
	r	v
91	110	109
92	112	111
93	113	114
94	117	118
95	123	—
96	122	—
97	125	—
98	127	129
99	149	126
100	121	—
101	115	116
102	66	128 (left)
103	73	74
104	44	27
105	8	9
106	71	72
107	62	63
108	—	87
109	75	76
110	40	41
111	—	79
112	—	85
113	86	—
114	80	—
115	78	77
116	91	90
117	56	57
118	37, 68	67
119	11	10
120	48	49
121	51	50
122	58	59
123	—	45
124	60	61
125	34	33
126	32	31

Folio	Strauss	
	r	v
127	52	53
128	65	64
129	88	89
130	—	130
131	132	—
132	12	13
133	43	131
134	42	92
135	54	55
136	94	102
137	97	98
138	137	99
139	106	—
140	107	—
141	104	—
142	105	—
143	96	103
144	101	100
145	17	18
146	23	124
147	—	70
148	69	—
149	83	84
150	19	—
151	16	—
152	36	35
153	24	26
154	—	81
155	7	29
156	28	30
157	82	—
158	25	—
159	—	93
160	1	—
161	3	4
162	5	6

Folio	Strauss	
	r	v
163	14	15
164	2, 46	47
165	21	22
166	146	95
167	147	145
168	142	138
169	39,	38
	128(right)	
170	120	20
171	143, 145a	141
172	—	155
173	154	—
174	156	—
175	148	133
176	135, 159	108
177	134, 140	144
178	153	—
179	152	—
180	119	150
181	158	157
182	151	160
183	—	139
184	136	137
185	—	165
186	166	—
187	—	167
188	168	—
189	161	—
190	—	169
191	170	—
192	—	—
193	162	—
194	164	—
195	163	—

CONCORDANCE TO BRUCK NUMBERS

Bruck	Strauss	Bruck	Strauss	Bruck	Strauss	Bruck	Strauss
1	45	42	59	83	28	123	118
2	37	43	60	84	30	124	115
3	52	44	61	85	69	125	116
4	53	45	38	86	16	126	142, 145a
5	48	46	10	87	24	127	108
6	49	47	11	88	26	128	133
7	50	48	33	89	25	129	134, 140
8	51	49	34	90	1	130	135, 159
9	54	50	64	91	7	131	139, 160
10	55	51	65	92	2	132	149
11	40	52	12	93	35	133	143
12	41	53	13	94	36	134	141
13	31	54	43	95	81	135	144
14	32	55	92	96	82	136	153
15	66	56	106	97	83	137	152
16	73	57	107	98	84	138	137
17	74	58	104	99	47	139	145
18	44	59	105	100	46	140	155
19	27	60	103	101	95	141	154
20	8	61	101	102	93	142	147
21	9	62	96	103	124	143	150, 157
22	88	63	100	104	123	144	151
23	89	64	102	105	122	145	156
24	71	65	97	106	121	146	119, 158
25	62	66	99	107	130	147	148
26	63	67	42	108	131	148	136
27	56	68	67, 68	109	132	149	165
28	57	69	94	110	125	150	166
29	87	70	5	111	127	151	167
30	75	71	6	112	129	152	168
31	76	72	3	113	126	153	169
32	79	73	4	114	39, 128, 138, 146	154	170
33	80	74	14	115	120	155	161
34	77	75	15	116	110	156	162
35	78	76	17	117	109	157	164
36	85	77	18	118	111	158	163
37	86	78	19	119	112	159	72, 98
38	90	79	23	120	113	160	29
39	91	80	20	121	114		
40	70	81	21	122	117		
41	58	82	22				

WATERMARKS OF THE PAPERS USED FOR THE "DRESDEN SKETCHBOOK"

		MEDER	BRIQUET
1.	High Crown	20	4902
2.	Bull's Head with Serpent	81	15374
3.	Cardinal's Hat	44	3412
4.	Anchor in Circle	171	587
5.	Trident with a Small Circle (Hausmann No. 32a)	—	—
6.	Waterwheel	175	13254
7.	Coat-of-Arms* (only on the blank sheet, folio 195, to which No. 163 is attached)	—	—
8.	Coat-of-Arms* (only on the blank sheet, folio 192)	—	—
9.	Crowned Coat-of-Arms with attached *b* (used by Dürer after 1520 only)	314	8287
10.	Snake* (only on folio 147)	—	—
11.	Crossed Arrows (used by Dürer predominantly while in Italy, 1505–1506)	—	6287
12.	Crossbow in Circle†	140	728

* Not used by Dürer.
† Not used by Dürer himself, but occurs in some posthumous impressions.

NOTE: The watermarks of the sheets of the *Dresden Sketchbook* differ in many instances from those of the fair manuscript of Book I of Dürer's *Four Books on Human Proportion,* mentioned in the Introduction. The watermarks of this fair manuscript indicate that the drawings are of various dates, spread over a considerable period of time. A second, very similar fair manuscript of Book I is preserved at London (Sloane 5230/11–114, 5228/9–45). In the London manuscript all sheets have the trident watermark used by Dürer particularly from 1502 to 1512. Cf. Walter L. Strauss, "Die Wasserzeichen der Dürerzeichnungen," *Zeitschrift für Kunstwissenschaft,* Vol. XXV, 1971, pp. 69–74.

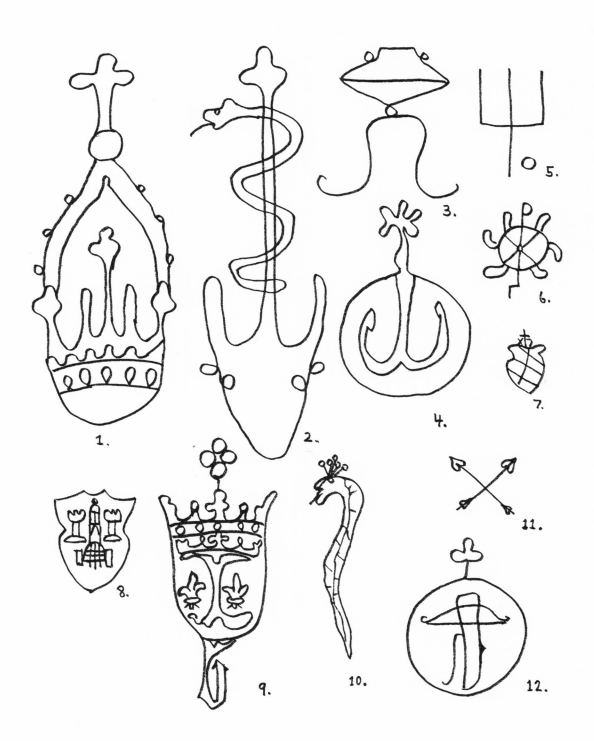

1.

2.

3.

4.

5.

6.

7.

8.

9.

10.

11.

12.

Dover Books on Art

Dover Books on Art

ART ANATOMY, Dr. William Rimmer. One of the few books on art anatomy that are themselves works of art, this is a faithful reproduction (rearranged for handy use) of the extremely rare masterpiece of the famous 19th century anatomist, sculptor, and art teacher. Beautiful, clear line drawings show every part of the body—bony structure, muscles, features, etc. Unusual are the sections on falling bodies, foreshortenings, muscles in tension, grotesque personalities, and Rimmer's remarkable interpretation of emotions and personalities as expressed by facial features. It will supplement every other book on art anatomy you are likely to have. Reproduced clearer than the lithographic original (which sells for $500 on up on the rare book market.) Over 1,200 illustrations. xiii + 153pp. 7¾ x 10¾.
20908-3 Paperbound $4.00

THE CRAFTSMAN'S HANDBOOK, Cennino Cennini. The finest English translation of IL LIBRO DELL' ARTE, the 15th century introduction to art technique that is both a mirror of Quatrocento life and a source of many useful but nearly forgotten facets of the painter's art. 4 illustrations. xxvii + 142pp. D. V. Thompson, translator. 5⅜ x 8.
20054-X Paperbound $2.50

THE BROWN DECADES, Lewis Mumford. A picture of the "buried renaissance" of the post-Civil War period, and the founding of modern architecture (Sullivan, Richardson, Root, Roebling), landscape development (Marsh, Olmstead, Eliot), and the graphic arts (Homer, Eakins, Ryder). 2nd revised, enlarged edition. Bibliography. 12 illustrations. xiv + 266 pp. 5⅜ x 8.
20200-3 Paperbound $2.50

THE STYLES OF ORNAMENT, A. Speltz. The largest collection of line ornament in print, with 3750 numbered illustrations arranged chronologically from Egypt, Assyria, Greeks, Romans, Etruscans, through Medieval, Renaissance, 18th century, and Victorian. No permissions, no fees needed to use or reproduce illustrations. 400 plates with 3750 illustrations. Bibliography. Index. 640pp. 6 x 9.
20577-6 Paperbound $6.00

THE ART OF ETCHING, E. S. Lumsden. Every step of the etching process from essential materials to completed proof is carefully and clearly explained, with 24 annotated plates exemplifying every technique and approach discussed. The book also features a rich survey of the art, with 105 annotated plates by masters. Invaluable for beginner to advanced etcher. 374pp. 5⅜ x 8.
20049-3 Paperbound $3.75

OF THE JUST SHAPING OF LETTERS, Albrecht Dürer. This remarkable volume reveals Albrecht Dürer's rules for the geometric construction of Roman capitals and the formation of Gothic lower case and capital letters, complete with construction diagrams and directions. Of considerable practical interest to the contemporary illustrator, artist, and designer. Translated from the Latin text of the edition of 1535 by R. T. Nichol. Numerous letterform designs, construction diagrams, illustrations. iv + 43pp. 7⅞ x 10¾.
21306-4 Paperbound $2.50

ANIMALS IN MOTION, Eadweard Muybridge. The largest collection of animal action photos in print. 34 different animals (horses, mules, oxen, goats, camels, pigs, cats, lions, gnus, deer, monkeys, eagles—and 22 others) in 132 characteristic actions. All 3919 photographs are taken in series at speeds up to 1/1600th of a second, offering artists, biologists, cartoonists a remarkable opportunity to see exactly how an ostrich's head bobs when running, how a lion puts his foot down, how an elephant's knee bends, how a bird flaps his wings, thousands of other hard-to-catch details. "A really marvellous series of plates," NATURE. 380 full-page plates. Heavy glossy stock, reinforced binding with headbands. 7⅞ x 10¾. 20203-8 Clothbound $15.00

THE BOOK OF SIGNS, R. Koch. 493 symbols—crosses, monograms, astrological, biological symbols, runes, etc.—from ancient manuscripts, cathedrals, coins, catacombs, pottery. May be reproduced permission-free. 493 illustrations by Fritz Kredel. 104pp. 6⅛ x 9¼. 20162-7 Paperbound $2.00

A HANDBOOK OF EARLY ADVERTISING ART, C. P. Hornung. The largest collection of copyright-free early advertising art ever compiled. Vol. I: 2,000 illustrations of animals, old automobiles, buildings, allegorical figures, fire engines, Indians, ships, trains, more than 33 other categories! Vol. II: Over 4,000 typographical specimens; 600 Roman, Gothic, Barnum, Old English faces; 630 ornamental type faces; hundreds of scrolls, initials, flourishes, etc. "A remarkable collection," PRINTERS' INK.

Vol. I: Pictorial Volume. Over 2000 illustrations. 256pp. 9 x 12.
 20122-8 Clothbound $12.95
Vol. II: Typographical Volume. Over 4000 specimens. 319pp.
9 x 12. 20123-6 Clothbound $13.50
 Two volume set, Clothbound, only $26.45

THE UNIVERSAL PENMAN, George Bickham. Exact reproduction of beautiful 18th-century book of handwriting. 22 complete alphabets in finest English roundhand, other scripts, over 2000 elaborate flourishes, 122 calligraphic illustrations, etc. Material is copyright-free. "An essential part of any art library, and a book of permanent value," AMERICAN ARTIST. 212 plates. 224pp. 9 x 13¾. 20616-5 Paperbound $6.95

AN ATLAS OF ANATOMY FOR ARTISTS, F. Schider. This standard work contains 189 full-page plates, more than 647 illustrations of all aspects of the human skeleton, musculature, cutaway portions of the body, each part of the anatomy, hand forms, eyelids, breasts, location of muscles under the flesh, etc. 59 plates illustrate how Michelangelo, da Vinci, Goya, 15 others, drew human anatomy. New 3rd edition enlarged by 52 new illustrations by Cloquet, Barcsay. "The standard reference tool," AMERICAN LIBRARY ASSOCIATION. "Excellent," AMERICAN ARTIST. 189 plates, 647 illustrations. xxvi + 192pp. 7⅞ x 10⅝. 20241-0 Clothbound $6.95

THE FOUR BOOKS OF ARCHITECTURE, Andrea Palladio. A compendium of the art of Andrea Palladio, one of the most celebrated architects of the Renaissance, including 250 magnificently-engraved plates showing edifices either of Palladio's design or reconstructed (in these drawings) by him from classical ruins and contemporary accounts. 257 plates. xxiv + 119pp. 9½ x 12¾. 21308-0 Paperbound $7.50

150 MASTERPIECES OF DRAWING, A. Toney. Selected by a gifted artist and teacher, these are some of the finest drawings produced by Western artists from the early 15th to the end of the 18th centuries. Excellent reproductions of drawings by Rembrandt, Bruegel, Raphael, Watteau, and other familiar masters, as well as works by lesser known but brilliant artists. 150 plates. xviii + 150pp. 5⅜ x 11¼. 21032-4 Paperbound $4.00

MORE DRAWINGS BY HEINRICH KLEY. Another collection of the graphic, vivid sketches of Heinrich Kley, one of the most diabolically talented cartoonists of our century. The sketches take in every aspect of human life: nothing is too sacred for him to ridicule, no one too eminent for him to satirize. 158 drawings you will not easily forget. iv + 104pp. 7⅜ x 10¾.

20041-8 Paperbound $2.75

THE TRIUMPH OF MAXIMILIAN I, 137 Woodcuts by Hans Burgkmair and Others. This is one of the world's great art monuments, a series of magnificent woodcuts executed by the most important artists in the German realms as part of an elaborate plan by Maximilian I, ruler of the Holy Roman Empire, to commemorate his own name, dynasty, and achievements. 137 plates. New translation of descriptive text, notes, and bibliography prepared by Stanley Appelbaum. Special section of 10pp. containing a reduced version of the entire Triumph. x + 169pp. 11⅛ x 9¼. 21207-6 Paperbound $5.95

PAINTING IN ISLAM, Sir Thomas W. Arnold. This scholarly study puts Islamic painting in its social and religious context and examines its relation to Islamic civilization in general. 65 full-page plates illustrate the text and give outstanding examples of Islamic art. 4 appendices. Index of mss. referred to. General Index. xxiv + 159pp. 6⅝ x 9¼. 21310-2 Paperbound $4.00

THE MATERIALS AND TECHNIQUES OF MEDIEVAL PAINTING, D. V. Thompson. An invaluable study of carriers and grounds, binding media, pigments, metals used in painting, al fresco and al secco techniques, burnishing, etc. used by the medieval masters. Preface by Bernard Berenson. 239pp. 5⅜ x 8.

20327-1 Paperbound $3.50

THE HISTORY AND TECHNIQUE OF LETTERING, A. Nesbitt. A thorough history of lettering from the ancient Egyptians to the present, and a 65-page course in lettering for artists. Every major development in lettering history is illustrated by a complete aphabet. Fully analyzes such masters as Caslon, Koch, Garamont, Jenson, and many more. 89 alphabets, 165 other specimens. 317pp. 7½ x 10½. 20427-8 Paperbound $4.50

VASARI ON TECHNIQUE, G. Vasari. Pupil of Michelangelo, outstanding biographer of Renaissance artists reveals technical methods of his day. Marble, bronze, fresco painting, mosaics, engraving, stained glass, rustic ware, etc. Only English translation, extensively annotated by G. Baldwin Brown. 18 plates. 342pp. 5⅜ x 8. 20717-X Paperbound $5.00

FOOT-HIGH LETTERS: A GUIDE TO LETTERING, M. Price. 28 15½ x 22½" plates, give classic Roman alphabet, one foot high per letter, plus 9 other 2" high letter forms for each letter. 16 page syllabus. Ideal for lettering classes, home study. 28 plates in box. 20238-9 $8.50

A HANDBOOK OF WEAVES, G. H. Oelsner. Most complete book of weaves, fully explained, differentiated, illustrated. Plain weaves, irregular, double-stitched, filling satins; derivative, basket, rib weaves; steep, broken, herringbone, twills, lace, tricot, many others. Translated, revised by S. S. Dale; supplement on analysis of weaves. Bible for all handweavers. 1875 illustrations. 410pp. 6⅛ x 9¼. 23169-0 Paperbound $5.00

JAPANESE HOMES AND THEIR SURROUNDINGS, E. S. Morse. Classic describes, analyses, illustrates all aspects of traditional Japanese home, from plan and structure to appointments, furniture, etc. Published in 1886, before Japanese architecture was contaminated by Western, this is strikingly modern in beautiful, functional approach to living. Indispensable to every architect, interior decorator, designer. 307 illustrations. Glossary. 410pp. 5⅝ x 8⅜. 20746-3 Paperbound $4.50

THE DRAWINGS OF HEINRICH KLEY. Uncut publication of long-sought-after sketchbooks of satiric, ironic iconoclast. Remarkable fantasy, weird symbolism, brilliant technique make Kley a shocking experience to layman, endless source of ideas, techniques for artist. 200 drawings, original size, captions translated. Introduction. 136pp. 6 x 9. 20024-8 Paperbound $3.00

COSTUMES OF THE ANCIENTS, Thomas Hope. Beautiful, clear, sharp line drawings of Greek and Roman figures in full costume, by noted artist and antiquary of early 19th century. Dress, armor, divinities, masks, etc. Invaluable sourcebook for costumers, designers, first-rate picture file for illustrators, commercial artists. Introductory text by Hope. 300 plates. 6 x 9.
 20021-3 Paperbound $4.50

EPOCHS OF CHINESE AND JAPANESE ART, E. Fenollosa. Classic study of pre-20th century Oriental art, revealing, as does no other book, the important interrelationships between the art of China and Japan and their history and sociology. Illustrations include ancient bronzes, Buddhist paintings by Kobo Daishi, scroll paintings by Toba Sojo, prints by Nobusane, screens by Korin, woodcuts by Hokusai, Koryusai, Utamaro, Hiroshige and scores of other pieces by Chinese and Japanese masters. Biographical preface. Notes. Index. 242 illustrations. Total of lii + 439pp. plus 174 plates. 5⅝ x 8¼.
 20364-6, 20265-4 Two-volume set, Paperbound $8.00

MASTERPIECES OF FURNITURE, Verna Cook Salomonsky. Photographs and measured drawings of some of the finest examples of Colonial American, 17th century English, Windsor, Sheraton, Hepplewhite, Chippendale, Louis XIV, Queen Anne, and various other furniture styles. The textual matter includes information on traditions, characteristics, background, etc. of various pieces. 101 plates. Bibliography. 224pp. $7\frac{7}{8}$ x $10\frac{3}{4}$.

21381-1 Paperbound $4.50

PRIMITIVE ART, Franz Boas. In this exhaustive volume, a great American anthropologist analyzes all the fundamental traits of primitive art, covering the formal element in art, representative art, symbolism, style, literature, music, and the dance. Illustrations of Indian embroidery, paleolithic paintings, woven blankets, wing and tail designs, totem poles, cutlery, earthenware, baskets and many other primitive objects and motifs. Over 900 illustrations. 376pp. $5\frac{3}{8}$ x 8. 20025-6 Paperbound $3.95

AN INTRODUCTION TO A HISTORY OF WOODCUT, A. M. Hind. Nearly all of this authoritative 2-volume set is devoted to the 15th century—the period during which the woodcut came of age as an important art form. It is the most complete compendium of information on this period, the artists who contributed to it, and their technical and artistic accomplishments. Profusely illustrated with cuts by 15th century masters, and later works for comparative purposes. 484 illustrations. 5 indexes. Total of xi+838pp. $5\frac{3}{8}$ x $8\frac{1}{2}$. Two-vols. 20952-0,20953-0 Paperbound $12.00

A HISTORY OF ENGRAVING AND ETCHING, A. M. Hind. Beginning with the anonymous masters of 15th century engraving, this highly regarded and thorough survey carries you through Italy, Holland, and Germany to the great engravers and beginnings of etching in the 16th century, through the portrait engravers, master etchers, practicioners of mezzotint, crayon manner and stipple, aquatint, color prints, to modern etching in the period just prior to World War I. Beautifully illustrated —sharp clear prints on heavy opaque paper. Author's preface. 3 appendixes. 111 illustrations. xviii + 487 pp. $5\frac{3}{8}$ x $8\frac{1}{2}$.

20954-7 Paperbound $6.00

ART STUDENTS' ANATOMY, E. J. Farris. Teaching anatomy by using chiefly living objects for illustration, this study has enjoyed long popularity and success in art courses and home-study programs. All the basic elements of the human anatomy are illustrated in minute detail, diagrammed and pictured as they pass through common movements and actions. 158 drawings, photographs, and roentgenograms. Glossary of anatomical terms. x + 159pp. $5\frac{5}{8}$ x $8\frac{3}{8}$. 20744-7 Paperbound $2.75

COLONIAL LIGHTING, A. H. Hayward. The only book to cover the fascinating story of lamps and other lighting devices in America. Beginning with rush light holders used by the early settlers, it ranges through the elaborate chandeliers of the Federal period, illustrating 647 lamps. Of great value to antique collectors, designers, and historians of arts and crafts. Revised and enlarged by James R. Marsh. xxxi + 198pp. $5\frac{5}{8}$ x $8\frac{1}{4}$.

20975-X Paperbound $3.50

Dover Books on Art

PENNSYLVANIA DUTCH AMERICAN FOLK ART, H. J. Kauffman. The originality and charm of this early folk art give it a special appeal even today, and surviving pieces are sought by collectors all over the country. Here is a rewarding introductory guide to the Dutch country and its household art, concentrating on pictorial matter—hex signs, tulip ware, weather vanes, interiors, paintings and folk sculpture, rocking horses and children's toys, utensils, Stiegel-type glassware, etc. "A serious, worthy and helpful volume," W. G. Dooley, N. Y. TIMES. Introduction. Bibliography. 279 halftone illustrations. 28 motifs and other line drawings. 1 map. 146pp. 7⅞ x 10¾.

21205-X Paperbound $4.00

DESIGN AND EXPRESSION IN THE VISUAL ARTS, J. F. A. Taylor. Here is a much needed discussion of art theory which relates the new and sometimes bewildering directions of 20th century art to the great traditions of the past. The first discussion of principle that addresses itself to the eye rather than to the intellect, using illustrations from Rembrandt, Leonardo, Mondrian, El Greco, etc. List of plates. Index. 59 reproductions. 5 color plates. 75 figures. x + 245pp. 5⅜ x 8½.

21195-9 Paperbound $3.50

THE ENJOYMENT AND USE OF COLOR, W. Sargent. Requiring no special technical know-how, this book tells you all about color and how it is created, perceived, and imitated in art. Covers many little-known facts about color values, intensities, effects of high and low illumination, complementary colors, and color harmonies. Simple do-it-yourself experiments and observations. 35 illustrations, including 6 full-page color plates. New color frontispiece. Index. x + 274 pp. 5⅜ x 8.

20944-X Paperbound $3.50

STYLES IN PAINTING, Paul Zucker. By comparing paintings of similar subject matter, the author shows the characteristics of various painting styles. You are shown at a glance the differences between reclining nudes by Giorgione, Velasquez, Goya, Modigliani; how a Byzantine portrait is unlike a portrait by Van Eyck, da Vinci, Dürer, or Marc Chagall; how the painting of landscapes has changed gradually from ancient Pompeii to Lyonel Feininger in our own century. 241 beautiful, sharp photographs illustrate the text. xiv + 338 pp. 5⅝ x 8¼.

20760-9 Paperbound $4.00

Dover publishes books on commercial art, art history, crafts, design, art classics; also books on music, literature, science, mathematics, puzzles and entertainments, chess, engineering, biology, philosophy, psychology, languages, history, and other fields. For free circulars write to Dept. DA, Dover Publications, Inc., 180 Varick St., New York, N.Y. 10014.